How To **Paint Flames**

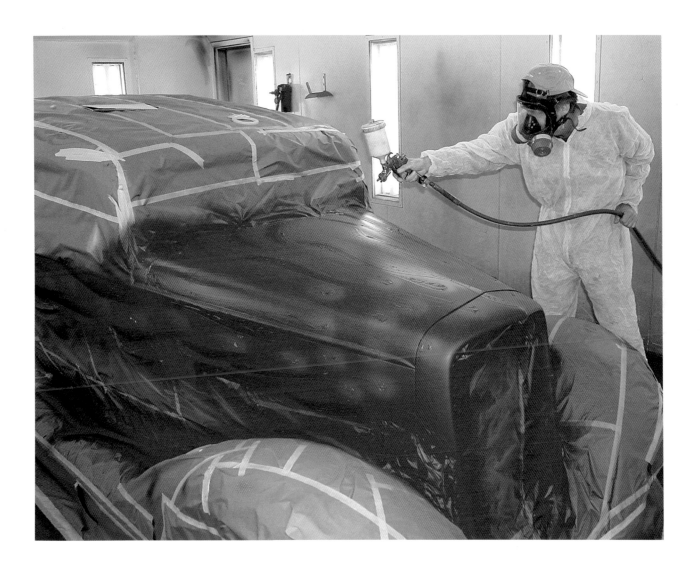

By Bruce Caldwell

First published in 2008 by Motorbooks, an imprint of MBI Publishing Company, 400 First Avenue North, Suite 300, Minneapolis, MN 55401 USA

Motorbooks titles are also available at discounts in bulk quantity for industrial or sales-promotional use. For details write to Special Sales Manager at MBI Publishing Company, 400 First Avenue North, Suite 300, Minneapolis, MN 55401 USA.

To find out more about our books, join us online at www.motorbooks.com.

ISBN-13: 978-0-7603-4136-0

Editor: Steve Casper
Creative Director: Michele Lanci
Design Manager: Kim Winscher
Layout: Heather Parlato
Front Cover photo: Peter Harholdt

Printed in China

10 9 8 7 6 5 4 3 2 1

About the author

Bruce Caldwell has been an automotive journalist and photographer since 1975 when he became associate editor of *Car Craft*. He was a feature editor at *Hot Rod* and editor of *Chevy High-Performance, Mustangs and Fords, Muscle Car Review, Chevy Action*, and *Street Rod Quarterly*. His work appears regularly in major truck, street rod, and performance car magazines. He has authored several automotive how-to books. He lives with his wife in Woodinville, Washington.

Acknowledgments

This book wouldn't have been possible without the generous help of these fine people and companies:
 Donn Trethewey
 Roy Dunn
 Travis Moore
 Mike Lavallee
 Denise Caldwell
 Craig Caldwell
 Jason Rushforth
 Barry Kluczyk
 Bob Cody
 Bob Cody Jr.
 Terry Portch
 Gary Becktold
 Dunn Auto Graphics, www.dunnautographics.com
 Killer Paint, www.killerpaint.com
 House of Kolor, www.houseofkolor.com
 Anest Iwata USA, Inc., www.anestiwata.com
 Rushforth Performance Design, www.jasonrushforth.com

Contents

Introduction

Flame painting is an art. It has many mechanical and technical aspects, but creativity is the core of custom flame painting. That's why there's no perfect way to design or paint flames. Opinions on how flames should look and how to paint them are as varied as the flames themselves.

The important thing about flame painting is to find techniques that work for you. Results are what matter. How the finished flames look is far more important than how they got there.

Flame painting involves a fair amount of experimentation, so getting started on any level is very important. Often, you won't know what works until you've discovered what doesn't work. Don't be afraid to make mistakes. Hopefully this book will ease the learning process by showing techniques that have worked for experienced flame painters.

Don't worry about copying existing styles. So what if you're the millionth person to paint traditional flames on a black '32 Ford? Would you rather have great-looking copycat flames or terrible but totally original flames? You can be more innovative as your experience level rises.

MY FLAMING PAST AND WHAT I'VE LEARNED

I've been interested in flame paint jobs since I was a young child. During the production of this book, I found some cars I had drawn when I was six years old. The cars were flamed. I made frequent use of the flame decals that came with the old AMT three-in-one, ¹⁄₂₅th-scale plastic model kits. I hand painted custom flames long before my motor skills were fully developed. I defaced my Tonka trucks attempting to be a junior Von Dutch.

I flamed wagons and crude gravity racers (pseudo soapbox derby cars). The first motorized vehicle I flamed was a '30 Ford Model A tractor conversion. I used Testors white model enamel on the faded red cowl. The tractor subsequently caught on fire, significantly preceding today's realistic flames, but we extinguished them.

I've owned several flamed cars and trucks. A couple of them have been *Hot Rod* magazine cover cars and appeared in other national publications. I've painted a couple flame jobs and helped more talented friends on others. I've made some serious mistakes, such as botching the clear coat of a *Hot Rod* cover truck, but it didn't show in the photos. I nearly ruined a one-year-old Cougar XR-7 when I painted it with a free spray gun that wasn't suitable for spraying graffiti. But I've always learned from my mistakes, and most importantly I've always had fun.

I've been fortunate to observe and photograph some extremely talented custom painters. I've done lots of magazine articles and a couple books on custom painting. I'm always fascinated by the different techniques. I've learned a lot from those artists. Key things I've learned:

Design
A flame job is only as good as its design.

Flow
The best flame designers and painters have a natural flow to their movements and work.

Color
Color is an important aspect of design. Flame colors should work well together, so they flow from one to another. Understanding contrast is also critical.

Tape
It usually takes many attempts to get a satisfactory layout. That means lots of wasted tape, but tape is a minor part of the total cost. Don't sacrifice design to save a few bucks on tape.

Mistakes
Mistakes happen. Pros don't get rattled, because they know how to fix problems. Many people can apply beautifully smooth paint as long as everything goes well. Pros know how to get a great paint job in spite of mistakes. That ability separates pros from amateurs.

Clear
A good clear coat is key to a beautiful flame job. Clear gives depth and brilliance as well as protection.

Buffing
Color sanding and buffing are arts. It's during this stage that the paint job comes alive. The work is tedious but pivotal to great flames.

Striping
Not all flames require pinstriping, but for those that do, color selection and line thickness are very important. Color choice determines how well the flames pop off the base color. Pinstriping affects the way the tips look and can cover minor mistakes.

HAVE FUN, SAVE MONEY

If it isn't fun, why bother doing it? Flame paint jobs aren't one of life's necessities. Flames are a way of personalizing a vehicle. They make a vehicle unique and memorable.

Saving money is fun too. The goal of this book is to help you achieve a great flame job, regardless of how much of the job you do. By doing some or all the work, you can reap substantial savings.

Top-notch professional custom painters charge thousands of dollars for show-quality flame jobs. Their prices

reflect the high costs of materials, their years of experience, and their countless hours of grunt work.

You can't do anything about the cost of materials, but any time you cut down on labor costs, you'll save money. Ensuring that the flames are exactly what you wanted is as important as saving money. When you maintain control, you get *your* flames, not someone else's interpretation of your ideas.

You can design your flames and make a paper pattern as shown in this book. You can take the pattern with its pounce wheel holes and body reference points to the painter. The resulting chalk pattern will be your design.

The best thing you can do to become a successful flame painter is practice, practice, practice. So get some blue fine-line tape and start flaming. And don't forget to have fun.

DEDICATION

To my parents, Wray and Elaine Caldwell, who always encouraged my creativity and applauded my efforts no matter how far outside the lines I strayed. They took me to art museums and displayed abstract modern art and sculpture in our home in an era when neighbors favored Norman Rockwell, Grandma Moses, and paintings of dogs playing poker. They supplied my siblings and me with all the art and writing supplies we could use. They indulged my passion for automotive magazines even though they viewed cars as mere appliances. Opportunities for learning and creative expression were only exceeded by my parents' abundant unconditional love.

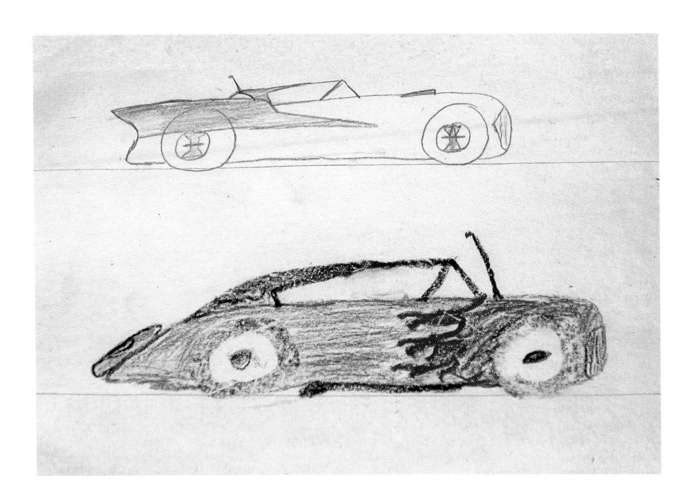

Chapter 1
Hot Ideas

All great flames start with an idea. A flash of color or a car in a magazine ignites a painter's imagination. The ideas percolate; photos are shot at car shows and rod runs; images are clipped from magazines; preliminary sketches are drawn; and ultimately masking tape is applied to metal.

Many rolls of masking tape and much more refinement of the original concept may be necessary before any paint is mixed. The design and inspiration part of flame painting is the most important element of a successful flame job. We can't stress this point enough: *a solid design is the foundation of a great flame job.*

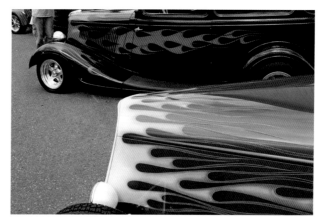

It's not uncommon at street rod shows to see same year/model vehicles parked next to each other but with different kinds of flames. This is a great way to compare styles and colors.

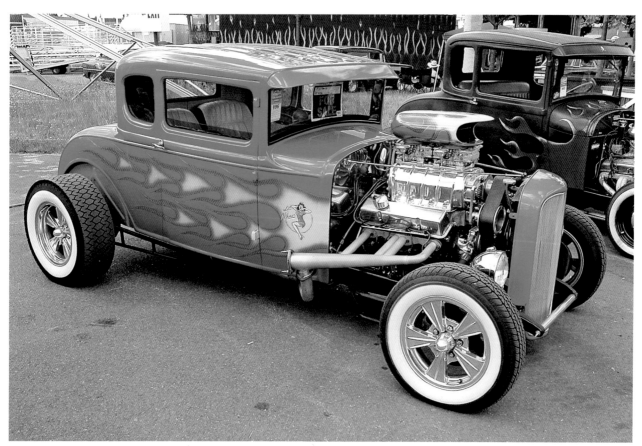

Ideas are everywhere, but you can't beat large shows for seeing lots of cool cars, trucks, and cycles in one place. Goodguys Rod and Custom Association events are spread across the country. You'll see thousands of wild hot rods on display, providing endless examples of great flames.

Without a beautiful design, the most expensive paint in the world is wasted. An awkward design is far more glaring than runs, bugs, dirt, or any other paint imperfections.

Flames are (for the most part) high-impact custom painting at its best. The bolder the flames, the more important the design. A few misshapen curves and licks can hide in ghost flames, but a single "start-and-stop" curve or a poorly placed lick can ruin an otherwise great flame job.

Flow is a key concept behind great flames. The best flames have a natural flow to their design. They're almost organic. They seem alive and impart a sense of motion. Poorly designed flames interrupt flow and create a visual disturbance.

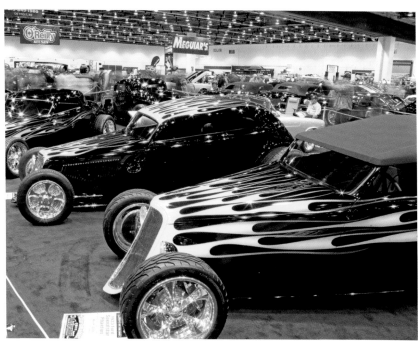

Big indoor winter car shows are also great sources of flame ideas. This group of Bobby Alloway–built hot rods was displayed at the legendary Detroit Autorama in Cobo Hall. The sinewy licks are known as Ohio Style flames and are credited to various painters, including Bill Roell and Wade Hughes.

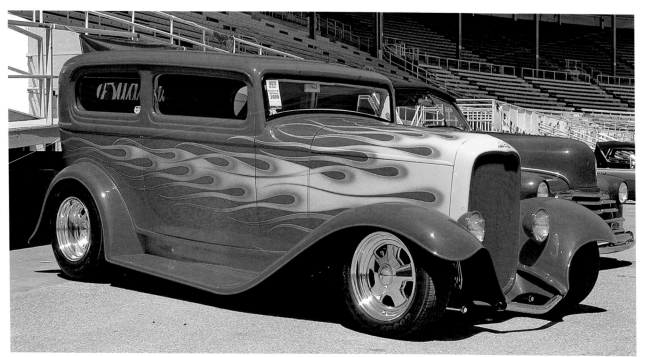

Flames and '32 Fords seem to be a natural combination. Craig Lang's beautiful chopped '32 Tudor was the cover car for the first edition of this book. Donn Trethewey painted the flames. This style of flames would look great on newer vehicles as well.

Always carry a digital camera along when attending car shows. With digital cameras, you can take countless photos and use them for future reference material. Take overall and close-up shots.

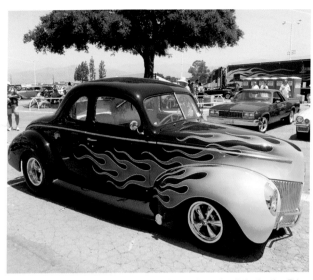

This style is often referred to as hooked-end flames due to the distinctive tips. This stunning 1940 Ford was flamed by legendary southern California painter Dennis Ricklefs, who is known for this style of flames.

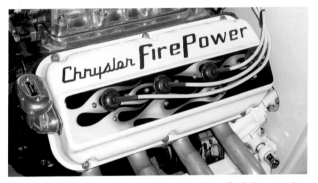

Flames don't have to dominate a car; they can be used very effectively as accents, as shown on the valve cover plates on this supercharged Hemi engine.

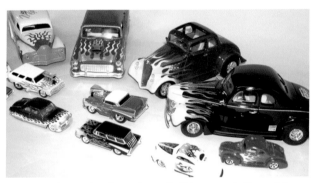

Die-cast model cars and trucks are also excellent idea sources for flame painting. Some very talented artists and designers are hired to conceive these paint schemes.

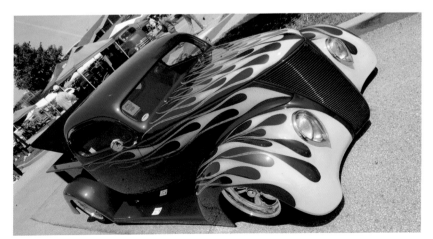

Contrast and flow are two key elements of a successful flame job. This phantom '37 Ford pickup was photographed at the NSRA Nationals in Louisville, Kentucky, where more than 10,000 hot rods turn out every summer.

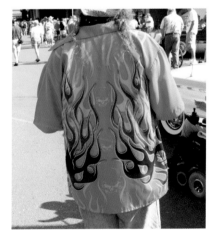

Flame ideas are everywhere, even on clothing. Noted custom painter Roy Dunn is featured in the how-to chapters of this book. He likes flames on his shirts as well as his cars.

Great flames should look good by themselves, but more importantly they should enhance the appearance of the vehicle. That's why it's important to spend as much time and tape as needed to get the design and layout perfect.

Flames are somewhat contradictory. On one hand, they represent the randomness of real fire. An actual car fire goes wherever it happens to burn. It's not a pretty sight. Stylized, custom-painted flames represent the idealized essence of flames. As such, they need to highlight and accentuate the natural lines of the vehicle. This is why the placement of each flame lick is so critical.

Several other factors combine with placement in producing a great flame job. These factors include thickness of the licks; length, rate of taper, and direction of flame tips; tightness of inside curves; symmetry or asymmetry; how licks pass through or around trim items; overlaps or lack of overlaps; the amount of oscillation in flame licks; and how flames are placed relative to sharp edges on fenders, hoods, and doors.

Thin bands of flames on this '32 Ford roadster can be used to accent body lines. Notice how the tips of the flames follow the curve of the rear quarter panel all the way down to the rear pan. The color contrast is wild, but due to its moderate size, it is not overpowering.

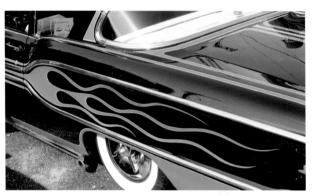

Flames are a natural way to highlight factory styling cues, as shown on the concave rear quarter panels of this custom '58 Pontiac.

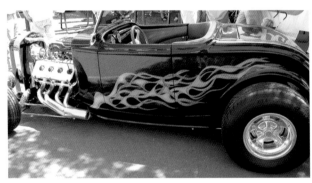

Flames don't have to do anything other than look cool, but the flames on this roadster appear to emanate from the exhaust headers.

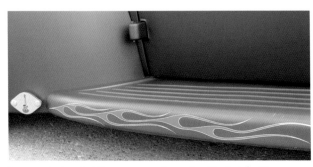

These running board miniflames are a smaller version of the "exhaust" flames seen on the roadster. The oval cap at the front of the licks is for exhaust cutouts.

In addition to the thousands of wild hot rods at major outdoor car shows, these venues are also great places to check out custom paint manufacturers. Most of them have extensive displays with lots of examples, color charts, technical information, and experts available to answer your painting questions.

The point is that a good design is every bit as important as painting skills. Both skill sets are necessary for a truly outstanding flame job, but design tops paint application.

Keen observation is at the core of great flame design. Some natural talent, a good sense of flow, and the ability to translate what your mind sees to tape on metal also help, but these traits can be improved with practice. Using rolls and rolls of masking tape is the best way to perfect these skills.

Once you spend time studying flames, you'll notice significant differences between the flame jobs that work, those that come close, and those where something just isn't right. Learn from the mistakes of others and don't be afraid to copy or incorporate elements of successful flame jobs you've seen on other cars. It's tough to come up with totally original designs. You can add your own personalized touches, but there are only so many ways to fit flames on a particular vehicle.

Flames can be as complex or as simple as suits your style. This T-bucket roadster features simple, single-color flames without pinstriping, but they look great against the orange body paint.

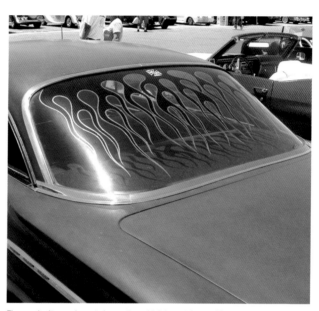

Flames don't even have to be on the vehicle's metal parts. The owner of this primered custom flamed the large bubble-style rear window.

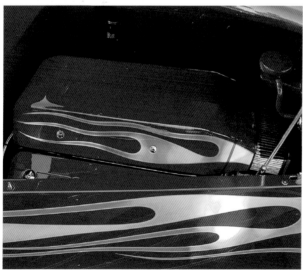

A high degree of detailing is common among the finest street rods. This red jewel has flames both outside and inside the hood. The flames on the throttle body cover match those on the solid hood panels.

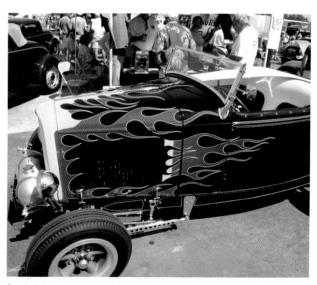

Certain hot rods are esteemed as icons of the hobby. The Tom McMullen '32 Ford highboy is one of those cars. The founder of *Street Rodder* magazine went through many iterations with his daily-driver roadster, but the most remembered version is the one with Ed "Big Daddy" Roth flames and pinstriping.

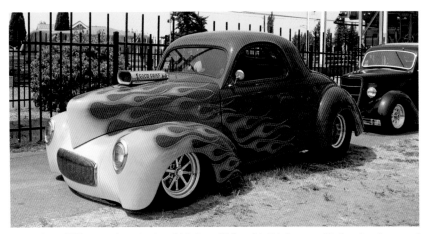

Flames can be hidden if you want their impact only some of the time. That's the case with this '55 Ford F-100. All its flames are confined to the engine compartment and underside of the hood.

A supercharged Willys coupe is a natural candidate for a wild flame job. Note how smoothly the pale yellow around the grille blends to the brighter yellow, which turns to orange. Blue pinstriping helps the flames pop off the red base color.

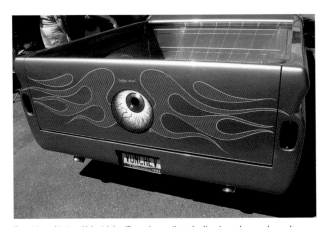

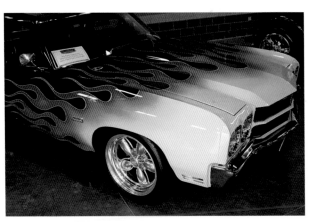

Speaking of hot rod/pinstriping/flame icons, they don't get much more legendary than Kenneth "Von Dutch" Howard, whose signature item was a flaming eyeball. The wild flames on this Chevy tailgate pay homage to Von Dutch.

Flame size and color have a lot to do with the amount of visual impact. The large-scale yellow and orange flames on this 1970 Chevelle really stand out against the black paint on the rest of the car. It's impossible not to notice this car.

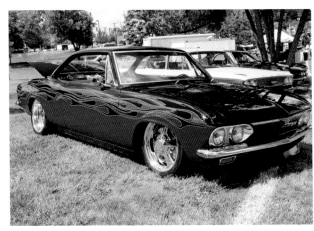

Flames can be used to separate a two-tone paint scheme, as illustrated on this highly modified Corvair. Note how the black licks border the lower red paint and how the red licks border the black upper paint. Blue pinstriping was again used to outline the flames.

Small amounts of flame work well inside side trim elements, as illustrated on the rear quarter panels of this red '57 Chevy 210 sedan. The realistic flames are subtle until you're right on top of them.

It's better to be accused of copying the flames on a well-known car than to have ugly but highly original flames. It's better to hear, "Those flames look like the ones on so-and-so's car" than, "Those flames look like #%@*!"

Inspiration can come from a myriad of sources. Flames are everywhere. Flames can be found on all kinds of commercial products, in advertising, as parts of logos, in computer graphics, and in video games—the sources are endless. A few obvious automotive-related sources are die-cast cars and trucks, event T-shirts, and car magazines.

Highly skilled artists often design the flames seen on toy cars and in magazines. Someone or some big company already paid for their design skills, so you don't have to. If you're lucky, you can find examples of flames on vehicles like yours. You can save a lot of money by building a model of your car or truck and flaming it to see how your idea looks.

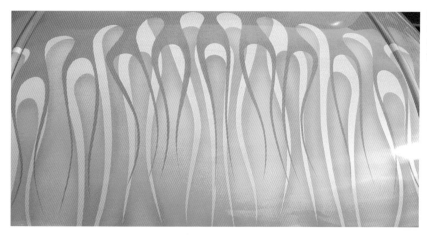

Multiple layers of flames take a great deal of time and taping, but the finished effect is wild. These carefully executed flames were done without pinstriping. This technique provides a lot of depth and a sense of motion.

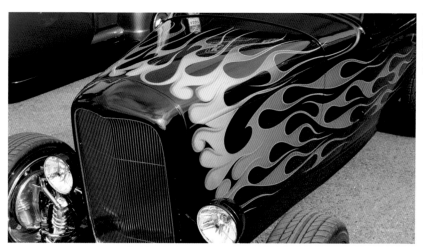

This '32 Ford uses negative-space flames (the main body color) on the grille shell and then transitions into traditional yellow and orange licks. It adds a contemporary look with the reverse-pointing tribal-style elements. The result is an excellent blend of old and new techniques.

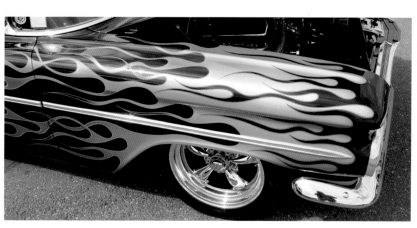

The front fenders of this black '59 Chevy sedan delivery also illustrate negative-space flames. The black licks flow into the light green main flames, which blend to darker green as they flow backward. Purple pinstriping borders the black licks, while different shades of green highlight the green licks.

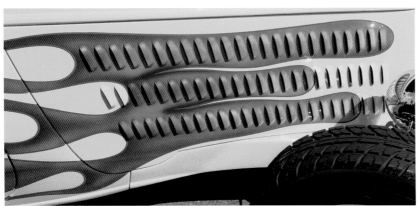

Louvers are a common hot rod element, but designing flames through or around them can be challenging. This '33 Ford coupe neatly handled the problem by wrapping licks around the louvers.

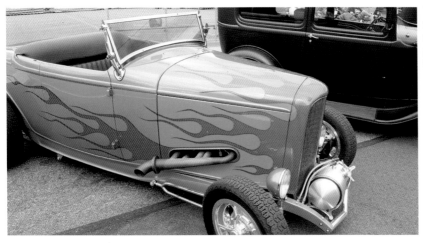

The orange flames on this wild, lime green '32 highboy roadster wrap around the side exit headers, which are a starting point for a set of flames. The nose and hood panel flames neatly flow around the seams of the three-piece hood.

Hiring a professional automotive designer like Jason Rushforth is a great idea, even for the do-it-yourself painter. A talented designer can actually save you money by providing a variety of color and style choices before you buy the expensive paint.

It isn't unreasonable to engage the services of a professional designer. The flames on many high-profile cars and trucks seen in magazines, on major show winners, and on vehicles built for big companies were first designed and conceived by professional designers.

Truly big-name designers are obviously expensive. You probably can't afford the fees that a major manufacturer pays, but many highly skilled designers are surprisingly affordable. When you're looking at spending many thousands of dollars on a custom paint project, a couple hundred or even a thousand dollars more for professional design help seems quite reasonable.

We spoke to Jason Rushforth of Jason Rushforth Performance Design (www.jasonrushforth.com) in Tacoma, Washington, to get some ideas about design. Jason's artwork appears frequently in national magazines, as do the finished cars and trucks. He does a lot of concepts for companies and individuals wanting to build vehicles for trade shows.

Jason emphasized that flames need to flow. Jason says that ellipses and curves should be uniform and have a similar curvature and flow, even if they are of different sizes. The same theory applies to flame licks. They should have a similar flow and taper, despite their differing lengths.

Jason feels that flames are organic and should be designed accordingly. Straight lines should be avoided at all costs. Any color flame is fine with Jason, but fades should be done with complementary colors. Traditional yellow, orange, and red flames look nice with blue or purple tips, but the main parts of the flames should be in the same family of warm colors. If you're not into traditional flame colors, there are lots of options. Some of Jason's favorites are silver to candy blue, like a propane flame, and lime green flames that resemble the color of antifreeze. He especially likes lime green flames on black, white, and silver cars.

Jason feels that, for the most part, pinstriping should be done in contrasting colors. He likes the pop factor of lime green and process blue, especially on black vehicles. According to Jason, flame tips should be random and shouldn't be perfectly opposing. Tips should alternate directions unless you run into trim items or door handles. The length of the tips depends on how long you want the vehicle to look.

Planning is key to a successful flame job. Don't be too eager to start shooting paint. The bright colors are what people see as the finished product, but it's the countless hours of planning, designing, prep work, and taping/masking that make or break a great flame job.

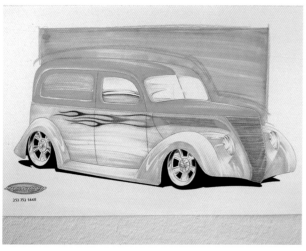

Jim Hart hired Rushforth to design the flames and two-tone paint scheme on his '37 Ford sedan delivery. This is one of Jason's sketches.

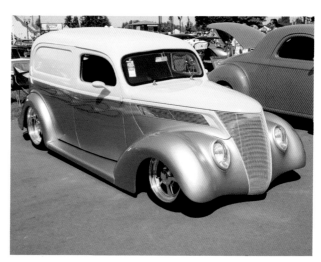

Here is the finished sedan delivery. Note how smoothly the flames flow out of the custom hood vents and how the point at the front of the vents complements the two-tone paint design. This attention to detail is a big reason to hire a designer.

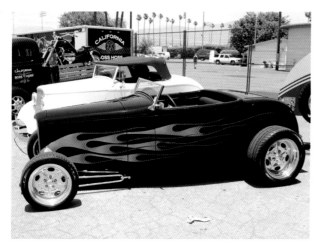

Flow is a key element of great flames. The flames on this '32 Ford highboy roadster are limited to the car's flanks. The hood is left black. The flames start low on the grille shell and flow smoothly upward toward the trunk lid. Notice the good use of red tips to overlap the larger orange licks.

The wild flames on this '32 highboy incorporate many neat ideas. There's a lot of overlapping action and several free-floating emphasis licks. The flames only partially cover the hood. Negative-space flames start the design. Shadowing and light-colored highlights enhance the 3-D look and the feeling of motion.

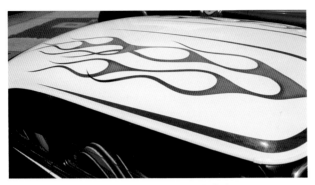

Flames can be used on any part of a car. This mid-1950s Ford custom uses a combination of flames and scallops to highlight the chopped top.

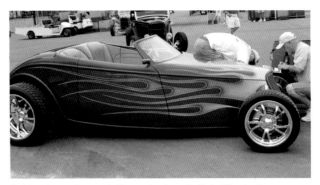

Certain colors, such as candy blue, work extra well with traditional yellow, orange, and red flames. Process Blue pinstriping helps make the flames pop. Note the effective mix direction with the tips.

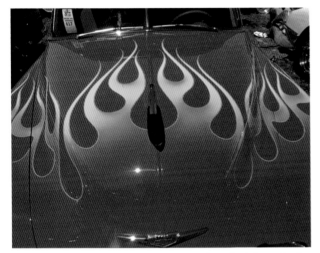

This early 1950s Chevy hood illustrates symmetry and how effectively a contrasting pinstripe can separate the flames from the main color. The orange on the nose is very close to the red base color, but the blue pinstriping makes them distinct. Notice how smoothly the orange blends into the yellow tips.

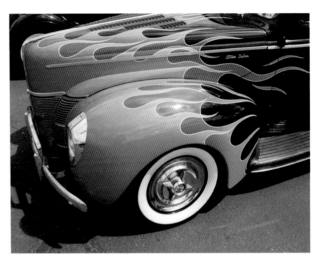

Painting a slightly lighter shade over darker underlying flames enhanced the complexity of these '40 Ford coupe flames. White pinstriping was used to separate the two shades of orange.

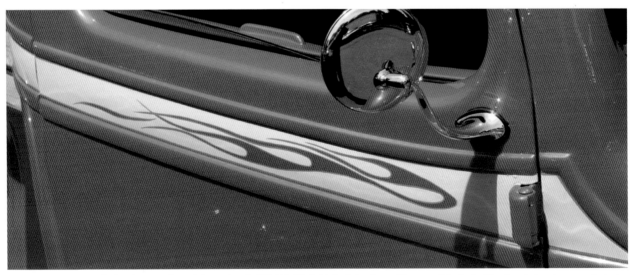

Small flames can be used effectively for accent, but scale is very important. The little licks inside the factory door molding area of this classic pickup flow nicely and are correctly sized.

Chapter 2
Color and Contrast

Two key elements of a great flame job, following closely behind an outstanding design and masterful taping, are color choice and contrast. The design establishes the flow of the flames, but color choice/contrast determines the impact.

Flames are a bold type of custom painting, but just how bold or subtle is largely a matter of color choices. The range of contrast can vary from subtle pearl ghost flames that appear only under ideal lighting conditions to neon flames visible from outer space.

Flame color has much to do with the vehicle's base color. The stereotypical black hot rod with yellow, orange, and red flames highlighted with either white or blue pinstriping is so traditional as to be a default choice. Black is a perfect base color because almost any color flames will work on black. White is another excellent base color, although it's not a very popular choice for hot rods. Various shades of gray primer run a close second to black as a traditional hot rod base color.

A total repaint project should rely heavily on research. The color choices are unlimited, but too many choices can often be as frustrating as too few options. This can be a good time to copy an existing car.

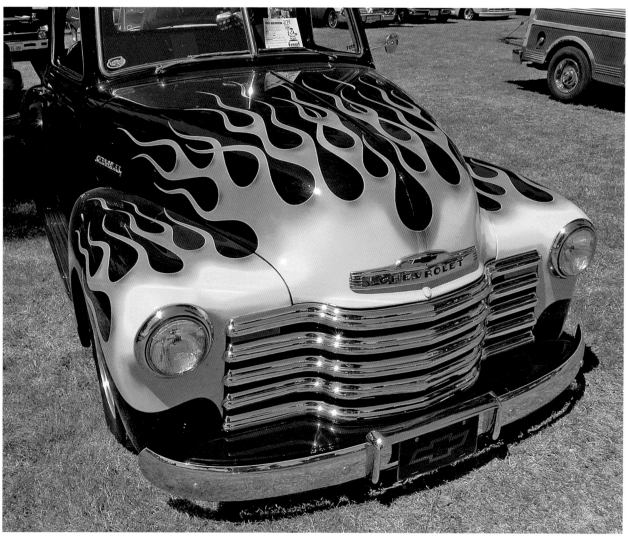

A black vehicle with yellow, orange, and red flames with blue pinstriping is about as traditional as it gets. It's nearly impossible to miss with this combination.

A cautionary note about photos in magazines or online is warranted. An image may have been enhanced via a program such as Photoshop. Polarizing or other filters may have been used on the camera lens. Even if the exact colors and paint brand are specified in an article, they might not look the same in real life. Magazine information is a good starting point, but test panels should be sprayed for accuracy.

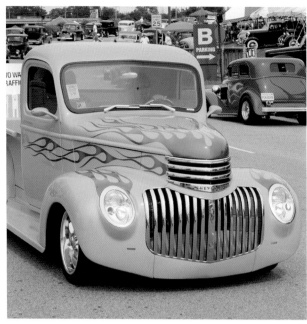

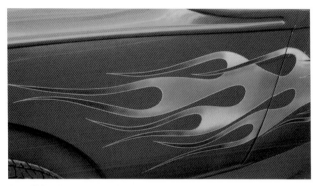

Junior Nelson is a well-known Tacoma, Washington, painter/striper who has gorgeous flames on his much-driven Model A highboy roadster. The lighter orange main flames and magenta tips complement the darker orange body. The green pinstriping is a great contrast color.

Here is another unique color combination. The blue flames aren't as unusual as the lime green base color. The modest size of the flames is helpful.

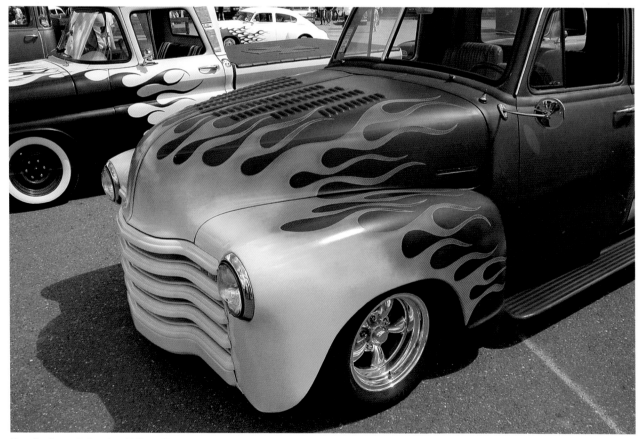

The yellow/orange/red combo with blue, white, or apple green pinstriping works as well on black primer as it does on gloss black. Both Chevy pickup examples limited their flames to the hood and front fenders.

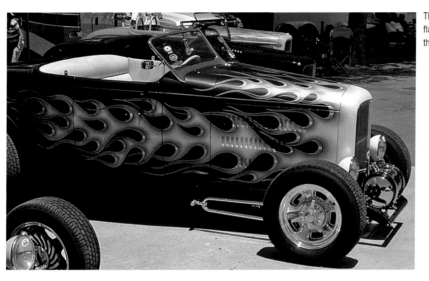

This candy purple '32 highboy has large nose-to-tail flames. A lot of fogging was done around the edges, and the inside curves were given a 3-D look.

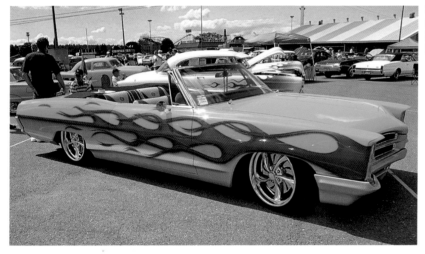

Along with color and contrast, flame size is an important consideration. The high-contrast purple flames on this Pontiac convertible are huge, but so is the car. Flames this big could overpower a smaller car.

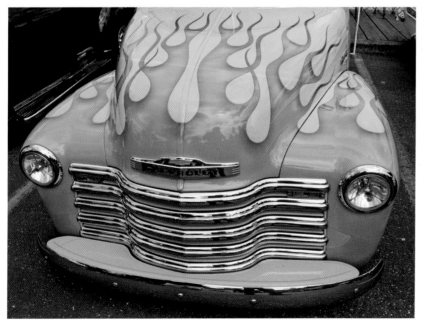

Uncommon color combinations can work well, but they might limit resale opportunities. The medium green flames on this yellow Chevy pickup are nicely designed and make the truck a standout at any show.

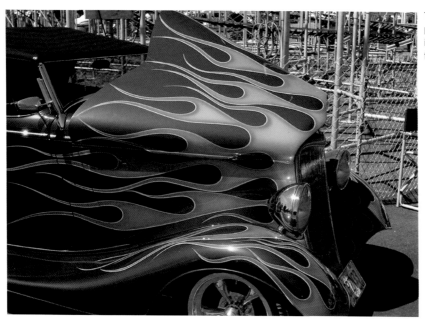

The flames on this '33 Ford roadster have incredible pop. The orange and school bus yellow licks are very intense, and the Process Blue pinstriping amplifies the contrast.

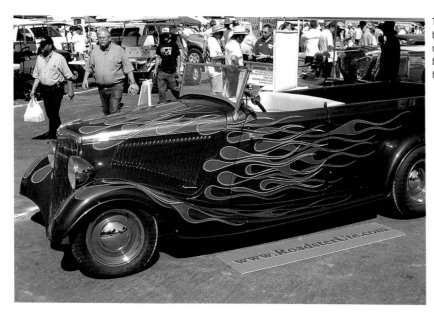

This '34 Australian ute also has orange flames on a purple body, but they don't have as much contrast as the '33 roadster pictured above because the flames start out purple before turning to orange. Also, the white pinstriping doesn't have the same impact as blue striping.

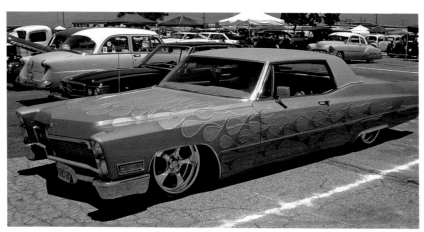

Here is another flamed land yacht, but the orange flames don't overpower this Cadillac because their color is much closer to the car's base color.

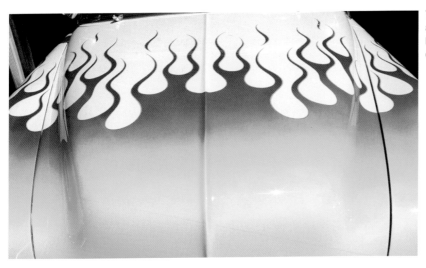

Traditional blended white/yellow/orange flames have ample impact, even on a white car like this '54 Chevy. Blue pinstriping was used. The color blending was expertly done.

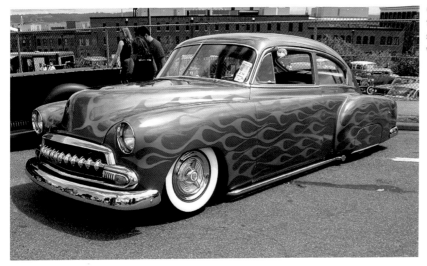

Green flames on a lavender base aren't a combination for the faint of heart. This multilick style is often referred to as seaweed flames, so the color is quite appropriate. It works well on this period-style Chevy custom.

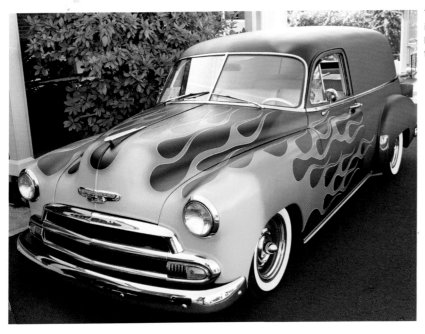

The yellow to orange blend on this Chevy sedan delivery is rather abrupt. The color contrast is great against the black primer base, and the red wheels work well with the flames.

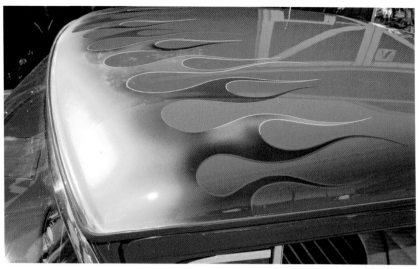

Using lots of different colors can be a challenge, but the painter of this '58 Ford Ranchero handled it well by limiting these candy flames to the front half of the roof. Blending all these candy colors is difficult, with very little room for mistakes. Note that many different pinstriping colors were used.

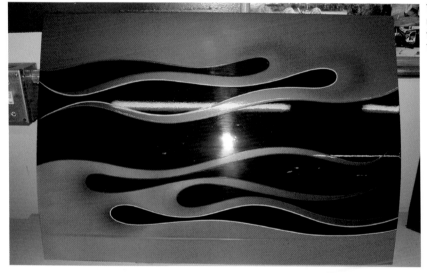

Test panels are an excellent way to compare colors on real metal with real paint. Donn Trethewey did the panel to help a customer decide on flame and pinstriping colors. These panels make great garage art.

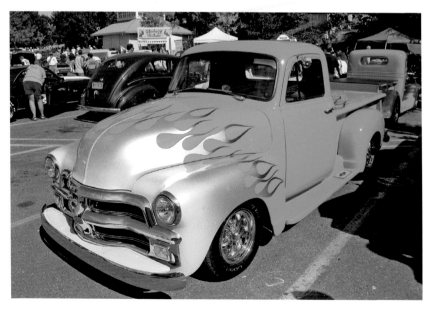

Flames can be any color. It's surprising how well some unconventional colors turn out. This blue Chevy pickup has white/silver/gray flames with magenta tips on the nose and tonneau cover.

Metal sign blanks are inexpensive and ideal for shooting test panels. Old fenders are more awkward to handle, but they have the added benefit of curves and styling creases. When paint manufacturers exhibit at street rod events, they use curved panels or old VW fenders. Customers can move and turn the samples to see how light affects the curved panels.

Viewing colors in natural light is very important. Paint viewed in a spray booth or workshop can look entirely different outdoors.

Paint chips and even open cans of paint aren't totally accurate representations of how the finished paint will look. The small size of paint chips and their proximity to other colors on the chip chart make them most useful for narrowing color choices.

The color and type of undercoat affects the look of paint chips. Charts usually show a specific top coat applied over the available undercoats, but the finished product depends on how many top coats were applied. These variables reinforce the value of spraying test panels.

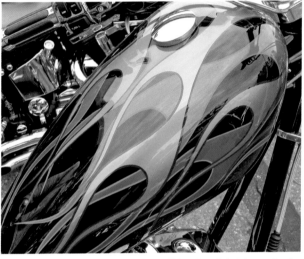

A black base is virtually unbeatable for flames. This motorcycle tank has overlapping medium and lime green flames.

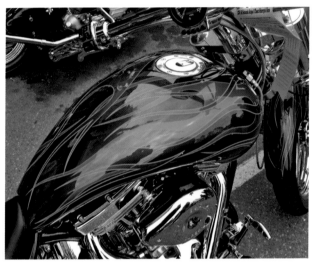

Complementary base and flame colors are always safe. The brighter candy blue flames work very well on the darker purplish blue tank of this custom chopper. Lighter blue pinstriping accents the flames.

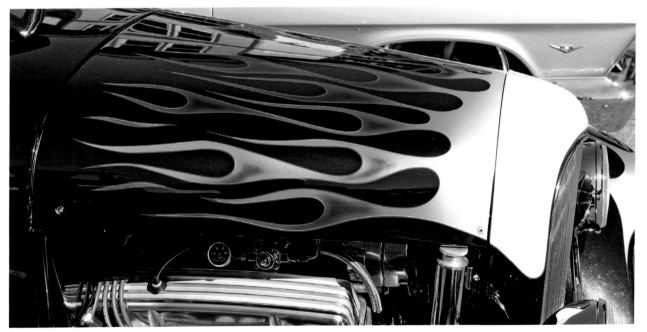

The choice of pinstriping color is very important. The bright red striping provides a high contrast between the black body and the white and blue flames. A less bold pinstripe color would soften the flames' impact.

Choosing flame colors for an already-painted vehicle is more difficult. Besides the vehicle's color, there is the matter of paint type. Solid colors are the easiest to flame. Metallic base colors can be challenging because solid-color flames can look disconnected. You don't want the flames to look like decals stuck on top of the existing paint. The flames should look like they're a cohesive part of the whole paint scheme.

Metallic, candy, or pearl flames work better on solid-color bases than the other way around. Very wild colors and types of paint (for example, violet flake flames on a primered hot rod) can be quite effective because the disparity of finishes pushes beyond mismatched to outrageously cool. The wilder the contrast or paint type disparity, the thinner the line between gaudy and great. The further a painter pushes the accepted boundaries, the greater the risks for failing, but most great custom painters are risk takers anyway. If they weren't, they'd be doing insurance collision repairs.

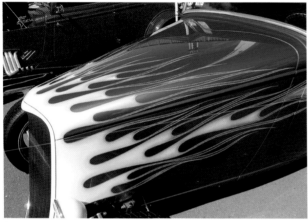

Candy blue is an excellent base color for flames. The white nose and lighter shades of yellow and orange soften the contrast somewhat, as do the relatively thin licks.

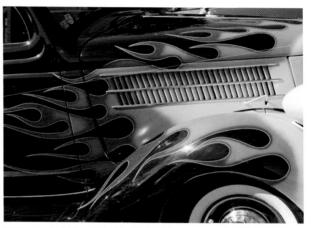

Apple green pinstriping with traditional colored flames was used on this '36 Ford. The impact of the green striping is particularly evident around the darker orange tips.

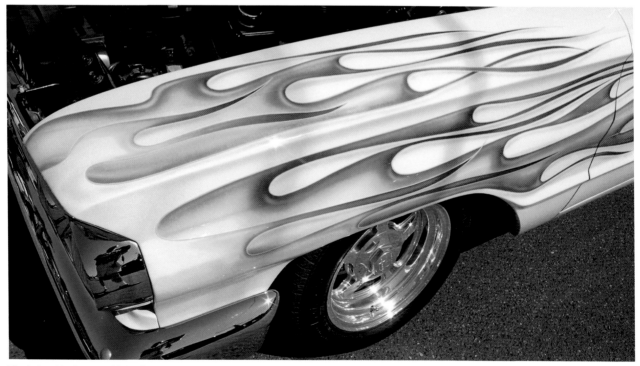

The design of the flames on this '64 Ford is wild, but the colors are complementary to the yellow base. The magenta tips and apple green pinstriping boost the impact without overdoing it.

Pushing the conventional flames envelope brings up a financial consideration. Trendsetters and extreme risk takers can suffer when it comes time to sell their hot rods. Car magazines are always looking for new and different vehicles to attract readers, but what was once the height of automotive fashion can quickly become dated and passé. Remember pastel colors and neon "heartbeat" graphics?

Hot rod trends are constantly changing, evolving, and recycling. Wheels, tires, suspension heights, and upholstery materials can be changed for a fraction of the cost of a new paint job. Adding flames to a plain car isn't a big deal, but undoing flames is an expensive proposition.

Another cost concern related to the color/paint choice is the ease and expense of possible repairs. Custom cars and trucks are generally driven less and pampered more, but accidents do happen. Any flame job can be difficult to repair, but candies, pearls, and flakes are extra difficult and expensive to replicate. Insurance coverage could be an issue too.

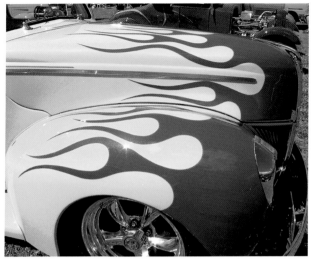

Solid pastel purple flames on a bright yellow base give this '40 Ford a unique high-contrast look. Magenta pinstriping heightens the contrast.

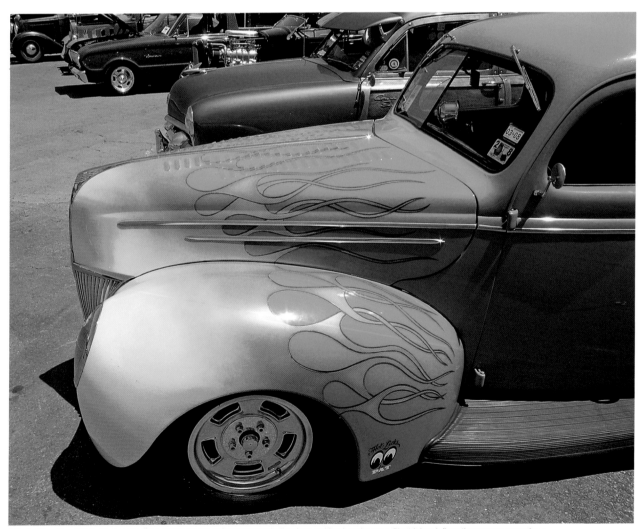

This Grabber Blue '39 Ford has more sinewy licks, with a prominent white/yellow/orange blend on the nose. Pinstriping defines the numerous overlaps.

It's a good idea to save some extra paint, regardless of what type and color were used for a flame job. This is especially important with custom-mixed colors. Take notes on how many coats were applied and other details of the painting process. This information could come in handy later.

Color impact can be noticeably affected by pinstriping colors. A pinstriped border isn't used on all flames, but striping goes a long way toward how the finished flames look. High-contrast colors provide added pop to flames. Contrasting striping is very useful when the flames are similar to the base color (for example, orange and red flames on a red vehicle).

Some pinstriping color choices may seem unusual, but talented stripers know that how the flames look from a distance is more important than how they look from a few inches away. Sometimes very thin stripes are used. They may not be visible from a distance, but they do serve a very useful purpose relative to the finished flames. These nuances of pinstriping are difficult to learn from a book, which is why most flame painters rely on highly experienced professional stripers for these all-important final touches.

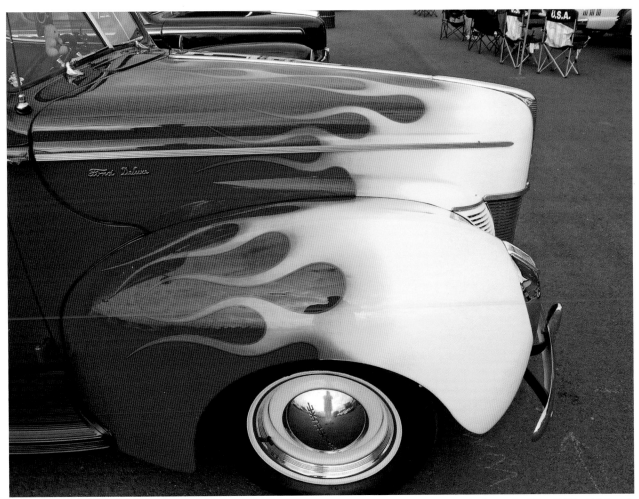

The 1939 and 1940 Fords are a longtime favorite of flame painters. Large shows typically have many examples, with widely varying flame styles. This red '40 has high-impact flames with lots of yellow on the nose. Extra-thick blue pinstriping helps define the flames.

Chapter 3
Taping Techniques

Masking tape is what separates the theoretical from the practical in flame painting. It's the custom painting equivalent of "where the rubber meets the road." In this case, it's where the tape meets the metal. All the photos, magazine clippings, sketches, and doodling don't mean doodley-squat if you can't effectively position masking tape on sheet metal.

It's time to tape the flames or tape your mouth—tape up or shut up. You can conceive your ideal flame job, but until you successfully transfer the ideas to the vehicle via masking tape (or any other masking medium), it's just a pleasant daydream.

Like every other aspect of flame painting, masking requires practice. The more flames you lay out, the more

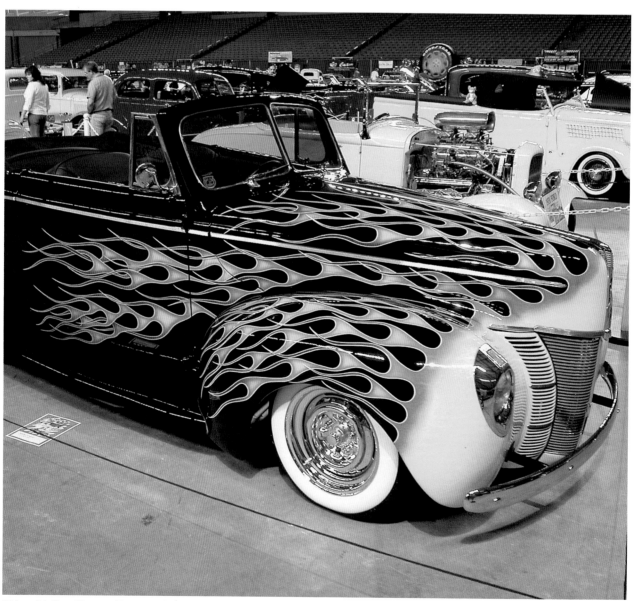

It takes a lot of layout tape, masking tape, and masking paper to execute a flame job as complex as the wild licks on this '40 Ford convertible.

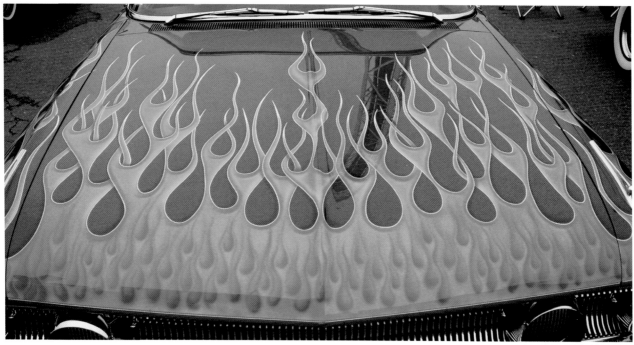

The numerous flames on this '62 Ford hood required a lot of taping. The many smaller flames along the front edge either had to be taped or carefully manipulated with stencils. Either way, it was a time-consuming chore.

Masking tape comes in a wide variety of sizes, colors, and types. The blue vinyl/plastic tapes are very useful during the design process, but the traditional crepe tape is much more economical. The yellow plastic squeegee is used for burnishing tape edges and working air bubbles out of transfer tape.

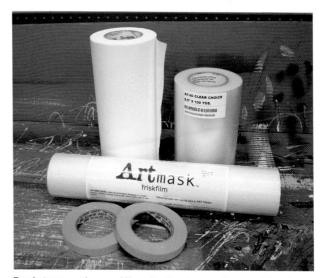

Transfer tape comes in many widths and is either clear or semitransparent. It can be placed over blue vinyl tape designs, or flames can be drawn on top of the transfer tape.

instinctive the process will be. The concept of free-flowing flames will be reiterated throughout this book. The masking process is where it all begins.

Inside curves are the most difficult part of flame layouts. A curve that isn't smooth, uniform, and flowing will stick out like a sore thumb and potentially ruin the job. Long licks can have different amounts of oscillation, wiggle, or whatever else you want to call the motion. This movement is much more subjective than the inner flame curves.

You should be comfortable and familiar with the way tape bends and stretches in corners. Plastic tape, such as blue fine-line from 3M, is much more flexible than standard masking tape. That's why most custom painters use some type of plastic tape for layout work. But even plastic or vinyl tape will kink if you start and stop partway through a curve. It's very important to make inner curves in one continuous motion. You're better off completely redoing a curve than stopping in the middle of it.

In some ways, taping flames can be thought of as an athletic endeavor. There's great value to finding your groove or being "in the zone." It's like downhill skiing; you'll ski much better if you relax and let your body and skis flow as a single unit. Instead of tensing at each mogul, you just ride along with the skis. You go with the mountain instead of against it. You get into a flow or rhythm.

Successful flame layout can involve similar feelings of rhythm and flow. It can also help to listen to relaxing music. This might sound like some goofy New Age "Zen of Flame Painting," but the point is that relaxing and focusing on achieving a good flow will produce superior layouts.

Once you and the tape are flowing, it's a good idea to keep going. Don't stop and analyze each lick. Do a large area and then step back and see what you like and what could use some tweaking. Often you can make minor adjustments to spacing between licks or to the amount of taper in a given flame lick. Other times the design just doesn't cut it and you need to start over.

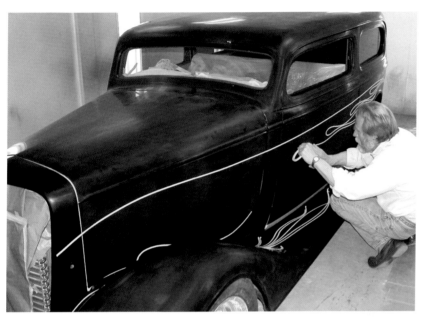

Donn Trethewey uses standard 3M beige or green ¼-inch masking tape for his initial design work. He establishes a gently flowing front-to-back length of tape as a general reference point for the design.

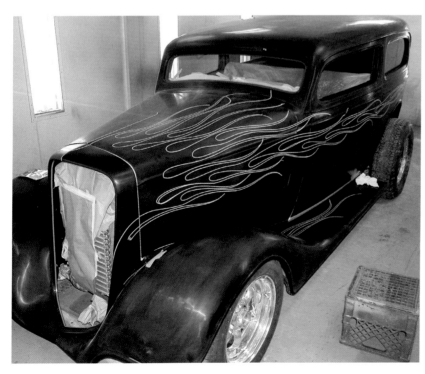

Donn typically designs and tapes the driver side of the car and uses it for the pattern. Details of pattern making are covered in Chapter 7.

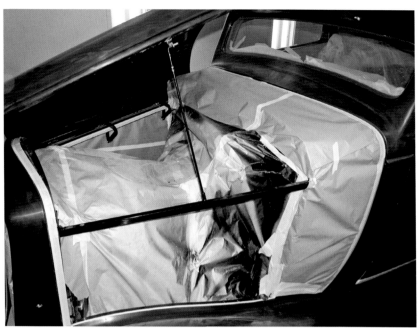

Every inch of the vehicle that isn't being flamed needs to be thoroughly covered and taped shut. Overspray will find the tiniest openings.

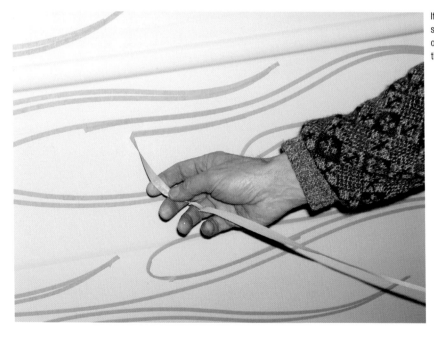

If Donn isn't satisfied with a flame lick or even a whole side of a car, he pulls off the tape and starts over. Sections of tape can be patched, and curves are far from perfect at this point. The sole goal is to establish the base design.

One caution about starting over: it's a good idea to keep a photographic record of what the last layout looked like. It's not uncommon to do a couple layouts and then realize that you really liked the first one best. Once you've pulled up the tape, it's tough to remember exactly what you did before.

Digital cameras are the slick solution to that problem. You don't need an expensive camera to make a basic reference image. You can compare layouts as you do them or you can download the images to a computer and study full-screen versions.

During the initial layout process, press the tape just enough to make it stick. Don't burnish the tape until you're totally satisfied with the design. You can easily reposition plastic tape if it hasn't been pressed hard against the surface. You can move tape that has been pressed down, but each time the tape is lifted, it loses some of its stickiness.

Tape that doesn't stick well is a serious concern. You'll want to avoid bleed-throughs. How many times you can lift and reposition a piece of tape is debatable. A time or two is usually fine, but several times can be questionable. Repositioning tape in corners multiple times is particularly risky because the tape has already been stretched to make the curve.

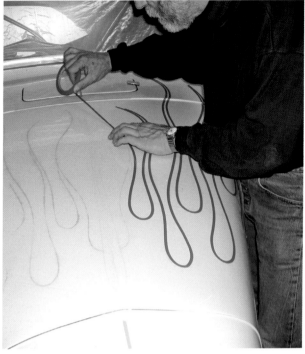

After the chalk pattern is established, Donn follows it with ¼-inch 3M blue vinyl tape. This is the tape that establishes the edges of the flames. Notice how Donn holds the tape roll with about a 10- to 12-inch lead while his left hand secures the tape.

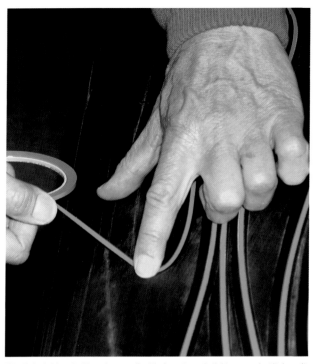

Thin ⅛-inch blue vinyl tape is more flexible for extremely tight curves, but it doesn't provide much adhesion area for subsequent tape layers. Notice the short lead used for tight curves. The tape is actually being stretched a little as the curve is made and secured.

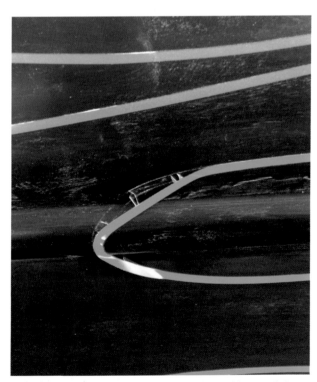

A downside to ⅛-inch vinyl tape is that it's prone to lifting on tight curves that cross raised areas, such as this hood styling line. Tape that's repositioned is far more likely to lift than tape that hits its mark the first time.

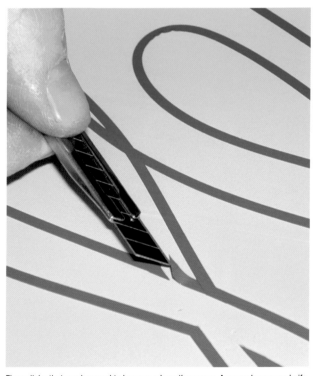

Flame licks that overlap need to be open where they cross. A supersharp snap knife can be used to cut and lift the removed tape section. Very light pressure must be used to avoid cutting the underlying paint.

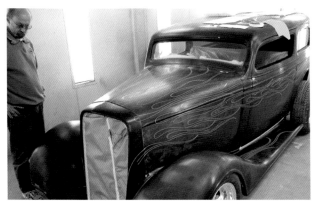

Flame layouts should be carefully examined up close and from as far away as possible before the final masking starts. Look for perfection in terms of flow, spacing, and direction of the tips. Remember that the flames will be thinner than they appear because the paint is inside the tape.

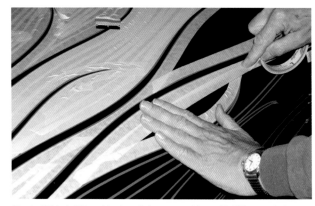

Standard ¾-inch 3M masking tape (beige or green) is used to fill in areas between flame licks. On flat areas like this hood, it doesn't matter if the tape starts at the top or bottom. Just be sure there aren't any gaps.

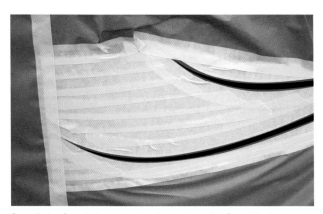

On vertical surfaces, it does matter how the tape is applied. Start at the bottom and work up with each overlapping length of ¾-inch tape. This method eliminates tiny "ledges" that can potentially trap overspray.

Extra care is needed at body seams and gaps. A burnishing tool or plastic filler squeegee works well for pushing cut tape ends into position.

Besides limiting the number of times a section of tape is moved, you can control unwanted lifting by always using top-quality automotive masking tape, using fresh tape, using tape at room temperature, and working on a totally clean surface with clean, grease-free hands.

Most custom painters like to have a foot or two of lead between the tape roll and the vehicle surface. The outstretched arm helps achieve the "flow," while the finger on the vehicle positions the tape.

Once the initial design has been taped, stand back and study it. Besides checking the flow of the licks, pay attention to the amount of space between licks. There needs to be a good balance between the flamed areas and the rest of the vehicle's surface.

Flames that don't have much space between them can look like a solid mass of color from a distance. Flames with too much space between them might be too small for the vehicle. An exception is when flames are painted just in a narrow band as an accent; in that case, the proportions are not as important. The key thing to look for is balance and the way the flames work with the whole vehicle.

A design/taping mistake that novices often make is not allowing for the width of the tape. A flame job can look great in blue plastic tape but appear a little small once it's been painted. The problem is that your eyes see the flames as reaching to the tape's outer edge. Pinstriping can help this some, but you don't want pinstriping as wide as tape.

Another design/taping consideration is viewing distance. When you're working on the flame job, you won't be more than a couple feet away, but most viewers will be many feet away. You work on a small part of the vehicle at a time, but the finished view is of the whole car.

When you're satisfied with the layout, it's time to make a pattern for the other side if you want symmetrical flames. That process is covered in Chapter 7. It isn't necessarily vital to make a pattern. Many painters do both sides of the vehicle freehand. Their reasoning is that people see only one side at a time, and flames aren't symmetrical. Instead of making a pattern, you can look digital photos of the first side as a general reference.

After the layout is done, it's time to fill in the gaps. First check every inch of tape. Pay particular attention to inside curves done in ⅛-inch tape. Follow the ⅛-inch tape with overlapping ¼-inch blue fine-line. Then tape the inner loops and areas between licks.

The goal in taping gaps is to avoid leaks and wrinkles. The problem with leaks is obvious, but wrinkled tape or masking paper will trap overspray or debris, which can fall back into the wet paint. Masking paper is less expensive than tape and works well for large flat areas. If you use it inside loops, fold over any excess paper and tape the folds shut. Try to make folds facedown (so the opening of the fold faces the floor) even though you plan to tape them.

Some painters fill in the gaps with ¾-inch masking tape, while others use 2-inch tape. Whichever you use, overlap each piece of tape. If you "stack" the layers of tape as you work, from bottom to top, the whole section can be removed as a single piece.

Transfer tape, which is popular for masking intricate designs, can also be used to mask off large areas. The only problem with transfer tape is that it needs to be cut away from the areas that will be painted. An X-ACTO knife or stainless snap-blade utility knife is the preferred cutting tool. Some painters like inexpensive disposable single-edge razor blades. All blades must be used with a light touch. You want to score the tape only enough that it will tear.

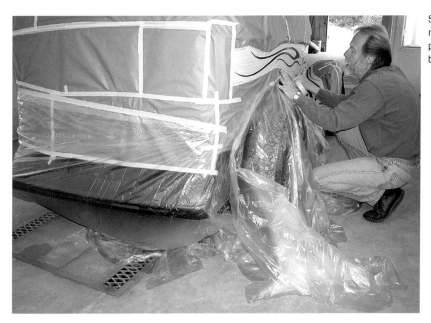

Sheets of thin, clear plastic are useful for the final masking stages. Most painters go as far as taping the plastic and/or masking paper to the floor of the spray booth so that no overspray gets on the chassis.

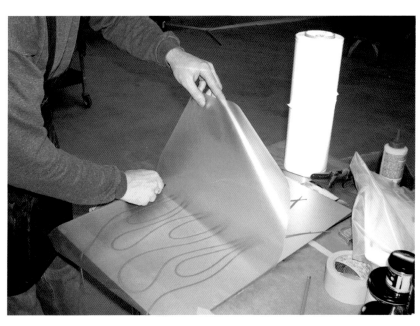

Relatively small areas can be masked with transfer tape. This works well for complex designs and airbrush work. These flames were done in blue vinyl tape, and the transfer tape was carefully placed over the design. Then the tape was cut away from areas to be painted. Transfer tape is standard for custom lettering.

A key technique in cutting transfer tape is to let the sharpness of the blade do the cutting instead of using pressure. That's why it is so important to use a fresh, sharp blade. Snap-blade utility knives make it easy to always have a sharp blade.

Besides masking off the flames, every other part of the vehicle needs to be protected. If there is the slightest opening, overspray will find its way in.

Any gap bridged by flames, specifically door jambs, requires extra taping. Some painters tape out the flames so they flow through the door jambs, but most prefer to just let the flames bridge the gap. That means the flames go around the lip of the door but not into the actual jamb.

Jambs should be taped before the initial flame layout is done. Then the layout proceeds by bridging the gaps. It's during the masking process that the blue vinyl tape should be cut in the center of each gap. Carefully wrap the loose ends around the edge of the door.

Taping is a very time-consuming and often tedious part of a flame job, but the extra effort spent here will be reflected in the quality of the finished product.

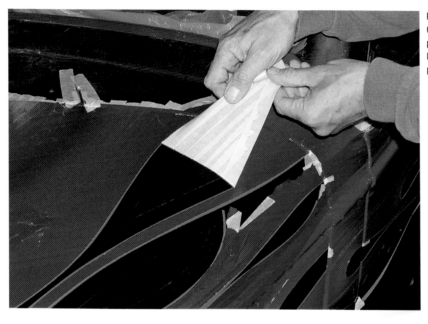

Removing masking tape is as important as applying it. Great care must be exercised to avoid lifting the still-fresh paint. An advantage to systematically applied tape is that large sections can be removed quickly. The tape should be pulled back over itself.

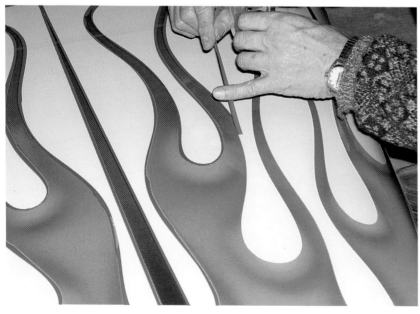

A critical operation is removing the blue vinyl tape. This is the tape that contacts the paint. Notice how the tape is being pulled back and away from the flame lick. If any section looks like it might lift the paint, use an X-ACTO knife to carefully separate the tape and paint.

33

Chapter 4
Surface Prep

Cleanliness, cleanliness, and cleanliness—those are the three most important aspects of surface preparation. Paint won't adhere properly if the surface isn't clean.

Many flame jobs, such as ghost flames, are done with small amounts of paint. Surface prep is even more important in these cases, since there is so little paint to cover problem areas. It also helps to have straight sheet metal underneath the paint. Remember that paint magnifies underlying flaws.

Many books on bodywork and basic painting cover surface prep in detail. This chapter will recap key points.

Any paint job will go more smoothly if you remove all extraneous items from the car. Emblems should be removed for a total repaint. When painting flames, you need to decide if the licks will flow around or under any emblems. Some painters treat emblems and molding trim as if they weren't there, and others are careful to work around them.

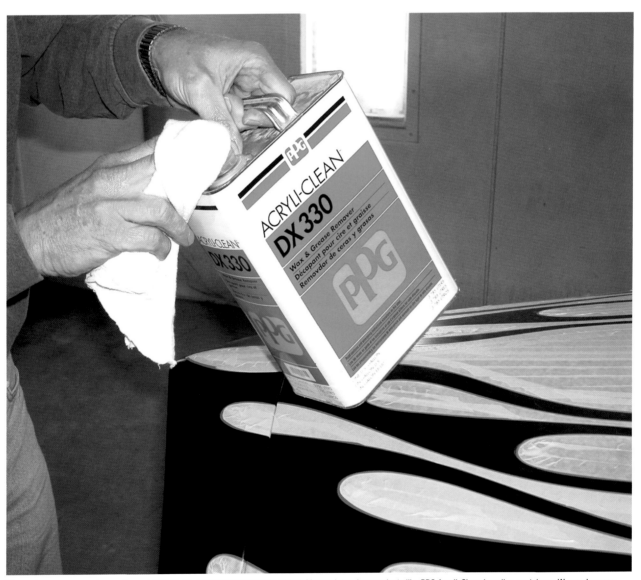

Wax and grease remover is a custom painting staple. Absolute cleanliness is critical. Most painters buy products like PPG Acryli-Clean in gallon containers. Wax and grease remover should be applied with one clean cloth and removed with another clean cloth.

Emblems and trim pieces are natural areas for wax and debris to accumulate. It can be helpful to make an approximate chalk outline of emblems so that you will remember their locations when laying out the flames.

You can't get a car too clean. Painting involves chemical reactions, and the best chemical experiments are done in sterile laboratories. Body shops generate a lot of dust, dirt, and airborne debris. That's why body shops have spray booths, but even spray booths require constant cleaning. If you don't have access to a spray booth, the area where you paint needs to be as isolated from the rest of your shop as possible.

Getting and keeping a car clean can involve multiple cleanings. It's best to do a thorough cleaning before any bodywork or base painting is done. By cleaning a car before any sanding is done, you eliminate the chance of grinding contaminants into the surface, where they may pop up later.

Cleaning the vehicle means eliminating all contaminants that could interact with the fresh paint. Silicone is the number-one enemy of painting. That's why professional painters get so upset about cars that have been detailed with silicone-based products.

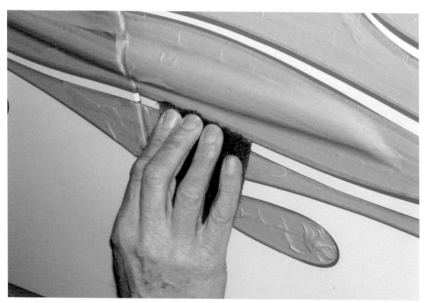

Full- or half-size scuff pads can be used on large areas, but much smaller pieces are needed along the edges of thin flame licks. Be careful not to lift the tape edges.

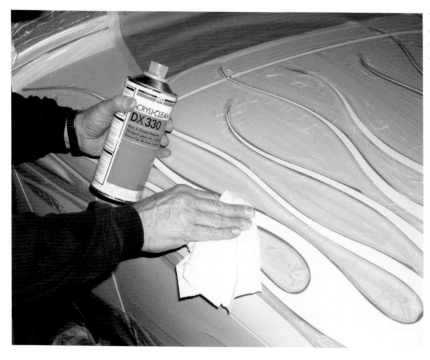

Wax and grease removers are also available in 1-quart containers, which are more convenient for cleaning small areas like flame tips. Always use the two-cloth application/removal system.

It's a good idea to wash the vehicle multiple times. Use soap that will remove wax. Remember to address areas like the inner wheelwells. You don't want caked-on dirt to get loose during the painting process.

A quality wax and grease remover is a must. Follow the instructions carefully. Most wax and grease removal is a two-cloth process—one to apply the product and a clean one to wipe it off. Wax and grease remover evaporates quickly, but it still needs to be wiped off. Use several clean, lint-free cloths for wiping. Don't use shop rags that have been professionally cleaned because they may retain chemicals.

An important note about wax and grease removers: they should be used only before sanding or bodywork. Once a surface has been sanded, it should be cleaned with a water-based cleaner like House of Kolor Post Sanding Cleaner KC-20. Regular wax and grease removers such as KC-10 are solvent-based.

Blowing off the vehicle with compressed air is part of most painters' preparation process. Care needs to be taken that the compressed air is clean. You don't want to blow contaminants all over something you're trying to clean. Body shops use multiple filters to keep their air as clean as possible.

Blowing off a car will stir up dust. That's why tack rags are an important part of surface prep. Tack rags are inexpensive, so get several. Turn tack rags frequently during use, so a clean surface is exposed to the area being wiped. Cleanliness extends to your person. Painters wear protective overalls to

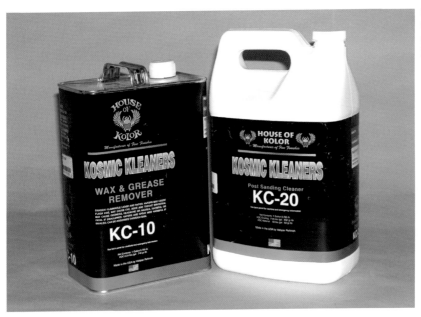

House of Kolor makes two cleaning products: traditional wax and grease remover (KC-10) and a postsanding cleaner (KC-20). KC-10 should be used before sanding. KC-20 is designed to remove sanding residue.

It's a good idea to protect your hands during the paint and bodywork process. Wearing disposable gloves also keeps the oils in your hands from affecting the painting surface. Protective hand creams/cleaners make cleanup easier.

protect themselves and the paint job. That same dual purpose applies to latex gloves. You don't want the natural oils in your hands to affect the vehicle's surface.

Product compatibility is related to surface prep. Accomplished painters can mix and match almost anything, but using dissimilar brands increases the chances of problems. The safest plan is to stick with one manufacturer from start to finish.

Curing time is another aspect of surface prep. The more time that elapses between bodywork and paint, the better. Follow manufacturers' recommended curing times and, if possible, exceed those recommendations. Hastily applied products with insufficient curing time can lead to underlying products bleeding through top coats.

Since flames are often done on top of other paint, surface prep outside of cleaning can be minimal. A light scuffing with a 3M Scotch-Brite gray scuff pad will provide enough "tooth" for the flame paint. The paint needs to be scuffed only enough that all traces of a shine are gone. You want the areas inside the flame design to be dull.

When using a scuff pad, take care not to damage the edges of the layout tape. You want the border of the flames to be scuffed but not at the risk of leaving ragged tape edges. Blow off the area and wipe it with a tack rag.

A lot of this surface preparation may seem like overkill, but it isn't. Cleanliness is essential for any beautiful paint job.

Most flame jobs need only a light scuffing with a gray 3M Scotch-Brite pad. The idea is to dull the glossy finish and provide some "tooth" for the new paint to adhere to.

Tack rags are inexpensive, so have a good supply of fresh ones available. Fluff the cloth and turn it frequently to pick up as much sanding debris and dust as possible.

Chapter 5
Tools and Tool Techniques

Flames can be painted with house paint and an old toothbrush, but it's much easier with the right tools. In the very early days of hot rodding, it wasn't uncommon for young enthusiasts to use a bug sprayer or a rudimentary spray gun hooked up to the exhaust outlet of the family vacuum cleaner.

Depending on how elaborate you want your flames to be, you can spend either a fortune on tools or very little. The smaller and more basic the flames, the less you'll need to spend on tools. Although it's tempting to buy a lot of trick tools right from the start, we recommend starting small and adding tools as your skill levels warrant.

An airbrush and a small compressor are sufficient to paint small flames. A small touchup or detailing spray gun is better if you have a big enough air compressor. Pinstriped flames require the least equipment (but more natural ability), and cans of spray paint will work on something like a rat rod.

WHAT TO BUY, WHERE TO BUY

The two main tools required for basic flame painting are an airbrush (or a small spray gun) and an air source. The air source can be as simple as cans of aerosol propellant, but the cost of multiple cans will quickly top the price of a small airbrush compressor.

Airbrush and spray gun prices vary tremendously, although their outward appearances seem similar. The old expression "You get what you pay for" holds true for custom painting tools. Superbargain spray equipment is tempting, but don't expect longevity or precision from such tools. But if you want to just play around and see if you have a knack for flames, these tools will get you started.

Most companies market products in various price ranges. A good price/quality compromise is to buy the entry-level professional-grade tool. We highly recommend buying

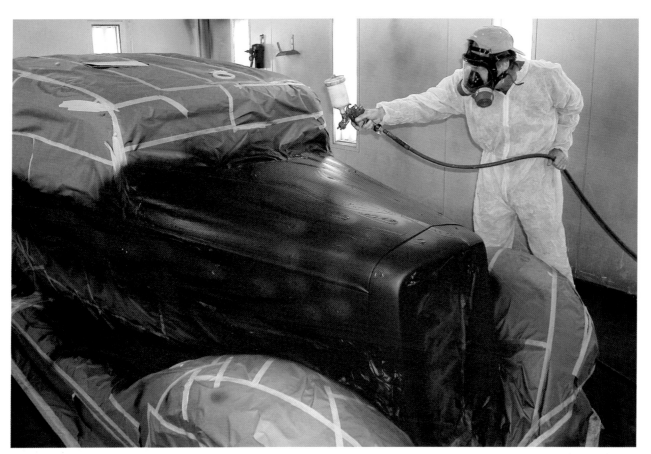

Both the right tools and the proper techniques are necessary for a great flame job. A professional spray booth is the ideal environment for a total repaint and flame job. Notice how Donn Trethewey holds the air line to keep it away from the wet paint.

established name brands. Check online sources, because prices can vary considerably. We don't recommend buying used tools (either online or at swap meets), because you can't test them or really know how they were used and maintained.

Online autobody/restoration companies and art supply companies can be excellent sources for competitively priced airbrushes and spray guns. These companies can be good sources of custom paint too. General retailers such as Sears and the big-box home improvement stores carry some spray equipment, but they're best as a source of affordable air compressors.

Local paint and body shop supply stores carry professional-grade tools, but their prices can be professional-grade too. These stores do offer the advantage of expert advice and the ability to check out products in person. They offer superior service, but their overhead (and thus their prices) is greater than that of a mail-order outlet.

COMPRESSORS

If airbrushing is all you want to do, almost any compressor will suffice. If total repaint jobs are planned, you need a serious compressor. An all-purpose shop compressor is a good investment that will provide years of service.

A compressor should meet and hopefully exceed the air requirements of your spray equipment. A compressor that's constantly struggling to keep up isn't good for custom painting.

Some small compressors are made specifically for airbrushes. They're easy to transport and store, but they can cost as much as shop compressors.

There are several types of airbrush compressors. The most basic are known as diaphragm compressors. They're loud, they vibrate, and they generate heat. Heat leads to moisture buildup, and you don't want moisture in your air lines. Diaphragm compressors don't put out a lot of pressure (usually around 30 psi), so they're best for limited hobby use.

Another type of small airbrush compressor is the oil-less compressor. It uses a piston instead of a diaphragm, so it can produce more air pressure than a diaphragm compressor and is quieter as well. This type of compressor often has an air holding tank, which means less stress on the motor.

"Silent" compressors aren't totally silent, but compared to other small compressors, their lack of noise is wonderful. Silent compressors are piston powered, have air holding tanks, and come in a wide range of motor sizes, air output capacities, and holding tank sizes.

AIRBRUSHES

Airbrushes are miniature spray guns. They're very versatile and fun to use. Once you get an airbrush and start playing around, you'll find it hard to put down.

Many professional flame painters rely on full-size production spray guns and touchup guns because of their ability to lay down large amounts of paint quickly. They use airbrushes for detailed custom graphics. When special effects,

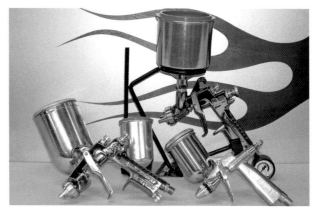

Modern spray guns come in a wide array of styles and sizes. This is a trio of Iwata HVLP (high-volume, low-pressure) spray guns and touchup guns. Left to right: an LPH-100 with a 400mL side feed cup; a round pattern (great for flame inner curves) RG-3L with a 130mL side feed cup; a gravity-feed center cup LPH-300 with a 400mL paint cup. A spare 150mL center post cup leans against the wire gun holder.

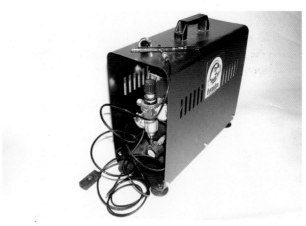

Large compressors are necessary for major paint projects, but if airbrushing is all you do, a compact, portable compressor is sufficient. One of the most popular airbrush compressors is this Iwata Power Jet IS-900. It's a silent (the least expensive minicompressors are quite noisy) compressor with an air reservoir, moisture trap, and built-in regulator.

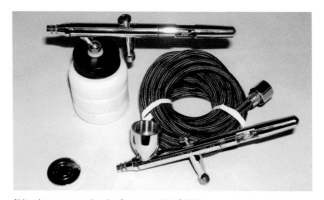

Airbrushes can range in price from way under $100 to several hundred dollars. The Iwata Eclipse line is very affordable; it's the preferred tool of many talented professionals. The airbrushes pictured here are an Eclipse HP-BCS (bottom cup) with a slip-fit plastic paint jar and an Eclipse HP-CS with a fixed, top-mounted thimble cup. Braided air hoses are available in many lengths.

such as unique textures within a flame lick, are required, airbrushes are the tool of choice.

Airbrushes have limitations, but those limitations can actually be a good thing for beginners and hobbyists. Since airbrushes are so small and easy to handle, less experienced painters can have greater control than with a full-size spray gun. A task such as shading the inner curves of flames can be done gradually with an airbrush. A pro wouldn't waste the time; he'd use a touchup gun.

A wide range of airbrushes is available—for everything from simple model car painting to highly detailed illustrations and fine art. Prices range from a few dollars to many hundreds. Expect to spend approximately $100 for an airbrush capable of automotive-quality work. Airbrushes in the $100 to $300 range provide ample versatility and precision for custom painting.

The professionals we photographed during the production of this book favored the Iwata Eclipse airbrush series. They produced beautiful results with various Eclipse models. The Eclipse series is Iwata's second least-expensive series, which shows that you don't need to spend a fortune to get professional results.

There are a couple main variations on airbrush design. The biggest difference is between single action and double action, referring to control of the air and paint.

In a single-action airbrush, the control lever or trigger moves only up and down. When the finger pad is depressed, both air and paint are released. Single-action airbrushes are inexpensive and easy to use.

A double-action airbrush has both an up-and-down movement and a back-and-forth movement. Pressing the finger pad releases air. Pulling the finger pad back releases paint. As the trigger is pulled back, it retracts the internal airbrush needle. That makes the fluid nozzle opening larger, which releases a greater volume of paint. Double-action airbrushes give you the ability to carefully regulate volumes of air and paint for precision control.

Some airbrushes mix paint and air externally, some internally. The most basic single-action airbrushes are external-mix units. Precision airbrushes use internal mixing.

Another variable is the location of the paint cup (or bottle). You can buy top- or side-mounted gravity-feed models, and siphon-feed models that place the paint bottle underneath the nozzle. Siphon-feed airbrushes are more common for automotive work. The advantage of having the bottle beneath the airbrush is that bottles can quickly be changed.

Gravity-feed airbrushes are more limited in the amount of paint that can be used at one time. An advantage of top-mounted paint reservoirs is the ability to use the airbrush with one hand. Bottom-mounted paint bottles rely on friction to stay in place, so it's possible to dislodge the bottle. Spilled paint would be a disaster, so most painters use one hand to control the trigger and the other hand to support the bottle.

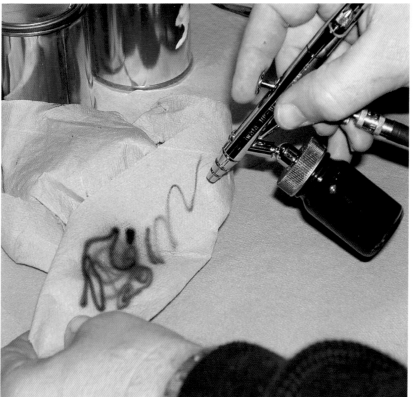

Test and adjust the airbrush's spray pattern before applying paint to a vehicle. How much the paint is thinned (reduced) impacts the flow and spray pattern.

AIRBRUSH BASICS

Airbrushes are the other main tool used in flame painting. The general concepts of using atomized paint are the same for both airbrushes and spray guns, but the size and locations of the controls are different. Consult the instructions that come with your airbrush for specific recommendations.

One problem with airbrushes is that they're much more delicate than spray guns. Too much adjusting can do more harm than good. Airbrushes tend to be set up just about perfectly right out of the box. The fluid needles are particularly delicate.

The most important thing for airbrushes is cleanliness. Their tiny passages easily clog with dry paint. A good way to gain control with an airbrush is to do practice exercises on a big tablet of sketch paper. You can use almost any paper, but 18 × 24-inch (or bigger) art class sketchpads work well. The least expensive newsprint is fine, since you're just practicing and discarding the paper. Some inexpensive water-based paints will work fine for practicing.

In addition to big pads of paper, it's a good idea to practice on less porous surfaces. You won't be painting flames on paper cars, so after you get comfortable with the basic techniques, try them on metal sign blanks. With water-based paint, you can practice airbrushing and then wipe the sign blank clean to use it again.

Paint should be strained every time it's poured into an airbrush jar or spray gun cup. You can adapt a full-size strainer for an airbrush by taping off the upper part of the mesh screen.

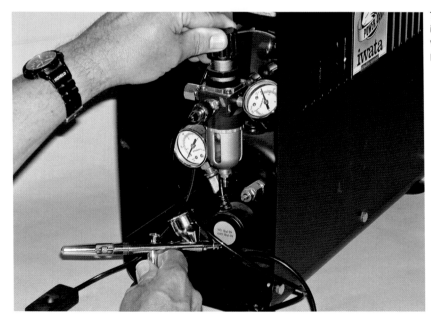

The large air pressure regulator on the Iwata Power Jet is knurled for easy and precise adjustments. Experiment with air pressures before painting to determine the ideal pressure for specific airbrushes.

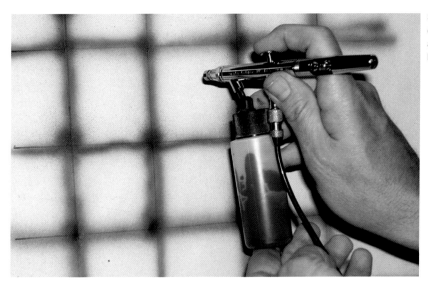

Slip-fit paint bottles seldom fall off, but resting the container on your free hand will help stabilize the airbrush and paint container. After painting a test grid, you can go back and practice shading or filling the squares.

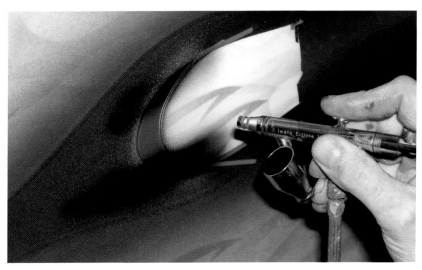

A tiny slip-fit thimble cup was used to produce delicate shadows on the inner curves of this flame lick. Small paint containers like this weigh almost nothing, which makes the airbrush light and maneuverable.

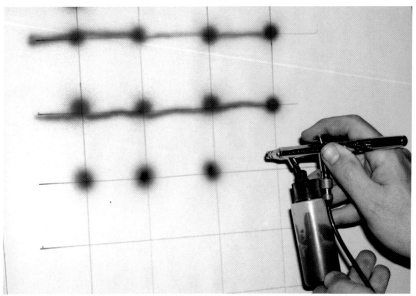

Dual-action airbrushes take time to master. Skill drills will improve your performance. A large sketchpad or even sections of masking paper make good test surfaces. This exercise involves tracing straight lines and applying consistently sized paint dots.

Line control and accuracy are two important skills. Distance from the surface affects the thickness and crispness of a line. The farther away the nozzle is, the wider and softer the line will be. Conversely, the closer the nozzle is, the thinner and more refined the line will be. Practice making different size lines. Use the airbrush in both directions. You need to be comfortable working from left and right and up and down.

When practicing lines, notice the difference it makes when the trigger is pulled all the way back compared to partially back. The farther back the trigger goes, the greater the volume of paint.

Learning when and how to release the paint is part of getting consistent lines. A dual-action airbrush should be used for all these exercises. Push down on the trigger first. That releases the air. Then slowly pull back on the trigger to release the paint. The opposite is true when ending a line. If you start the paint first and then give it a blast of air, you'll get a big splotch of paint. It's the same as with a spray gun; the air is the first thing on and the last thing off for every pass.

Another thing to practice is your body position and the way you hold the airbrush. You might do fine with one hand, or you might feel more secure using your free hand to support the bottom of the bottle or even the bottom of your airbrush hand. Practice moving smoothly over relatively long distances, which will make it easier to do things like shading the inner edges of flames.

One aspect of airbrushing is similar to driving quickly on a twisty road or even snow skiing. The idea is to look ahead and plan where you're going. Don't worry so much about where you are right now, but look ahead. This technique is called optical leading. It's another aspect of obtaining that all-important flow.

Speed is another airbrush technique to master. When you're in the zone and everything is flowing well, it's easier to go quickly than slowly. When you paint slowly, you're more apt to be jerky. Confidence is a big component of speed. It all gets back to lots and lots of practice.

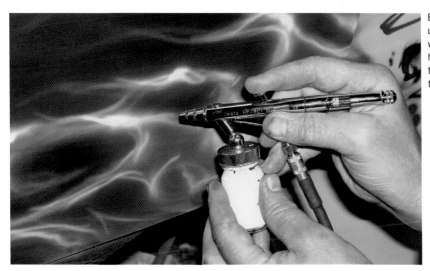

Even highly experienced professionals like Roy Dunn often use their left hand to support the paint jar, particularly when doing very fine detail work like the light yellow highlights on these realistic flames. Notice how Roy holds the airbrush and places the pad of his right index finger on the dual-action control valve.

Airbrushes should be cleaned as soon as you're through using them. The tiny passages and nozzle tips can easily become clogged with dry paint.

SPRAY GUNS

Spray guns and touchup guns are necessary for all but the smallest flames. Spray guns are required for total repaints and applying primers. Touchup or detail guns are good for hobbyists and small- to medium-size flames.

One drawback of touchup-size guns is their small paint cups. Different size paint cups offer some versatility. Some touchup guns can be equipped with an adapter for small plastic airbrush paint bottles.

Flame painting depends a lot on details. Touchup or mini–spray guns allow you to get close to the work area. Some models, like the Iwata LPH-50, can be adjusted down to a 1/8-inch spray pattern. That's airbrush territory. The Iwata LPH-50 can also spray a 4-inch pattern. There are different nozzle sizes, which affect spray pattern widths. The LPH-50 requires only 1.8 cubic feet per minute at 13 psi. Its low air consumption means it can be used with almost any compressor.

HVLP stands for "high volume, low pressure." In many locales, the Environmental Protection Agency (EPA) mandates HVLP spray guns because they produce less overspray than older, traditional spray guns.

The HVLP guns we used were all gravity feed. That means the paint cup is mounted above the nozzle. A benefit of gravity-feed guns is that they will work with small amounts of paint and aren't prone to spitting.

A benefit of side-mount paint cups is that they can be rotated. This feature makes it easier to change from painting horizontally to painting vertically. A benefit of center-mount paint cups is their superior balance.

Spray gun maintenance is vital to a good paint job. Always clean your equipment as soon as the job is completed. Guns are far easier to clean when the paint is still wet. Dried paint can clog a gun's tiny internal passages and lead to disastrous results.

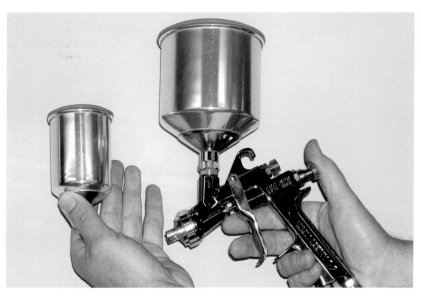

Spray guns that accept different size paint cups are versatile. This Iwata LPH-300 is fitted with a 400mL cup, but it can also be used with a 150mL cup. These are aluminum cups, but plastic cups are also available.

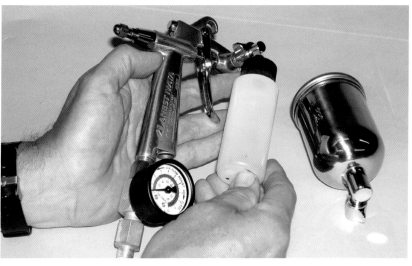

Iwata offers a neat adapter for side-feed HVLP spray guns. It allows 2-ounce slip-fit bottles to be used in place of the larger aluminum 130mL cup on the right. With the little plastic bottles, several colors can be mixed in advance and quickly changed.

Touchup guns can be had with a traditional fan-style nozzle (air cap), as seen on the Iwata LPH-50 (left), or a round nozzle, as seen on the RG-3L (right). The specialized round nozzle makes the RG-3L more like a big airbrush than a traditional touchup gun.

Most spray guns have two main adjustment knobs. The lower knob on this Iwata LPH-300 is for material (paint) adjustment. It controls the flow of paint from the cup. When paint flow is reduced, pattern size is reduced. The upper knob is the air control. It regulates the amount of air going to the air horns on each side of the nozzle/air cap.

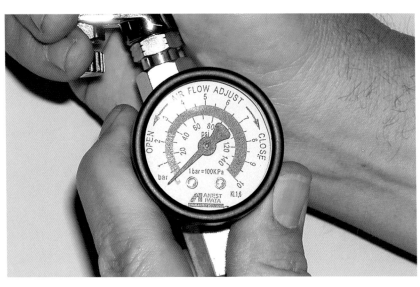

It's important to be able to regulate air pressure at the gun in addition to regulating it at the compressor. This Iwata regulator/gauge restricts air when turned to the right and increases airflow when turned left. It mounts between the gun handle and the air hose coupling.

Air regulation and purity are important considerations when working with compressors and spray guns. One or more moisture filters should be located between the compressor and the spray gun or airbrush. Moisture in air lines can totally ruin a paint job by causing ugly splotches. In addition, oil is often mixed in with the air because of how compressors are lubricated. Contaminants such as oil and silicone will produce fish eyes in the paint job.

Air pressure can be regulated at the compressor, but it's also good to measure and regulate it at the spray gun. Depending on your compressor setup, and the diameter and length of the air hose, air pressure can drop considerably by the time it reaches the spray gun. Having a regulator at the gun aids in making accurate adjustments.

Spray Gun Basics

Wrist and arm control are the primary techniques to master with spray guns. The goal is to maintain robotlike consistency in the rate of paint application, pattern size, amount of overlap, and nozzle distance from the surface being painted.

Whenever your arm wavers, you risk uneven paint application, or worse. Being too close causes runs; being too far away causes dry, coarse paint. Tipping the nozzle causes streaking. Spraying consistent patterns ensures uniform paint coverage.

You don't want to arc or swing the spray gun. That produces uneven coverage. You also need to practice starting and stopping each pass. The idea is to start the airflow before you reach the panel and to ease into the paint by continuing to pull back on the trigger.

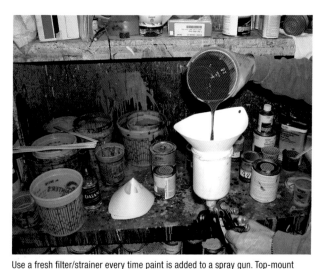

Use a fresh filter/strainer every time paint is added to a spray gun. Top-mount paint cups won't stand by themselves, so a wire stand or workbench mount is a handy accessory.

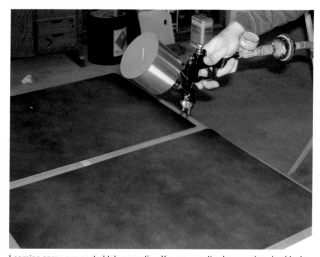

Learning spray gun control takes practice. You can practice by prepping sign blanks for airbrush designs. These blanks are receiving a very light first pass, which aids adhesion for subsequent passes. These panels are parallel to the ground, which simulates painting hoods and roofs.

It's also good to practice shooting vertical surfaces. This sign blank was mounted on an old easel. Ideally, the gun nozzle should be as close to parallel to the surface as possible. The lower the surface, the more difficult it is to maintain the ideal gun position.

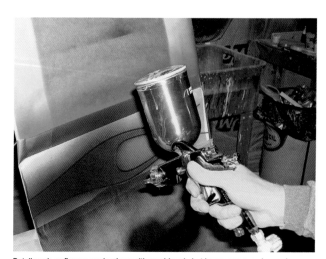

Detail work on flames can be done with an airbrush, but larger areas, such as color blends, are best done with a full-size spray gun or a touchup gun, as shown here. Travis Moore likes the medium-size spray pattern produced by the Iwata LPH-100 touchup gun.

In addition to maintaining a uniform distance from the surface, you need to move along the car at a consistent rate. With flames, spray the entire length that is receiving a particular color.

Obtaining a uniform, nonstop pass often means walking the length of the vehicle. Don't stand in one spot and stretch the spray gun.

Your spray gun should come with specific instructions for making adjustments. Generally speaking, there are two adjustment knobs. The knob in a straight line with the nozzle is material adjustment. It controls how much paint (volume) flows out of the paint cup. Limiting the amount of paint volume will constrict the pattern width.

The other knob, which is usually the top one, controls the amount of air that reaches the nozzle horns. Each horn has two small holes where the air exits. When the trigger is pulled back, the fluid needle is retracted. How far the needle is retracted controls how much paint is released. The paint goes past the needle to the hole in the center of the nozzle (or air cap), where it meets the air from the nozzle horns. The result is atomized paint.

The fan pattern should be determined and adjusted before applying any paint to the car. Use a section of masking paper taped to a wall to adjust the fan pattern. The idea is to get as close as possible without causing runs.

SAFETY GEAR

A respirator or spray mask is the most important piece of safety gear, because isocyanates (an extremely toxic compound found in paint catalysts) can enter your body through your eyes or any other mucous membrane. Professional-quality respirators can be had for under $50. Full-face masks are more expensive, but they offer the benefit of eye protection along with the respirator.

Respirators are effective only if you consistently wear them. The mask should fit snugly to your face. Good respirators have adjustment straps and over-the-head harnesses to keep the mask in position.

The filter cartridges in respirators are replaceable and should be replaced according to the manufacturer's directions. Replacement cartridges are very inexpensive, so don't skimp on using fresh ones.

The more complex the paint is, the more likely it is to be toxic. Products that use catalysts can be very nasty. The chemicals are essentially making a plasticized product. If the paint dries to a rock-hard finish on your car's body, it can do the same thing to your body. When using catalyzed paints and clears, your hands, face, eyes, and all skin surfaces need to be protected.

You can buy single-use, disposable paint overalls or spend more and get washable ones. Protective gloves are a good idea any time you handle paint products, catalyzed or not, as are head socks that protect your head and hair. Hand creams that dry to a protective coating make cleanup much easier.

Fire safety equipment is another must-have. Paint is highly flammable, and it doesn't take much of a spark to cause a serious problem. Class A/B fire extinguishers (used for common combustibles and flammable liquids) should be mounted within easy reach. The extinguishers should be wall mounted, not just sitting on the floor. Fire safety includes keeping the shop free of combustible debris, keeping paint cans sealed (preferably in an approved fireproof cabinet), and not smoking in the area.

Painting generates a fair amount of waste paint and solvent products. These hazardous materials need to be safely collected and properly disposed of. Professional shops have services that remove and recycle waste solvents. Local regulatory agencies can tell you how to properly dispose of your old chemical products. Often, solid waste facilities can handle toxic liquids as well. Never put paint products down any drain or into a septic system.

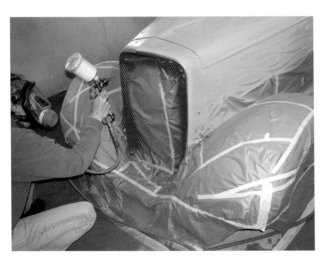

It helps to be flexible when painting a car. Donn Trethewey squatted to maintain the proper gun/spray pattern position while shooting red paint on the nose of this flamed '35 Chevy.

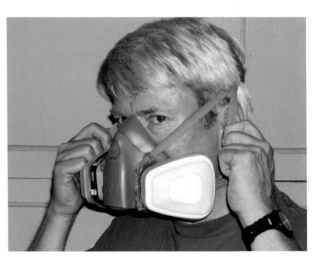

A high-quality respirator is a mandatory piece of equipment. Spray masks aren't expensive. Replacement filters are cheap, too, so replace them frequently. Match the filters to the type of paint being used. Masks with adjustment straps ensure a secure fit.

Chapter 6
Paint Products

Modern automotive paints are complex, and they're not very interesting to read about. Most auto enthusiasts care only that the paints work, not about how they work. Brilliant chemists make sure all the complex chemical formulations do as they were designed and that the colors stretch the limits of the imagination.

Probably the most important thing to know is the value of sticking with one company's system. That's the best advice for avoiding problems. Paint companies design all their products to work well together. It is possible to mix and match brands, but why take chances?

The use of a single company's products is called a system. The number of major players in the automotive refinishing field isn't very large, and even fewer companies specialize in custom paints. This makes it pretty simple to determine which system works best for you.

A second key to avoiding problems is to read and follow directions. That may sound overly simple, but too many people either don't read the company-supplied instructions or don't follow them explicitly. Don't try to second-guess the experts. Any small-time savings up front can easily be lost if a problem occurs.

A tri-coat or three-stage paint system consists of a base, a candy, and a clear. The base color is very important because it shows through the candy coats. White is a common base coat, but for Cobalt Blue Kandy (UK-05), a Stratto Blue base coat will give an intense blue. Stratto Blue is available in two degrees of metallic. The BC series is coarser, and the FBC has finer metallics. Color charts give an idea of how various base coats affect the final color, but to be truly appreciated, the colors must be seen in sunlight.

A neat thing about House of Kolor Shimrin metallic bases, such as this Solar Gold (BC-01), is that they can be cleared for a wild final finish or be used as a base coat for candy colors. All paints should be thoroughly stirred and strained before using. The high metallic content is evident from the sparkle on the mixing stick.

HOK Shimrin pearl bases, such as this beautiful Lime Time Pearl (PBC-38), can also be cleared and used as a final color or used as a base for candies. Gold, silver, and white base coats have more latitude as to which top coats can be applied over them, but bases like Lime Time can be used with various green or blue candies to create some truly wild greens.

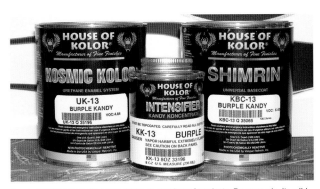

House of Kolor offers the same colors in a variety of products. For example, its wild Burple (a bluish purple) can be had as a Kosmic Urethane Kandy (UK-13), a Kandy Koncentrate Intensifier (KK-13), and a Shimrin Kandy (KBC-13), as shown from left to right.

Paint companies publish technical information about their products and typically detail which products can be used with each other. Companies also specify things like the best reducers to use for varying temperatures, reduction ratios, time between coats, and suggestions for clear coats.

Paint supply stores have tech sheets for the paints they sell. The stores want you to be well informed. Ask the counter people if you have any questions. They want you to succeed, because they don't want to hear from you if something goes wrong. The staff at your paint supply store is a valuable resource, so use it.

PAINT BASICS

Paint consists of pigments, binders, and solvents. Pigments are the color; binders, also known as resins, hold the pigments together; and solvents are the carriers that allow pigments to be sprayed. Solvents are pretty much dissipated by the time the pigment reaches metal or shortly after.

The role of solvents is to get the pigment and binder from the paint cup to the vehicle surface. When the solvent evaporates, the pigment and binder harden into sheets of color that stick well to properly prepped metal.

Reducers (solvents) are designed to work best within set temperature ranges. That's why there are fast, slow, and medium temperature reducers. The colder the spraying conditions, the faster the reducer needs to be, and vice versa. Some paints need to be sprayed within a specific temperature zone, so that consideration is the most important. The temperature range of the reducer is used to fine-tune for conditions.

"Acrylic" is a word commonly associated with paint. Acrylic means plastic, as in acrylic plastic. The acrylic in paints improves durability. "Urethane" is another common term. Urethane (or polyurethane) paint is very durable.

Urethane paints have many positive characteristics. They're easy to use and apply, and they utilize a catalyst to provide their famous durability. The downside is that these catalysts use isocyanates, which can be very harmful to your health. That's why safety issues are so important.

VOLATILE ORGANIC COMPOUNDS

Volatile organic compounds (VOCs) are the by-products of overspray and solvent evaporation. The EPA wants to limit the amount of VOCs released into the atmosphere. That's why body shops now use enclosed gun-cleaning tanks instead of just shooting cleaning solvents into the air.

VOCs are behind modern spray booths and HVLP (high-volume, low-pressure) spray guns. Anything that will reduce overspray helps reduce the amount of VOCs in the air. A motivating factor for developing waterborne (instead of solvent-borne) paints is the reduction of VOCs.

HOK Kandy Koncentrates are small containers of superconcentrated candy paint. Kandy Koncentrates can be used to boost or alter the color of regular HOK Kandy paints. They can also be added to Intercoat Clear for use in graphics and airbrush work. Since only a very small amount of Kandy Koncentrate is needed for airbrush work, it's helpful to punch a small hole in the pressed-in seal instead of removing it. A little concentrate can be easily dribbled into a mixing cup.

House of Kolor Intercoat Clear (SG-100) can be used as a medium for delivering powdered or paste pearls. SG-100 must be applied over Shimrin universal bases. The color of the base determines how much pearl to use. The use of test panels helps in determining the final colors.

STAGES

Paint systems can be referenced by stages. There are single-, two-, and three-stage systems. The terms "base coat/clear coat" and "tri-stage" are also used.

A single-stage paint is one that will cover well with two or three coats. These products are pretty much "blow and glow" or "apply, dry, and fly"—painter's slang for a quick enamel paint job that doesn't require any postspray work. You blow (spray) on the paint and it glows (shines) immediately. You don't do extensive work to get a finished shine.

A big downside to single-stage paints is that because they don't require sanding and buffing, any debris that gets in the paint is pretty much there to stay. That's why state-of-the-art spray booths are the best places to apply single-stage paints.

Base-coat/clear-coat systems are very common. The color is applied in the first step and the shine comes from step two, when the clear is applied. Wet-sanding and buffing complete the process.

Candy paints are an example of tri-stage paint systems. A base coat, usually gold, silver, or white, is applied first. Then the transparent color coats are added. The number of coats determines the intensity of the color. A clear top coat protects everything.

Three-stage systems are very common in flame painting. Besides the basic three base coats of gold, silver, and white, lots of other bases can be used. House of Kolor has an extensive lineup of base coat colors. The large number of base colors and candies makes for an almost unlimited array of final colors.

PAINT FOR FLAMES

You could paint flames with latex house paint if you so desired. Some fine flames have been done with a different shade of primer over a primer base. Flames can be painted with everything from simple striping enamel to the wildest $2,000-per-gallon color-shifting paint.

Many of the flames in this book were painted with normal base-coat/clear-coat paints. The colors selected were often pure mixing colors instead of colors formulated for a specific year and model vehicle. Mixing colors tend to be very pure versions of colors and are therefore very bright. Bold, bright reds, yellows, and oranges are a mainstay of traditional flames.

Experienced painters are adept at blending base colors for their own special shades. That's not a good idea for beginners. It's too easy to make mud.

CUSTOM COLORS

As great as the traditional yellow-orange-red combination is, modern painters love custom colors. Even people who use the basic trio often do customized variants of those colors.

Throughout the production of this book, many House of Kolor products were used. HOK is a leading manufacturer in the custom paint industry; custom paint is its main business.

The basis of the HOK system is a wide array of base paints that can be covered by an equally wide array of top coats. Add to those top coats a whole line of dry pearls and flakes and you get an almost endless number of custom colors and effects.

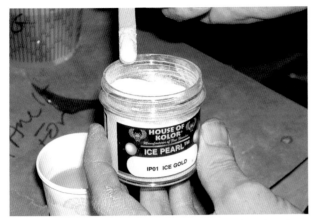

Pearl powders are highly concentrated and often come in very small containers. A clean flat stick (such as a Popsicle stick) can be used to add HOK Ice Pearl Gold to a small cup of SG-100, which can then be used for highlights applied with an airbrush.

A tremendous variety of dry pearls and flakes can be added to HOK paints and clears, such as Intercoat Clear (SG-100). The pearls and flakes come in many colors and particle sizes.

An endless array of colors can be achieved by mixing paints, but there are so many wild ready-mixed colors that custom mixing isn't really necessary. By using established colors, it's easier to repeat a look or make repairs. Using similar colors, as shown by these three HOK colors (Trublue Pearl, Majik Blue Pearl, and Lake Violet Pearl), is an easy way to make subtle changes.

Think of custom colors as the building of layers. The base coat is very important, because it sets the tone for the whole paint job. The base coat continues to show through successive colors, to a greater or lesser extent depending on the number of top coats. When pearls and flakes are added, those layers also contribute to the overall effect.

Custom colors are only as good as the clear coats that protect them. The choice of clear depends on things such as local EPA regulations concerning VOCs, drying time, and whether or not multiple layers of artwork are involved. The appropriate catalysts and reducers must be used with the corresponding clears. The type of clear chosen affects the window of opportunity for wet-sanding and buffing. Things like this need to be planned to optimize the whole paint system.

CATALYSTS

Catalysts are a critical component of many paint and clear systems. Catalysts are potent chemicals and need to be treated as such. Most paint products have fairly long shelf lives, but not catalysts. Once a catalyst is opened, it becomes sensitive to the air in the can.

Catalysts can go bad quickly, so you should buy just enough for the job at hand. For optimum results, buy it just before you need to use it. Be especially careful when pouring catalysts. This is when they are the most hazardous to your skin and respiratory system. Wear gloves and a spray mask. You should also wear eye protection (goggles or a full face-mask respirator) because dangerous isocyanates can enter your system through your eyes or any other mucous membrane. Catalysts may look clear and innocuous, but they're highly toxic.

Safety should always be your number-one concern when painting.

Catalysts are a necessary evil of urethane paint systems and most clears. Extreme caution needs to be exercised when handling and spraying anything with a catalyst. Besides a respirator, eye and skin protection is required.

Chapter 7
Flame Painting Basics

Aflamed '32 Ford is a double hot rod icon. A deuce coupe or highboy roadster is almost anyone's definition of a classic hot rod. Add a wild flame paint job and you've supersized that iconic image.

Not all cars are as easily classified as hot rods as '32 Fords, but flames are a sure way to move any car or truck into the hot rod realm. It seems very appropriate that something as literally and figuratively hot as fire is so intimately connected with hot rods.

There are many ways to paint flames, both from a stylistic standpoint and in terms of step-by-step practical matters. This chapter details how traditional symmetrical flames are designed and painted. The two example cars, Jim Carr's '35 Chevy sedan and the late Craig Lang's '32 Ford coupe, were both painted by flame expert extraordinaire Donn Trethewey of Port Townsend, Washington.

Donn has been painting hot rods for decades, along with various career and business interruptions, but he's now reached a point where he paints (cars or whatever) when the muse, not the bill collector, beckons. Donn loves the process as well as the results, so if he and the car owner aren't simpatico, he won't be bothered. His results and his long list of repeat patrons, including Carr and Lang, validate his dedication to his art.

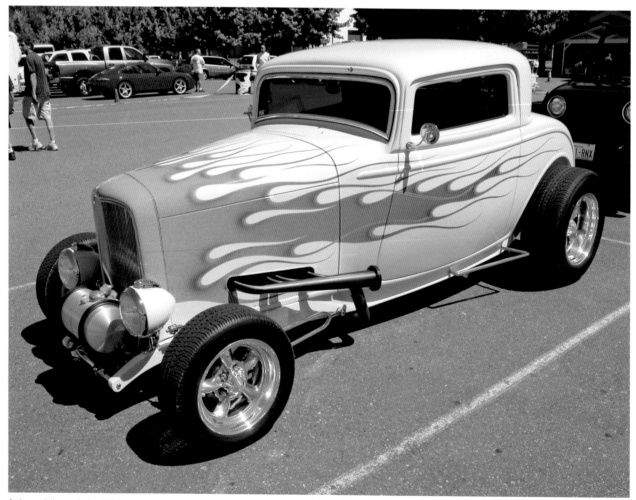

A chopped, three-window '32 Ford coupe covered in flames is an iconic hot rod. This is the "after" shot of the late Craig Lang's coupe, which is featured in this chapter's how-to photos.

This is the little deuce coupe before Donn Trethewey gave it a hot makeover. Divers Street Rods in Startup, Washington, built the coupe to their usual high standards, but the vanilla paint was just too plain vanilla.

The other car seen in the how-to photos is Jim Carr's 1935 Chevy sedan, which had been on the road for decades and was in need of a fresh look.

Flame artist extraordinaire Donn Trethewey of Port Townsend, Washington, feels that flow is a key element of any flame job. Therefore, he begins his designs with a long, slightly undulating length of masking tape to serve as a reference point.

Donn is adamant about design and color; in a previous corporate life he was an art director for big advertising agencies. As for color, Donn will literally spend days experimenting with different colors until he finds the desired combination. Even after settling on a color scheme, he will often alter colors midway through a flame job. To speed up the process and to be sure the car's owner is in agreement, Donn often sprays test panels. Once the paint hits the car, it's very difficult to make significant color changes.

Donn likes flames that are basically symmetrical. They don't have to match exactly, but he likes them to be close. That means he designs one side of the vehicle and makes a pattern for the other side. Hot rod flames are stylized representations of fire, not precise copies. People see only one side (or the front and one side) at a time, but symmetrical flames make sense from a practical standpoint. You have to do the design only once. Also, if you're happy with the first side, why risk trouble with a different design on the other side?

Donn has done so many flame jobs that the designs seem to flow smoothly from his mind to his fingers to the tape and onto the vehicle. Still, if he isn't completely satisfied with a particular lick or even a whole side of a car, he's not afraid to rip off all the tape and start over. Remember, masking tape is the least expensive part of a flame job. Use as much as it takes to get the design right.

Donn favors starting with the driver side, as do most painters we observed during the making of this book, but either side works fine for pattern making. Blue vinyl tape is the standard flame layout tape, but Donn saves money during the initial planning stage by using lime green 3M ¼-inch masking tape.

You can go through a lot of tape doing layouts, and standard masking tape costs about a third as much as plastic tape. Donn also likes the green tape because it's easier to see under the pattern paper. After the pattern has been determined, the green tape is removed and replaced with blue fine-line tape.

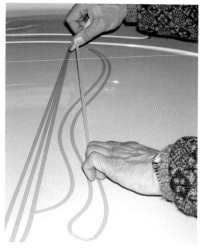

Donn likes to use regular ¼-inch 3M masking tape for the initial layout work. It's less expensive than blue vinyl tape. He uses the masking tape for pattern making, so the exact shapes aren't critical. Notice how he holds the lead piece of tape taut while he uses his other hand to press the tape to the surface.

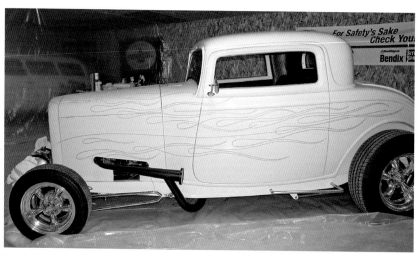

Here is the basic design on the left side of the car. Note the smooth-flowing front-to-back center reference tape and how the flame shape reflects the reference tape. The large piece of plastic underneath the car will be used later to seal off the chassis from overspray.

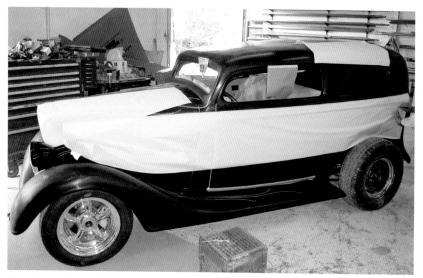

The flames will be symmetrical, so a pattern must be made for the right side of the car. A long length of butcher paper or standard masking paper can be used for the pattern. A pattern is made for the side of the car and the hood. Once the pattern is made, the green layout tape is removed.

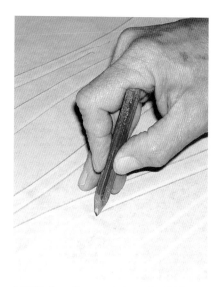

A dull No. 2 pencil, a carpenter's pencil, a Stabilo pencil, or a crayon can be used to trace the underlying tape design onto the pattern paper.

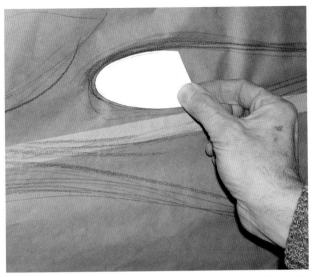

The pattern can be fine-tuned for flow and smoothness by either taping it to a wall or placing it on a section of clean cardboard on the floor. Smooth inside curves are a key element of great flames, so Donn makes a poster board template to check curve consistency.

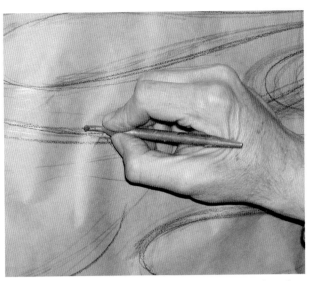

The flame design is traced and perforated with a pounce wheel. The tracing surface should have some give, so the tiny holes go all the way through the paper.

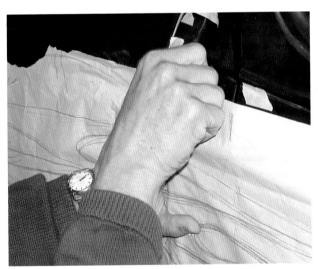

Reference points must be established in several places so that the perforated pattern will be returned to the correct location on both sides of the vehicle.

Blue carpenter's chalk placed inside a clean shop rag is most often used to trace the pattern perforations, but Donn also uses common baby powder on black cars. Apply the chalk liberally, so it gets through all the holes.

On the other side of the car, only the blue tape is used. In general, thinner tape is easier for beginners to manipulate on curves. Also, the blue plastic tape stretches around corners easier than the green tape. Experiment with a couple different sizes and types to determine which one works best for you. It's not a saving using a less-expensive tape if your lines aren't smooth and flowing.

Masking paper or butcher paper can be used for the pattern. A continuous piece is preferable to pieces taped together. Mark several reference points as the paper is positioned over the underlying outline tape. The pattern needs to go back in the exact location after it's been perforated with a pounce wheel.

You can see and feel the masking tape flames underneath the paper. Use a common No. 2 pencil with a dull (not sharp) point to trace the flames on the pattern paper. When you're satisfied with the design, and sure that no areas were missed, remove the pattern from the car. The green pattern tape can be removed now. Tape the paper to a workshop wall or place it on a piece of plywood or cardboard on the floor. Then use a wider marker, such as a grease pencil or a Stabilo pencil, to make the flames more visible.

Next Donn uses a template, which he makes from construction paper or part of a file folder, to check the uniformity of the all-important inner curves. This is a critical step.

When the design is well marked, it's time to use the pounce wheel. This inexpensive little craft tool is available at art supply stores. The pounce wheel perforates the paper so that chalk will get through.

The pattern is returned to its exact location on the car. That's why the reference marks are so important. The pattern

is securely taped so that it won't shift. Carpenter's chalk in a clean shop rag is liberally dusted over the pattern. When the pattern paper is lifted up and away (so as not to disturb the chalk), you'll see the flame design.

The perforated pattern paper is carefully flipped over to the other side of the body. Using the same reference points as on the first side, the pattern is secured. The chalk is once again dusted, and a virtually symmetrical flame pattern appears.

After the chalking comes the final taping. For this stage, Donn uses 3M blue plastic tape. He likes the ¼-inch tape

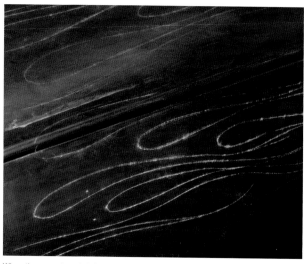

When the paper template is removed, the chalk/powder design will be visible. It doesn't have to be perfect because it only serves as a guide for the masking tape.

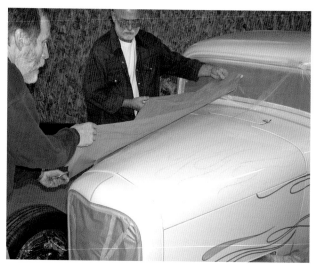

Donn typically starts on the left side of the vehicle. When he's satisfied with the chalk outline, he carefully flips the pattern over and secures it via his reference marks to the right side of the hood or body. Take care lifting and moving the pattern so as not to smudge the chalk on the first side. The chalk and rag are again used to mark the pattern.

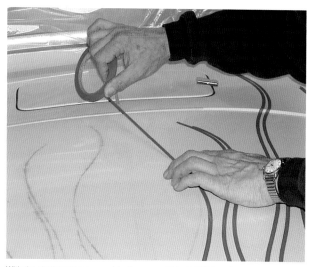

With the chalk pattern as a guide, Donn uses ¼-inch 3M blue vinyl tape to trace the design. Many painters prefer the thinner ⅛-inch tape, but Donn likes the more secure edge of the wider tape. It takes more skill to form tight inside curves with the thicker tape.

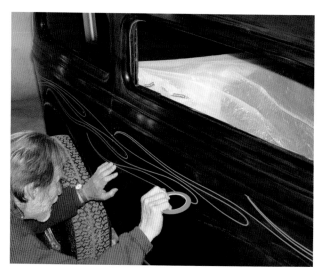

Notice how Donn has about 1 foot of lead between the roll of 3M vinyl tape in his right hand and his left hand, which is pressing the tape to the body.

because it offers more area for the following layers of tape and paper to adhere to. Painters who do the initial layout with ⅛-inch blue tape often need to come back with a course of ¼-inch tape. The goal is to eliminate any possible cracks where paint might seep through. Paint will find even the tiniest security breach.

Constantly check the integrity of all masking tape. It's helpful to do a check after each new round of tape instead of waiting until the very end. Following the blue tape outline with ¾-inch green tape will fill in a lot of

gaps. The remaining open areas should be systematically filled with tape. Layer the tape from bottom to top. That way the seams face down and are less likely to trap overspray. Systematically applied tape comes off quicker and in larger sections.

Large areas that need taping can be handled more efficiently with 2-inch tape. Masking paper can be used on extra-large areas. Be careful to avoid creases with masking paper. Any creases need to be taped over; otherwise, overspray can settle in and blow out at inopportune times.

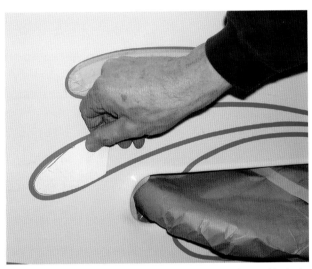

The paper inside-curve template from the pattern-making stage is reused to check the consistency of the taped curves. This little trick can make a huge difference in the finished flames.

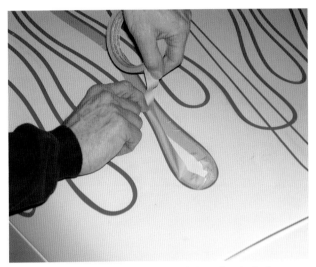

Once he is satisfied with the position of the blue vinyl tape, Donn begins the time-consuming job of taping off all areas that will remain cream colored. Standard ¾-inch masking tape is used for most of the chore. It's affordable and easy to manipulate.

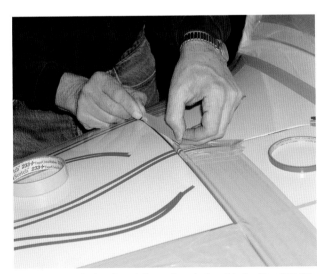

The top of the hood, where it meets the cowl, required much taping. Donn likes the flame tips to cross onto the cowl, although the quicker taping solution would be for the tips to end on the hood. This is another one of those little details that separates a great flame job from an average one.

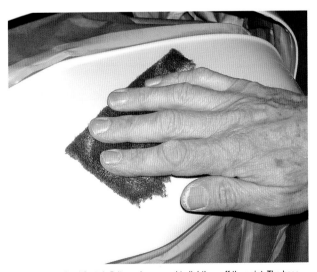

A small piece of red Scotch-Brite pad was used to lightly scuff the paint. The base paint was more than a year old, but it had had a pampered existence. The level of surface prep depends on the age, freshness, and condition of the paint.

Besides taping around the flames, every other part of the car must be covered. As a method of protection and to save time, most painters use large sheets of plastic. The plastic comes in handy during the wet-sanding process as it continues to protect the chassis, wheels, and tires.

Areas like door jambs require a lot of attention when taping. Chances are excellent that the flames will cross door jambs. Paint needs to be shot where the flames meet the edges of the doors but nowhere else. That means the jambs need to be thoroughly taped while it's still possible to open the doors.

Donn likes the flames to cover the door and body edges but not the innermost part of the jamb. Some painters go to the added work of running the flames all the way through the latch side of the door and door jambs. This looks impressive when the door is open, but Donn feels flames are meant to flow, so there isn't any need to display them with open doors. Also, his way saves a great deal of work.

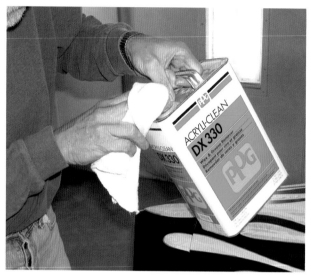

Cleanliness is essential. Use compressed air to blow off the car (watch for dust in any masking paper creases) before wiping it down with wax and grease remover. Apply the remover with one clean cloth and remove it with another.

A fresh tack rag should be used before any paint is applied. Fluff up the tack rag and turn it frequently.

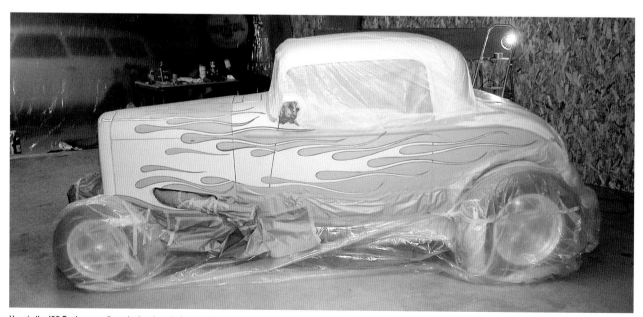

Here is the '32 Ford coupe all masked and ready for paint. The size of the flames is very evident, as is the flow of the long trailing licks. The plastic that covers the wheels and tires was placed on the floor at the start of the job so it could be used later.

After all the taping is completed, the car must be lightly scuffed with a clean red Scotch-Brite pad. Which color Scotch-Brite pad you use depends on how much scuffing is required (whether the paint is new or old). The idea is to give the paint some "teeth" to aid the adhesion of the flame paint. Wax and grease remover, compressed air, and fresh tack rags are used to complete the prep process (see Chapter 4). A fresh tack rag should be used right before painting.

Donn likes pure mixing colors that he custom blends, but paint choice is up to the individual painter. Donn usually starts at the front. Depending on the colors, he will often spray the whole flame pattern with the nose color. He may go lighter toward the tips, depending on the nature of the colors chosen for the tips.

Donn typically applies a second color from the tips to the inner curve areas. He then uses a third color to highlight the curves. He may also highlight just the tips with another color.

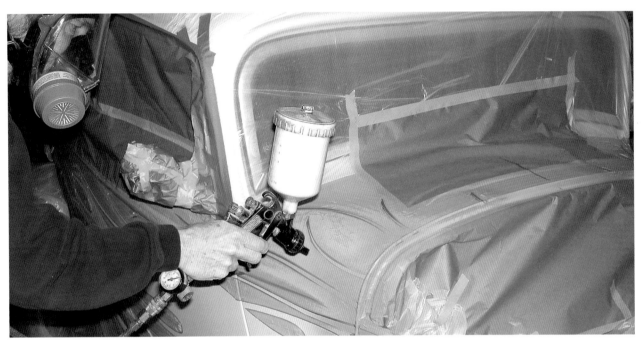

The top of the hood was initially removed so that all the inside edges and the grille shell could be painted. The edges of the cowl and lower hood panels were painted first. A light tack coat is applied to improve the adhesion of the following coats.

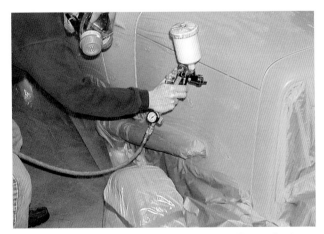

After the yellow paint around the hood perimeter had flashed off, the top hood section was reinstalled. While the hood was off, its edges were painted. Notice how Donn uses his free hand to control the air hose.

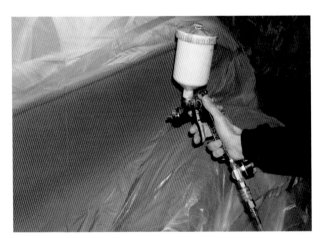

A very vibrant orange was custom mixed for the second color. It covers the back half of the flames and was shot right over the first color. Because all the colors are in the same general spectrum, there isn't any problem about spraying one over the other. The bright yellow base can actually be beneficial from a brightness standpoint. Donn likes to fog or blend the orange into the yellow.

Crossover colors depend on the design. Sometimes different colors are used. Other times the areas are distinguished with later pinstriping.

Painting the crossovers requires care. The work is done while the other colors are very fresh, although dry to the touch. Surrounding areas need to be masked to protect against overspray, but don't press the tape too hard. The goal is to protect without harming the adjacent areas.

Blending colors and making fades are skills that come with experience. A flame with very distinct color changes is usually the sign of a beginner. Donn lessens the paint coverage where a second color overlaps the underlying color. By applying color in relatively light coats, he can make easier blends. This is known as fogging a color.

Overspray is related to blends and fades. Overspray is the lightest part of the paint. It literally dries before it hits the metal, so it wipes off easily and doesn't affect the parts you want to stay clean. Usually, though, overspray is unwanted, because you don't want dry paint to get into wet paint, and you don't want one color to contaminate another. However, some overspray can be beneficial when blending colors. By having a transition area, the overspray will "melt" or blend when the clear top coats are applied.

Follow the paint company's instructions for drying time between the color and clear coats, and for when it's OK to remove the masking tape. Generally, the tape is removed while the paint is relatively fresh but not wet. Edges are less apt to chip while the paint is still a little flexible.

Removing the masking tape is an important part of flame painting. The tape must be removed carefully and methodically. Only remove the masking paper and tape immediately surrounding the flames. The rest of the car needs to remain masked. More messes will be created during the color sanding and buffing stages.

A sharp utility knife or X-ACTO knife is handy when untaping. If a section of paint appears to be sticking between the flame and the tape, cut the paint at the edge of the tape. Hopefully, the paint will lie back down instead of sticking to the tape and ripping.

When removing the masking tape, the idea is to pull it back over itself. When you get down to the blue plastic tape that abuts the flame, pull it back and away at an angle. This method allows the tape to slide out from underneath the paint rather than pulling up into it.

Two or three clear coats are usually applied over the flames. Clear coats can be shot over only the flames, although some painters clear the entire vehicle. Some painters clear the flames, color-sand them, clear the whole car, and then finally color-sand the entire vehicle. Color-sanding and buffing are covered in Chapter 16.

Flames may or may not be accented with pinstriping. Pinstriping helps set the flames apart from the rest of the car. Use of the right color can help the flames pop via contrasting colors. Pinstriping is also useful for hiding any problems with edges.

Many beginning flame painters farm out the pinstriping, but general information about striping is covered in Chapter 12.

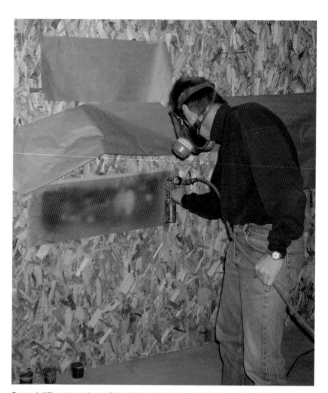

Several different versions of the third color were mixed. Pieces of masking paper were taped to the wall so that Donn could experiment with the third color and the highlight color.

In addition to testing paint on masking paper, Donn likes to hold up the paint on a mixing stick right where it's slated to go. Holding the accent color against the larger expanse of school bus yellow gives a better idea of the contrast.

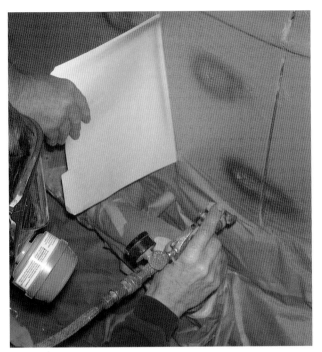

Donn chose to add the hot pink highlight to the inner curves before applying the third color, magenta, to the tips. The primary flame colors are yellow, orange, and magenta. Hot pink is the highlight color, which most painters add last, but Donn chose to use it before he did the magenta tips. The area looks two-toned because he first fogged the inner edges with the second color, orange. A common manila file folder is used to help control overspray.

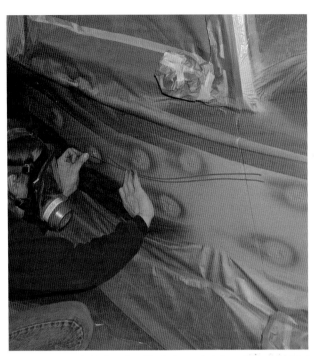

Some overlap areas had to be untaped for the base color to be applied and then retaped for the third color overlap. Referring to the paper pattern helps in positioning the tape.

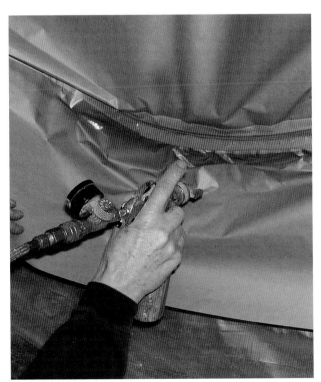

The magenta paint was gradually built up to avoid any runs. Care must be used with the masking tape because the paint is still relatively fresh. The tape needs to protect without lifting underlying paint.

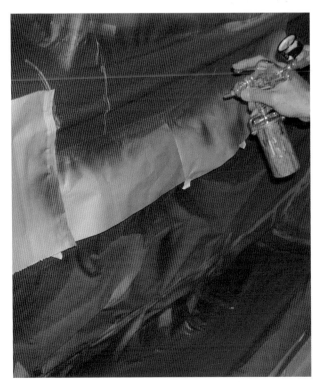

Use plenty of masking paper (judiciously applied) when adding colored highlights to the tails of the flames. Be aware of overspray and control it.

A clear top coat is the final step. The clear provides both shine and protection.

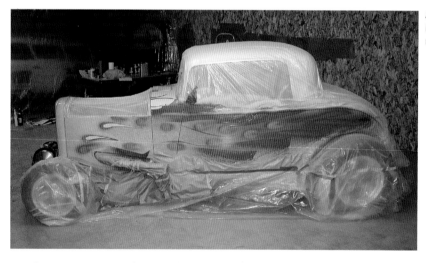

A hint of the brightness to come is evident once the clear has been applied. Follow the manufacturer's directions regarding cure time for the clear.

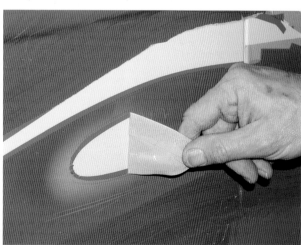

When unmasking time arrives, go slowly and carefully. The paint is still "soft," so you don't want it to lift. The technique of pulling the tape back on itself always applies. Notice how overlapping the tape makes it come off in easy-to-manage sections.

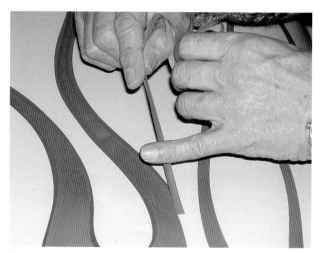

Removing the blue vinyl tape is the most important step because this is the tape that has contact with the paint. Again, notice how the tape is pulled away from the paint.

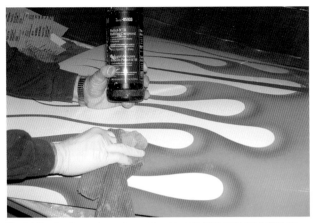

The finishing touches such as color-sanding, power buffing, and hand buffing are covered in Chapter 16. In areas where a power buffer isn't safe or practical, Donn applies 3M Perfect-It III rubbing compound by hand.

Robin's egg blue was selected for pinstriping the flames. This close-up shot shows how the striping separates and defines the flame licks. Notice how carefully the pinstriping wraps around gaps such as the hood/cowl area.

The finished flames on the '32 Ford coupe gave the car a whole new personality.

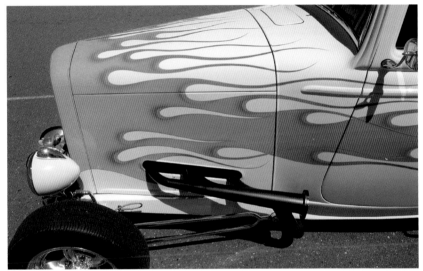

The Donn Trethewey flames on Jim Carr's 1935 Chevy sedan drastically changed the appearance and style of the well-traveled street rod. A unique touch was putting flames on the running boards and the parts of the front fenders that face the hood.

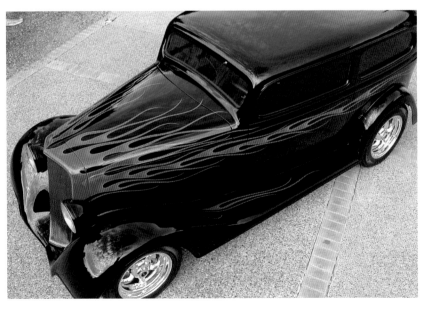

Chapter 8
Realistic Flames

Realistic flames are what the name implies—an accurate rendition of actual fire. This stylized version of real flames has become quite popular in the past 10 years or so. The flame style goes by various names, including real flames, realistic flames, wall of fire, and 3-D flames.

Mike Lavallee is probably the best-known practitioner of realistic flames. His company, Killer Paint, Inc. (www.killerpaint.com) in Snohomish, Washington, calls its flames True Fire (a copyrighted name) and offers various products under that name, including templates and instructional DVDs. Mike has appeared on many automotive-themed reality TV shows, and his paint artistry has shown up on magazine feature cars, custom motorcycles, die-cast model cars, and limited-edition toolboxes. One of Mike's best customers has matching flames on several trucks and on an offshore racing boat and a helicopter.

Mike is more than a custom painter—he's an artist in the truest sense of the word. He paints as well with an airbrush as other artists do with traditional brushes. His illustrations of animals and people are outstanding. Mike in action is hard to capture with a still camera—his airbrush is constantly in motion.

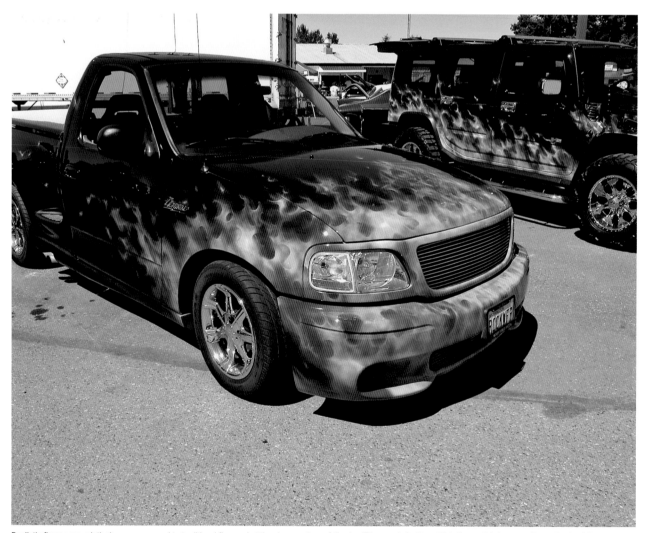

Realistic flames are relatively new compared to traditional flames, but they have a strong following. The popularization of this flame style is generally credited to Mike Lavallee of Killer Paint. This Ford Lightning pickup and Hummer are examples of his work.

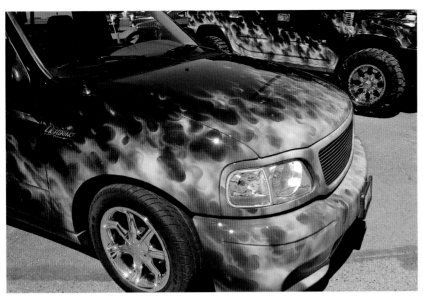

A close-up of the Lightning illustrates the complexity of realistic flames. They appear to be actually burning, which of course is the goal!

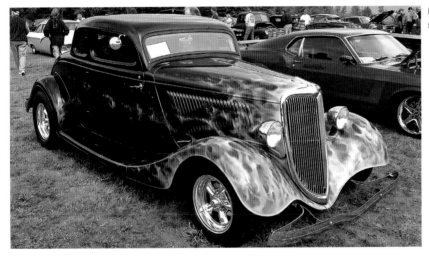

Randy Vail's 1934 Ford coupe is one of the better-known street rods to receive the Mike Lavallee True Fire treatment.

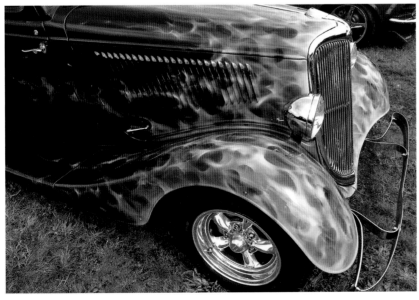

The flames on the Vail '34 Ford run down the front fenders and trail across the solid running boards. A few little bursts of fire made it to the rear fenders. Since realistic flames don't involve taping, it's easy to paint over and through louvers.

Mike instinctively knows where to put colors and what shapes to use. Mike suggests that people who want to paint realistic flames should photograph and study real fires. Mike uses this trick himself. It doesn't need to be a very big fire. It can be in a fireplace or a barbecue pit. Take a series of photos to capture the flames at the different stages of combustion.

Mike uses House of Kolor paints in an Iwata Eclipse HP-CS with the small top paint cup. He sets the initial air pressure at 40 psi. The small paint cup requires more refilling than a larger paint container or a detail gun, but Mike likes the added control of the little airbrush. The Iwata airbrush is so lightweight that it almost becomes an extension of his hand.

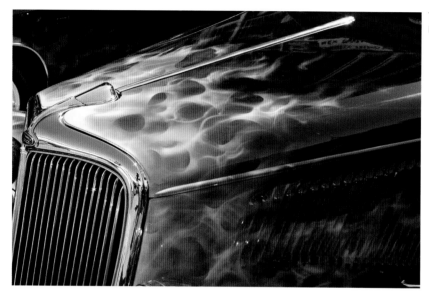

This close-up of a '34 Ford hood shows the magenta highlights at the flame tips.

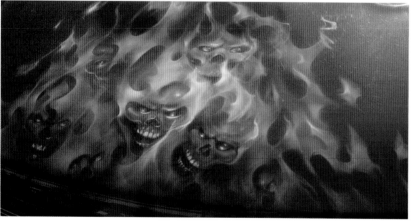

Mike Lavallee likes to incorporate other images within his True Fire flames. This truck hood has multiple skulls within the flames.

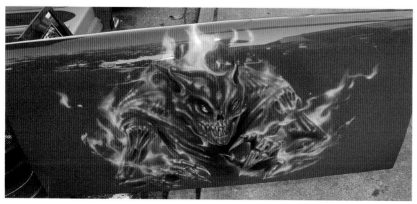

The side-hinged tailgate on this radical Ford Lightning pickup has a demon engulfed in fire.

To deal with the small paint cup of the Eclipse HP-CS, Mike premixes bottles of the colors he plans to use. The plastic bottles have squirt tops so that he can easily refill the paint cup. Standard surface prep procedures are used.

The first color serves as the base for subsequent colors. Mike uses House of Kolor Basecoat White (BC-26) reduced at the standard two parts paint to one part reducer. He uses the HOK reducer best suited to current temperature conditions.

Realistic flames are all about layering colors, so Mike has to think several steps ahead. Where the white goes impacts the brightness of following colors, especially on a black vehicle.

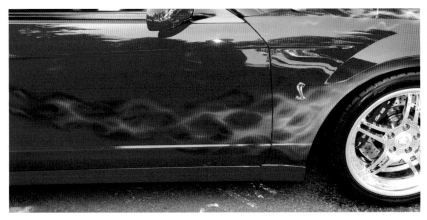

Realistic flames roll off the front wheelwells of this hot Mustang Cobra. The licks flow upward like real flames would if the car were in motion.

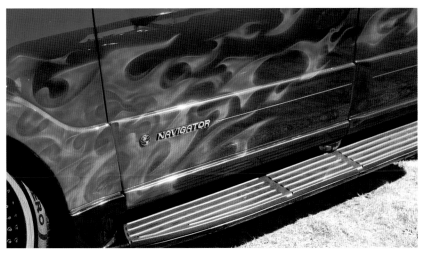

Realistic flames take on a surrealistic look when they're done in certain colors. The blue flames work well against the blue body of this custom Lincoln Navigator.

Green is another popular color for realistic flames. The flames can be used anywhere, as seen on the inner door panels of this custom Chevy truck.

Early in the design process, Mike focuses on getting the underlying shapes. The design flows up and back. The white is added slowly. Some of the white is definite and some of it is wispier. Mike applies the white paint freehand and with a plastic Artool solvent-proof stencil. Mike teamed up with Artool for his own line of stencils.

It's important to use stencils designed for automotive paints. The edges of paper stencils will quickly curl and get

fuzzy. The Artool stencils serve as the base shapes for the freehand airbrush work.

Overspray is a constant concern because the paint is applied rather dry. Mike keeps a fresh tack rag handy to wipe off overspray. Overspray isn't as critical on black vehicles as it is on colors like red or yellow. The candy colors that follow the white base coat can hide a lot of minor overspray on a black vehicle. A black vehicle has a

A good way to understand how real flames look and flow is to photograph them in a controlled environment. This photo was taken in a campfire pit, but a fireplace would also work. The photos show where the different colors and shapes tend to be. Photos also illustrate the multilayered look of real flames.

If you want to literally watch Mike Lavallee produce his True Fire flames, you can purchase two instructional DVDs through his website, www.killerpaint.com.

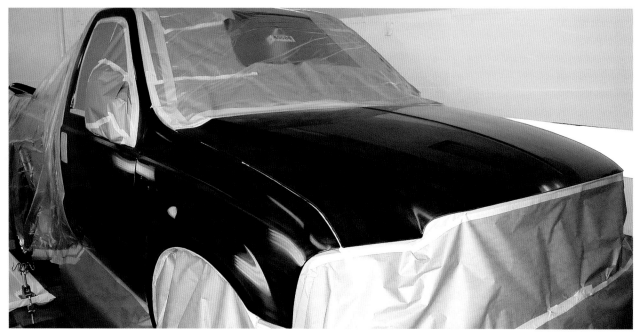

We photographed Mike Lavallee applying blue True Fire flames to Mike Harding's Ford F-350 pickup. The truck was new, so the black paint had to be only lightly scuffed and cleaned. All areas not receiving flames were carefully masked.

distinct advantage over other colors, because mistakes or excessive overspray can be hidden with more black paint. The shade of black doesn't have to be exact. It can even be thinned HOK Basecoat Black (BC-25). On a yellow vehicle, on the other hand, the touchup yellow has to be a precise match or errors will stand out.

The blue flames shown in the examples were painted with HOK Cobalt Blue Kandy (UK-05). It was reduced two parts paint to one part reducer. Mike lays the cobalt blue on pretty heavy but still applies it with the small-capacity Iwata airbrush. Streaks are unwanted when applying the blue, so Mike sort of pulsates the paint delivery in an in-and-out manner. A standard back-and-forth, left-to-right motion is more apt to leave streaks. The in-and-out motion also helps with the layering and appearance of depth.

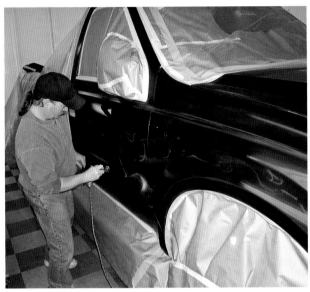

Mike starts the flames by laying down House of Kolor White Basecoat (BC-26) in an Iwata Eclipse HP-CS airbrush. He likes the small top-feed paint cup for its excellent control and ease of use. The airbrush is like an extension of his index finger.

White paint is used to establish the general underlying shapes. The lines tend to flow up and back. The visible sanding scratches will disappear when the truck is cleared, wet-sanded, and polished.

Solvent-proof stencils are used to make the hard, well-defined shapes. Artool is a major source of custom paint stencils. It even has Mike Lavallee stencils designed specifically for realistic flames.

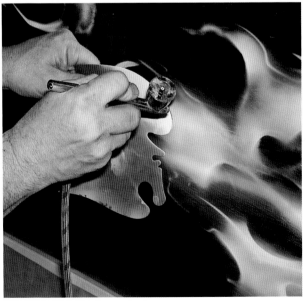

The white base paint is applied both freehand and using Artool stencils. The stencils provide defined shapes that serve as foundations for the freehand shapes.

The white paint is applied rather dry, which generates a lot of overspray. Overspray is the lightest part of the paint. It literally dries before it hits the metal, so it wipes off easily and doesn't affect the parts you want to stay clean. Fresh tack rags should be used frequently to remove overspray.

A good amount of white paint is used for the base flames (especially on a black vehicle). It makes subsequent colors more vibrant. The blue paint that's shot over the white base will be noticeably brighter than the blue shot over black.

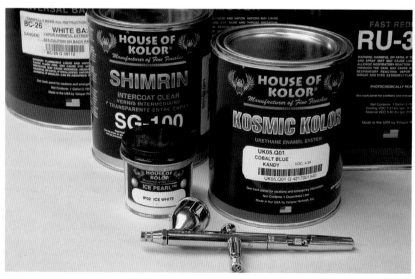

Mike used House of Kolor products for the blue True Fire flames. Two essential colors are the white and black base coats. The primary action color was Cobalt Blue Kandy (UK05). HOK Ice White Pearl (IP02) was mixed with Intercoat Clear (SG-100) to produce the reflective highlights. A compact Iwata Eclipse HP-CS airbrush was used.

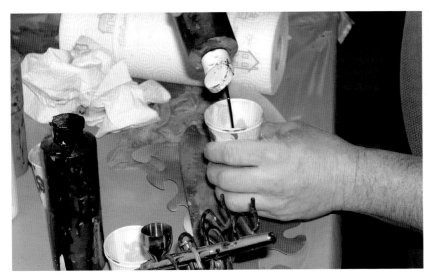

The whole True Fire process is very fast paced, so Mike premixes the necessary colors and keeps them in squirt bottles for quick refills. He uses doubled paper drinking cups to mix and dilute colors.

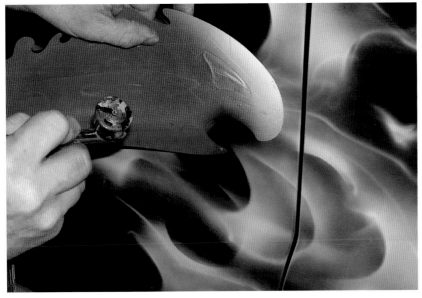

A great thing about black vehicles is that they're easy to fix if too much white paint is applied. If Mike thinks an area has too much white or if he doesn't like a shape, he corrects the problem with thinned black paint.

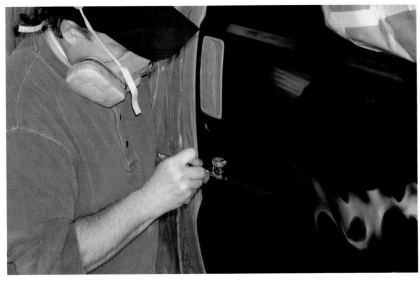

HOK Cobalt Blue Kandy is urethane paint, so Mike wears a respirator when applying it. He moves the airbrush in and out to promote a look of depth and to avoid streaks.

After the base amount of cobalt blue has been applied, Mike goes over the design with some white pearl mixed in HOK Intercoat Clear (SG-100). The pearl gives highlights to the design. Pearls need to be very well mixed to keep the reflective particles in suspension. Sometimes pearls need a little extra reducer. Mike warns others to watch for splatters with pearls as they come out of the airbrush nozzle. You don't want splatters. If too much pearl gets on an area, it can be toned down with the black paint.

Mike used dry white pearl on the examples shown here. HOK also offers tinted pearls, including blue, red, gold, and violet. The blue pearl would be a good choice for blue flames.

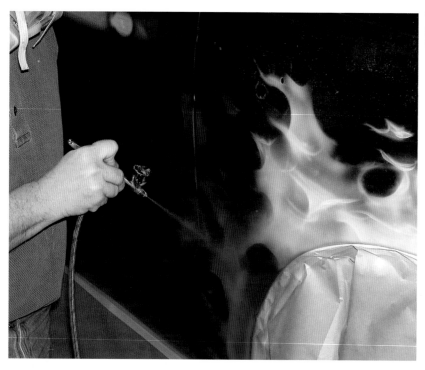

The blue paint is the primary color, so it's applied generously. Knowing how much color to apply is largely a matter of experience.

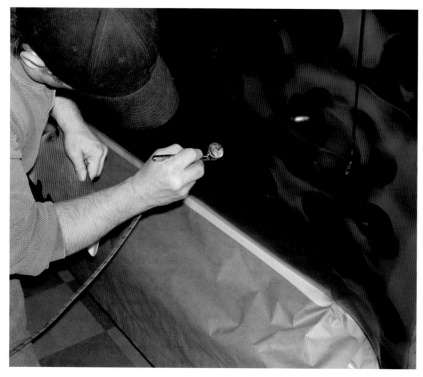

After the main blue paint was applied, Mike went back with more diluted black paint and touched up any overspray areas. Careful use of the diluted black paint helps add definition to the blue licks.

The candy blue paint really pops against the black base color. The same techniques apply to all candy colors. One can see in this photo that the concentrated blue paint goes where the painter wants it. Then the misty blue overspray gets removed with a tack rag. Modest amounts of overspray are OK with realistic flames because the clear blends them into the ethereal look.

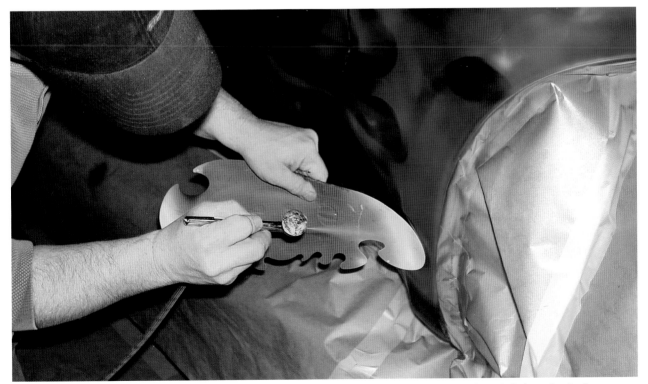

Pearl highlights are added over the candy blue. The stencil gives sharpness to the pearl highlights. Sunlight will catch these areas and promote the impression of motion.

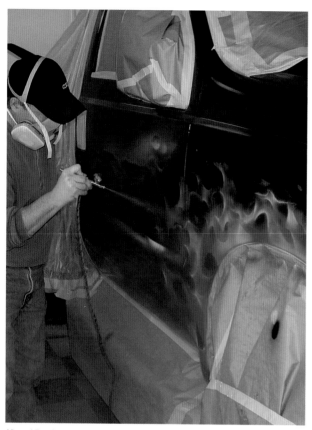

After adding the pearl highlights, Mikes goes back over the flames with more cobalt blue paint. The blue that goes over the pearl has extra brilliance. Again, knowing how much paint to use, and where to use it, is a matter of experience and artistic talent.

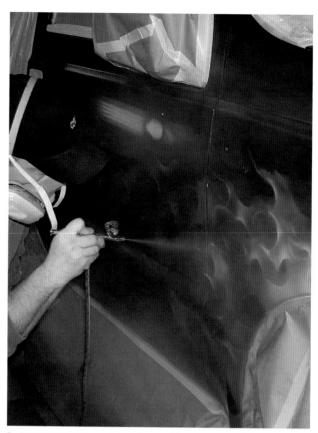

Beginners may be concerned about the overall hazy appearance of the flames during the painting process, but this is normal due to overspray. Frequent use of a fresh tack rag helps. The clear top coat will make the colors sharper.

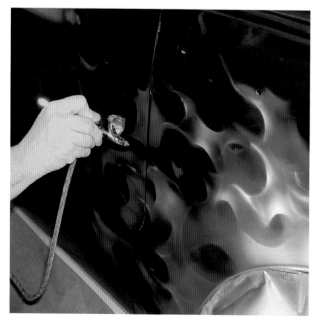

The whole process of painting True Fire flames involves a great deal of fine adjustments. Mike is constantly changing colors and going back to sharpen colors and add highlights. These flames are multilayered in the extreme.

This photo was taken before the clear top coat was shot. To give an idea of the finished look, a little wax and grease remover was applied. Overspray and sanding scratches are still evident above the flames.

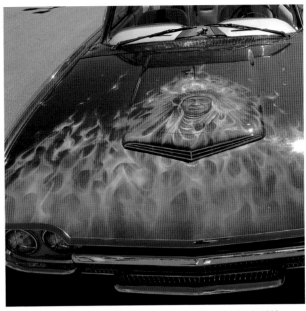

Here is the finished F-350 pickup. The look is subtle but very effective. The brilliant cobalt blue has great depth and contrast against the black truck.

Mike Lavallee's artistry is displayed on the large, wide hood of a classic 1960s Thunderbird known as the Warrior. In addition to his renowned flames, Mike is an extremely talented airbrush illustrator.

A nitrous oxide bottle is a good place for realistic flames.

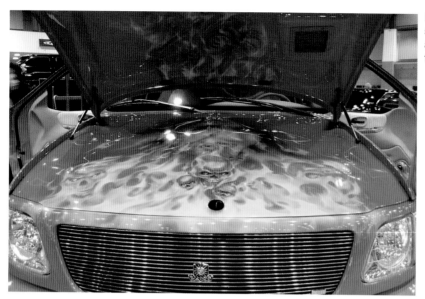

Lavallee went wild on his personal pickup. It's a rolling showcase of his airbrush mastery. The hood has flames and images inside and out. A special engine cover was fabricated to provide more room for his art.

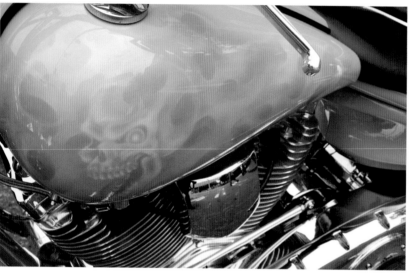

Motorcycle gas tanks aren't big, but they're a great place for realistic flames. The yellow licks on this wild green tank flow out of a skull.

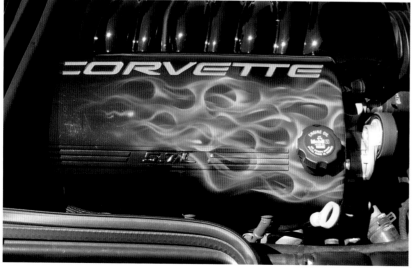

Realistic flames work well as engine compartment accents, as illustrated on this late-model Corvette.

The exposed supercharged Hemi engine in this highboy roadster makes a great "source" for realistic flames. Flames are a natural for a hot rod with a hot engine.

Jason Rushforth designed the flames on this Chevy pickup hood. Subtle realistic flames were placed inside the more traditionally shaped flames. Airbrushed shadows help the flames appear to float above the hood.

Realistic flames were effectively used within the classic Super Sport stripes on the cowl induction hood of this 1969 Camaro.

Chapter 9
Easy and Inexpensive No-Spray Flames

The idea of easy-to-do flames that are inexpensive and don't even require a spray gun sounds like the opening line of an infomercial or a bait-and-switch scam. We were quite skeptical when we complimented the great flames on Allen Dunn's chopped and primered 1949 Plymouth two-door sedan and learned that the flames were done by Allen's brother, Roy, with an inexpensive household foam paint roller and Sign Painters' 1 Shot lettering enamel.

Roy, who admits the trick is a variation of an old sign painter's technique, selflessly shared the method. When sign painters need to cover a large area quickly, they use a small foam roller rather than a brush. Roy employs this trick when lettering large commercial trucks at his shop, Dunn Auto Graphics (www.dunnautographics.com). Roy does use an airbrush to add details, but that step isn't mandatory. It's perfectly acceptable to do the whole job with a foam roller.

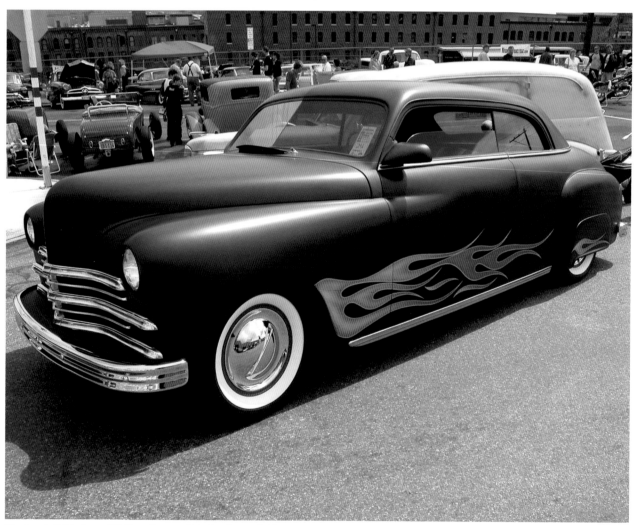

Allen Dunn built this chopped '49 Plymouth coupe. His brother, Roy, applied the wild flames with Sign Painters' 1 Shot enamel and a common foam paint roller. This technique is easy to duplicate.

No-spray flames (Roy calls them 1 Shot flames because they're done with 1 Shot lettering enamel) are perfect for primered vehicles and rat rods. They're great for any first-time flame painter; you can perfect your design and layout skills without the expense of equipment or costly custom paints.

Three key elements of this technique are sign painter's masking material, also known as transfer tape; 1 Shot enamel; and a foam paint roller. The masking medium goes by various names, including TransferRite, R Tape, and Auto Mask. If you can't find transfer tape at a local sign painter's supply, a little Internet searching will turn up mail-order sources. The job could be done with traditional masking tape, but it would take much longer, and the design stage would be more difficult.

The masking paper has a light tack adhesive. It's best that the paper be solvent-proof, so general art supply store frisket (stenciling) materials might not work well. The transfer mask is usually clear or slightly opaque, so you can see what's underneath and still be able to do layout work on top.

Sign Painters' 1 Shot lettering enamel is the longtime staple of the sign painting industry. It has excellent flow characteristics and doesn't require a clear top coat. Besides all the factory color choices, you can make virtually any color you desire by combining colors. The enamel can also be sprayed through an airbrush when properly diluted. Sign Painters' 1 Shot striping enamel is very durable and easy to touch up if it ever gets scratched or chipped. Durability and low maintenance make this product ideal for commercial trucks.

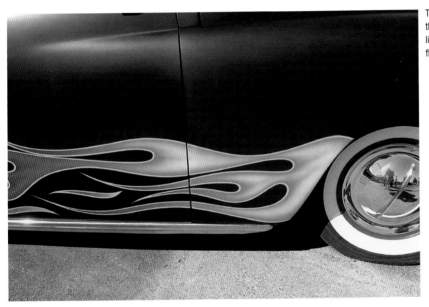

This close-up view of no-spray 1 Shot flames shows how the edges were fogged. The flames were outlined in bright lime green. The green really helps the orange and yellow flames pop off the primered car.

A key ingredient for no-spray flames is Sign Painters' 1 Shot enamel. This inexpensive paint comes in a huge array of standard colors, plus wild fluorescent and pearl colors.

For primered cars, 1 Shot flames are perfect. They look great against the matte paint and can be removed without ruining the paint job. Sign painters often use spray-on oven cleaner when they need to remove lettering. Before you use oven cleaner on your car, however, experiment on something expendable. If not used properly, oven cleaner can take off more than the paint you wanted to remove.

By painting 1 Shot flames on a primered vehicle, you can see how they will look. Because the car is in primer, removing flames at this stage is pretty easy, but the flames might look so good that you'll decide to leave the car in primer.

Roy used a prefinished blank metal sign to demonstrate 1 Shot flames. He didn't prep the surface, but if the flames are going on a car, it should be prepped first. Follow standard practices of washing, wiping down with wax and grease remover, scuffing with a Scotch-Brite pad, wiping down again with wax and grease remover, and using a tack rag.

Transfer tape comes in a variety of sizes and is available from commercial vinyl sign-making supply firms and online art supply companies. The flames can also be done with traditional masking tape, but transfer tape is much quicker.

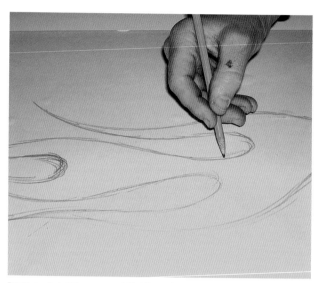

Roy Dunn started the no-spray 1 Shot flame demonstration by placing a piece of transfer tape on a metal sign blank. Roy uses the TransferRite brand, but any similar product will work. The transfer tape allows him to sketch the flames with a common No. 2 pencil with a relatively dull tip.

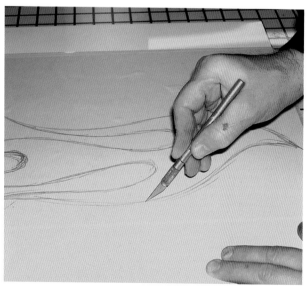

Use an X-ACTO knife with a fresh blade to gently cut out the design. You want to cut the tape but not the underlying metal. A smooth, light touch is the key to successful pattern making.

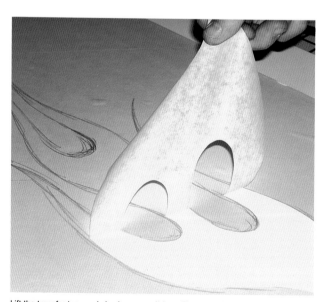

Lift the transfer tape and slowly remove it by pulling up and back as shown. If the cuts were smoothly made, the tape will separate easily.

The key to painting flames without spray equipment is an inexpensive foam paint roller. A 3- or 4-inch-wide roller is sufficient. The foam must be smooth, not textured.

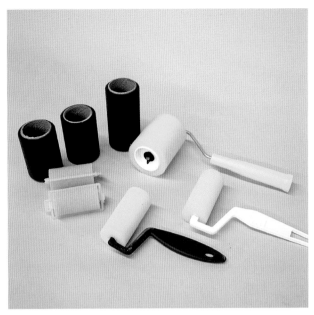

Small foam rollers are available in a variety of widths. You can buy inexpensive replacement rollers so that you don't have to buy multiple handles. Foam hair rollers can be used to experiment with different colors and techniques on the flame tips.

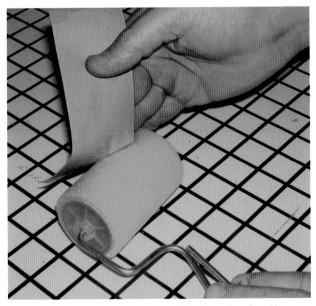

The foam roller must be totally free of lint or debris. Use a piece of masking or duct tape to clean the foam prior to immersing it in paint. Debris will show in the finished flames.

Pour the Sign Painters' 1 Shot enamel onto a glossy magazine, which will serve as a palette. Lemon Yellow was used for the base color.

A single piece of TransferRite masking paper was placed on the sign blank. Use care with masking paper to avoid wrinkles. A plastic squeegee can be used to smooth out any minor wrinkles. When larger areas are being flamed, the masking paper can be slightly overlapped. If you use a butt joint, the possibility of paint getting between two pieces is great.

Once the masking paper is in place, a common lead pencil can be used to sketch the flames. The design doesn't have to be exact at first. You could also draw with a grease pencil or a Stabilo pencil. Stabilo pencils, available at art supply outlets, are water-soluble, which is preferable to grease or china markers.

When you're satisfied with the design, use an X-ACTO knife or a similarly sharp, fine-pointed knife to cut out the design. Great care must be used on this step, especially if the flames are going on a painted rather than a primered surface. You must cut only the masking material. Any cuts in the actual paint will show up later.

A sharp knife and a light touch will help you achieve crisp tape edges. It wouldn't hurt to practice making cuts before trying it on a vehicle. A key technique is to make a continuous cut from one flame tip to another. Don't stop cutting in a curve or in the middle of a line. You won't be able to accurately start up again, and that will leave a ragged template. After the area to be flamed has been removed, go around the edge of the design with your finger to be sure the mask is firmly attached.

Color choice is up to the individual, but if you go with a custom shade, be sure to mix up enough to cover the whole project. The traditional flame hues of red, yellow, and orange are easily obtained right out of the can.

Load the foam by rolling it through the paint several times. Make sure the roller is saturated with paint.

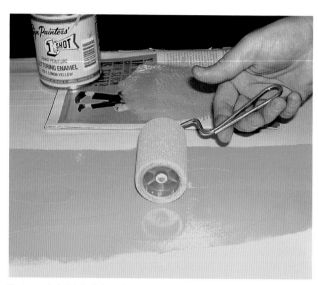

To demonstrate this technique, Roy will do the flames on a prefinished blank metal sign. The secret to smooth paint application is to hold the roller handle as lightly as possible. Let the paint flow out of the roller without bearing down. Take advantage of 1 Shot's excellent flow-out characteristics.

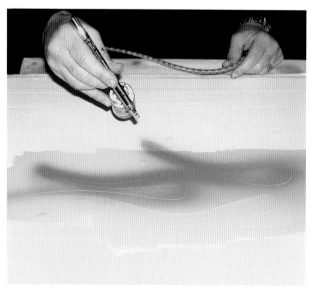

Roy adds highlights to the outer edges and inner curves by reducing some orange 1 Shot enamel with either 1 Shot brand reducer or mineral spirits. Reduction ratios are a matter of experimentation. He uses his trusty Iwata Eclipse airbrush and portable Power Jet compressor.

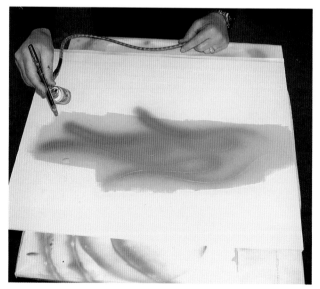

Magenta was used on the flame tips. The bright colors are out-of-the-can 1 Shot colors, so they can be easily touched up if necessary. It might look as if a lot of paint has been applied, but it won't look that way once the mask is removed.

Remove the masking/transfer tape by starting at the tips. This makes for smoother edges. Pull the tape up high away from the still-wet paint. Do not drag the transfer tape across the paint.

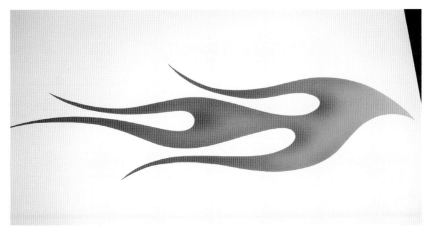

Here are the unmasked flames. They look fine as is, but Roy adds pinstriping to make them really pop. These flames would look even better on a black surface.

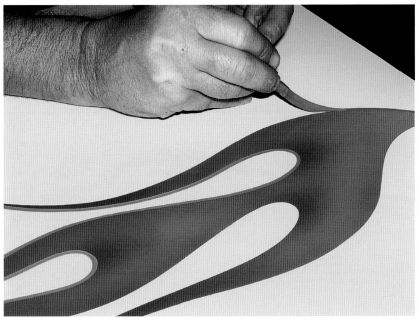

Roy used 1 Shot Process Blue, a very popular color for outlining flames. A No. 00 pinstriping brush is used to make the long, relatively straight lines.

The application tool is a 3- or 4-inch-wide foam paint roller. These little trim rollers are available at home improvement centers for a couple dollars. The foam needs to be clean and free of any debris. Running a piece of masking tape over the foam will ensure cleanliness.

The 1 Shot lettering enamel is applied full strength. Pour it on a "palette" such as a glossy magazine page. Run the foam roller through the paint until it is saturated but not dripping. Apply the paint to the vehicle by lightly rolling it on. A light touch spreads the paint without creating any texture. Don't make any more passes with the roller than necessary.

It's best to apply a single color with the roller. If more colors are desired, it can be tricky to use a roller where the different colors meet. The best way to add more colors is with an airbrush. Roy Dunn uses his trusty Iwata Eclipse airbrush, hooked up to an Iwata Power Jet portable compressor. Adding highlights with an airbrush really makes the flames come alive. The highlights should be added right after the main color has been applied. The 1 Shot lettering enamel needs to be reduced to flow properly through an airbrush. Sign Painters' 1 Shot offers its own reducer, or you can use mineral spirits. Mix the paint and reducer in a little paper cup. Start with a 50/50 blend and experiment to find the ratio that works best with your airbrush. The paint should be thin enough to flow well through the airbrush but not so wet that it runs or sags.

Traditional highlights are along the edges, at the tips, and on the inside edges of the curves. On the sample flames,

Roy used orange along the edges and magenta at the tips. He also added a little magenta to the inside of the curves. When you look at the photos, it might appear that a lot of paint was applied with the airbrush, but there is as much on the masking material as on the actual metal surface.

It's best to work quickly when applying highlights. The colors blend together better when they are still wet. As soon as you're through applying color, you can remove the masking materials. Start at the tips and pull forward. Lift the mask up high away from the paint. You don't want the mask to touch any of the still-wet paint.

On our sample flames, Roy pinstriped them right away. That's easy for a pro to do because he knows how to keep his hands out of the fresh paint. A beginner might be better off waiting for the paint to dry before doing the pinstriping.

Pinstriping takes much more practice than painting these easy flames, so you might want to skip this step or have a professional do it. For making the difficult inner curves, Roy suggests using a small lettering quill instead of a striping brush. The shorter bristles of the lettering quill are easier to control than the long bristles of the striping brush. The downside is that the quill doesn't hold much paint, so you can't use it for long, uninterrupted lines. The quill width should match the width of the pinstriping brush.

No-spray or 1 Shot flames are a great way to learn about flame painting. You can put them on mailboxes, tool chests, trash barrels, or whatever. It's a good way to practice without spending much money on paint or equipment

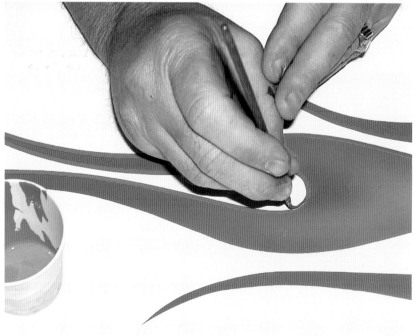

Inner curves are the most difficult part for novice pinstripers. Roy switches to a small lettering quill for the inside curves. It's easier to manage the short bristles of the quill. The lettering quill size needs to match the pinstriping brush.

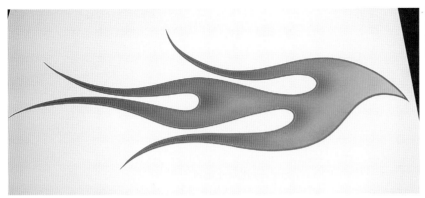

Shown here is a finished project done with roll-on no-spray 1 Shot flames. Besides being quick and easy, these flames don't need a clear top coat because 1 Shot is a glossy enamel.

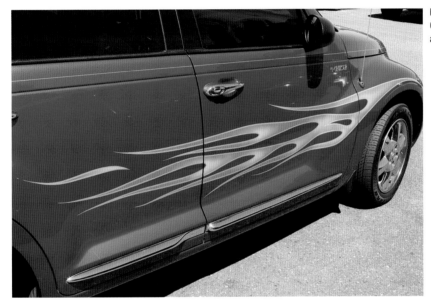

Here are some of Roy Dunn's 1 Shot flames on a PT Cruiser. The yellow and orange licks contrast nicely against the bright blue body.

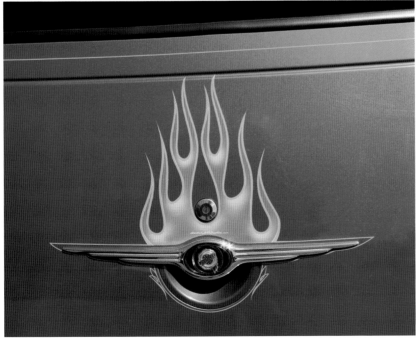

No-spray flames are perfect for small accent flames like these above the rear hatch emblem on the PT Cruiser.

Chapter 10
Primer and Flames

Flames don't have to be perfect to be fun. It certainly helps to have a good design, but the application of paint doesn't have to be flawless to be attractive. Traditional, low-buck, old school, and rat rod–style cars and trucks have put a lot of fun back in the old car hobby. Their emphasis on style over substance (and big bank balances) has reinvigorated the original rebel nature of hot rods.

The earliest hot rods were a youthful way of thumbing collective noses in the faces of older, uptight, regulatory adults. Hot rods were a means of going fast, looking cool, and having fun on minimalist budgets. Jettisoning unnecessary parts to save weight was the least costly method of improving performance. Crudely executed art reflective of circle track race cars and fighter planes made hot rods stand out. Flames and scallops were significant parts of the hot rod look.

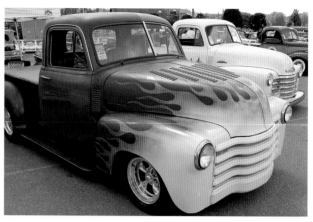

The 1947–1954 Chevy pickups are highly popular hot rod material. Look at the difference between the flames and primer of the truck in the foreground and the nicely painted yellow truck behind it. Flames can completely change a vehicle's personality.

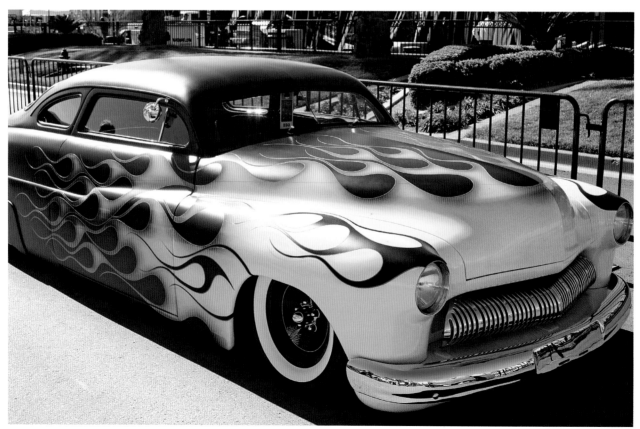

Radically chopped and lowered Merc customs look extra-tough in black primer or semigloss black. Add a massive set of complex flames and you've got an even meaner-looking hot rod.

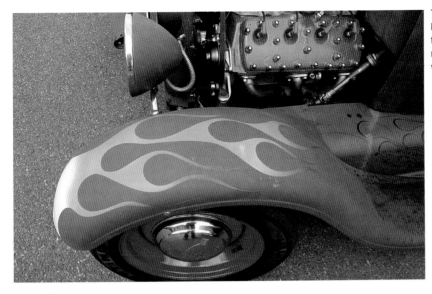

The painter of this red oxide primer Model A hot rod limited its flat-finish flames to the front fenders. The flames add interest but could easily be painted over or replaced with different fenders. Note that the flames weren't pinstriped.

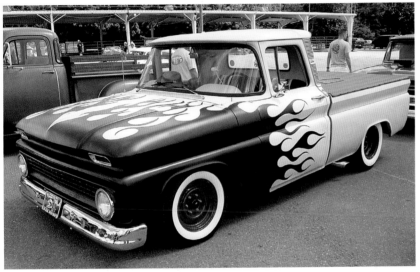

Semigloss black trim paint (or the equivalent) is a good way to achieve the primer look without worrying about the longevity of the paint. The large-scale flames on this neat '63 Chevy pickup are pretty traditional on the doors, but the hood has some reverse-direction tribal-style licks. Red pinstriping is a very effective outline.

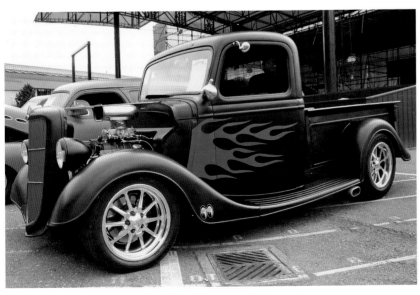

The bright blue flames on this '36 Ford pickup are simple and mostly confined to the doors. The grille bars were painted the same color for added interest and cohesiveness.

As shown by no-spray flames, described in Chapter 9, acceptable results can be had with very simple tools and materials. No-spray flames are a natural for primered cars, but there's more to primered cars and trucks and flames.

Primered, or unfinished, vehicles have always been part of hot rodding. The usual implication was that a vehicle was under construction and that a beautiful paint job would be one of the last additions. Primer is now so popular that many builders stop right there. When asked when a rod will be finished, they answer, "It *is* finished."

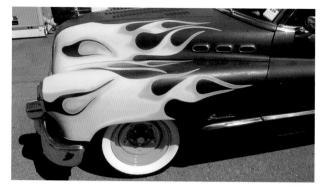

The saying "Go big or go home" certainly applies to the wild yellow and green flames on this primered early 1950s Buick. The fluorescent green wheels increase the wild look.

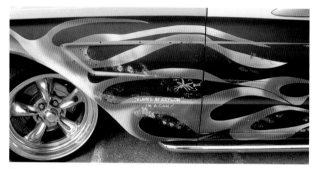

Flames are fun, so who cares if your design and layout skills aren't the best? The crazy flames on this predominantly primer-covered 1960s Thunderbird were painted with Krylon aerosol spray paint.

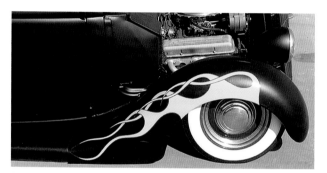

Contrast is a good thing to have with flames and primer. Pastel green flames with red pinstriping, grille bars, and wheels work well against the satin black finish of this '35 Ford Cabriolet. Only the fenders were flamed, so it would be easy to un-flame the car.

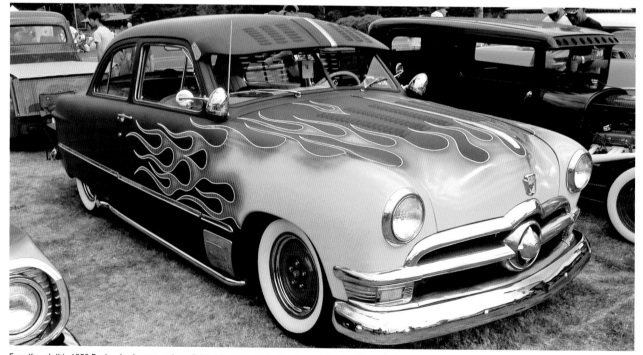

Even though this 1950 Ford sedan has a nonglossy finish, it's pretty certain that the car is finished. The extent and quality of the flames, along with excellent chrome, indicate a car that was built to look like this finished; it's not at an in-progress stage. The color fade/blend work is great.

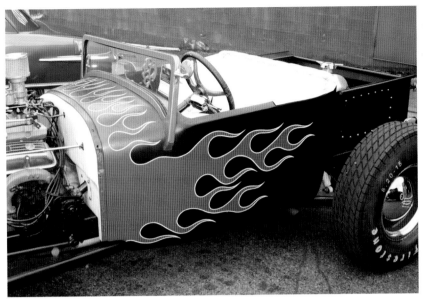

Limiting flames to a single color is a good way to simplify and speed up the process, as seen on this abbreviated roadster pickup. Red flames with wide white pinstriping jump off the flat black body.

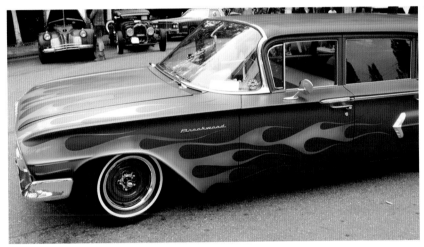

The nicely executed blue flames on this satin-finish blue 1960 Chevrolet Brookwood station wagon are outlined in red, which helps them stand out, even though the body and flames are in the same color family.

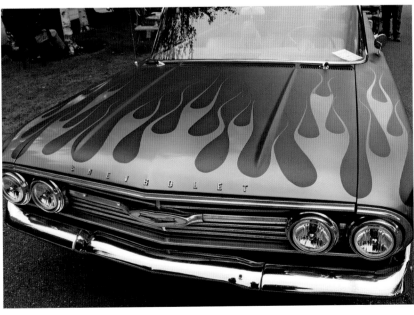

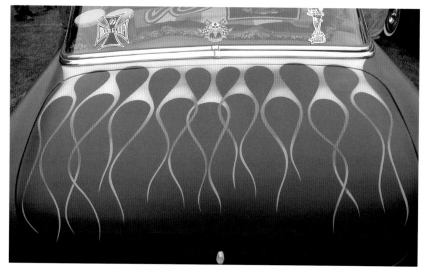

Flames on primered, satin, semigloss, or flat paint can either be cleared or left uncoated so that they, too, are flat. However, most painters opt for some type of protective clear, but with a flattening agent to maintain the semi-gloss look.

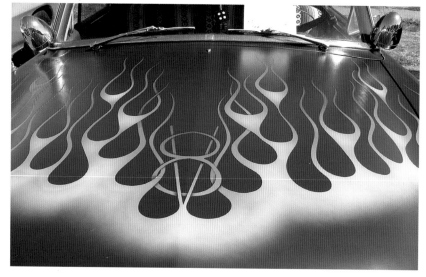

The popularity of primered hot rods and customs means that many paint companies offer semigloss colors to expand the range of colors. Note how a Ford V-8–style logo was incorporated into these flat-finish flames.

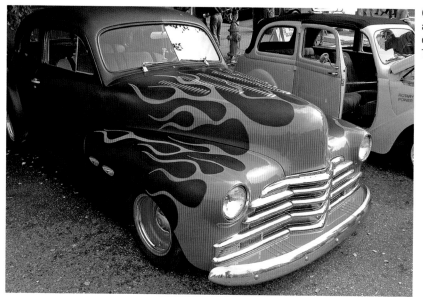

Glossy flames with a protective top coat can look great against a traditional black primer, especially when the contrast is as bold as the pink flames on this '47 Chevy. The tips are purple, as is the pinstriping.

In the booming 1990s, megabuck street rods and custom trucks became so ubiquitous that a low-dollar backlash evolved. Primered hot rods (loaded with attitude) often stole attention from six-figure show cars. Tinted primers were used instead of the usual black, gray, and red oxide shades. Some painters went halfway to glossy with matte finish and semigloss paints. These trends are still quite popular and commonplace.

Flames (or scallops) are a great way to make primered cars and trucks stand out from vehicles with solid primer. The flames can be shot in glossy custom colors, solid OEM colors, or tinted primers. A black primered car could have subtle gray primer flames.

Some builders of primered rods and customs leave most of the sheet metal in primer but finish a small area, such as the roof or dashboard. Custom car builders particularly like to apply intricate designs, including flakes, candies, lace, cobwebs, scallops, and flames, to the roofs of otherwise primered cars. Some of these wild roof designs might be overpowering on a whole car, but they look great on a smaller scale.

Design, layout, masking, and painting techniques are the same for primered cars as for finished cars, but less-than-perfect paints and application methods can be used without the results looking terribly wrong. You can use aerosol spray paint on a primered car, whereas using it on a painted car would seem like vandalism.

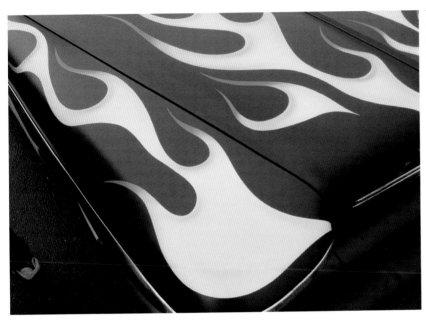

Yellow provides a strong contrast to black primer or flat black paint. These flames were very carefully taped, which left perfect edges. The yellow stands out even without pinstriping.

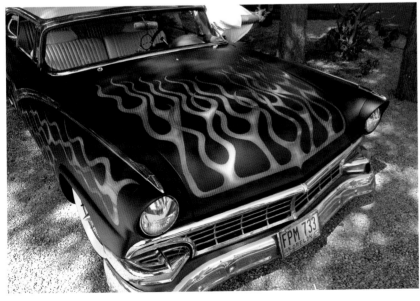

Orange seaweed-style flames provide a lot of action on the hood and sides of this primered '56 Ford.

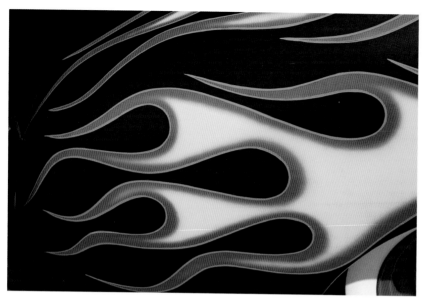

Process Blue is a tried-and-true 1 Shot lettering enamel color that's ideal for pinstriping flames, especially ones on black or primered cars. This close-up also shows how well the edges and curves were fogged with orange.

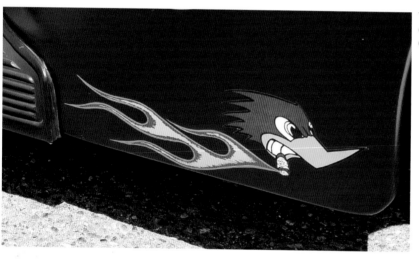

This primered '39 Ford front fender has a neat detail: small flames coming off the cigar of a very determined-looking woodpecker.

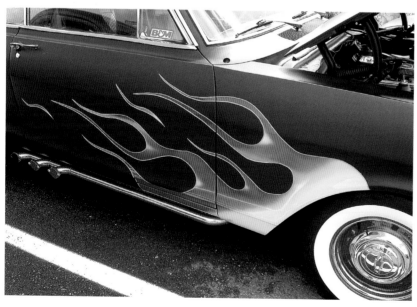

These traditional colored flames on an early Nova were simplified by their placement on only the front fenders and doors. Note the two free-floating licks.

If you try aerosol paint cans, buy the most expensive paint. You'll also need the best aerosol propellant and a good nozzle. The paint should be at room temperature; you can place the can in a bucket of warm water to warm it. Shake the can superwell. Check the nozzle often for paint buildup to avoid drips or splatters. Test the spray pattern before applying paint to the vehicle. Apply multiple light coats an even distance from the surface.

A big advantage of spraying flames on a primered car is that you can remove them and start over if they're not satisfactory. The bad flames should be totally removed (not painted over) before covering the area with fresh primer.

Contrast is a key design element for flames on primered cars. The natural contrast between flat paint and glossy flames is one part, but so is color contrast. Wild pinstriping colors such as apple green, violet, and school bus yellow can really pop against black primer.

Flames on a primered hot rod are a great way to add a finished element without the extra work and expense of a total top-to-bottom, front-to-back custom paint job.

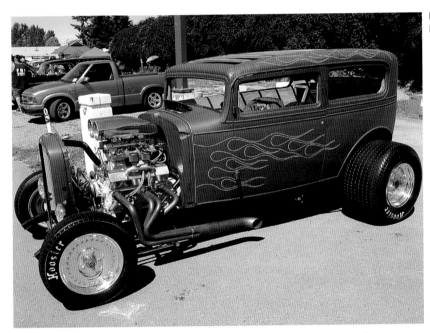

From a distance, this obviously unfinished highboy sedan looks like it has pinstriped flames.

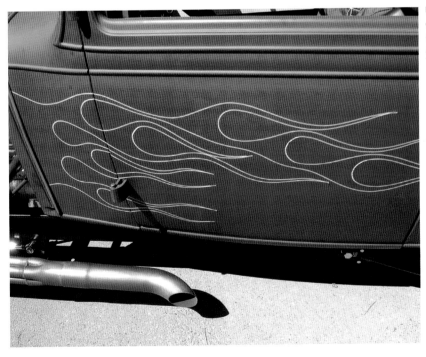

Upon closer inspection, it's revealed that the flames were done with ¼-inch masking tape. This is the ultimate quick, easy, and cheap way to flame a primered car, but longevity and weather resistance are severely limited.

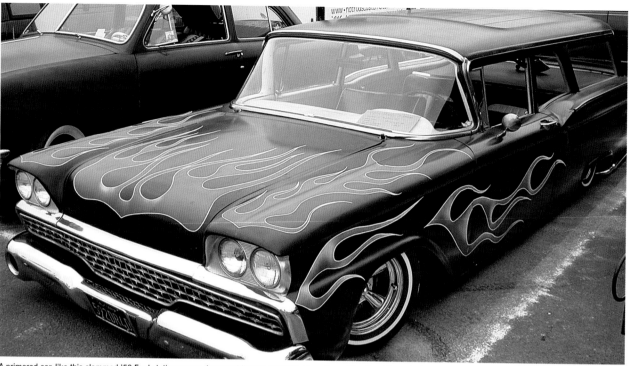

A primered car, like this slammed '59 Ford station wagon, is a great "canvas" for experimenting with unique flame designs because the flames aren't necessarily permanent.

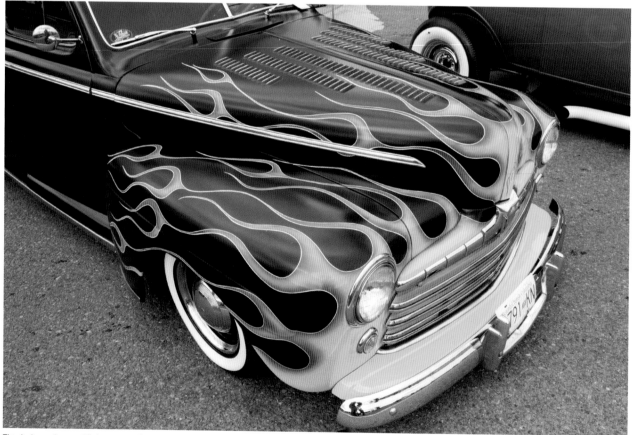

The design, colors, and fades are excellent on this satin-finish '47 Ford, but they were obviously taped without regard to the stainless hood trim. The flames would look better if they had been raised above the trim piece or if the trim piece had been shortened.

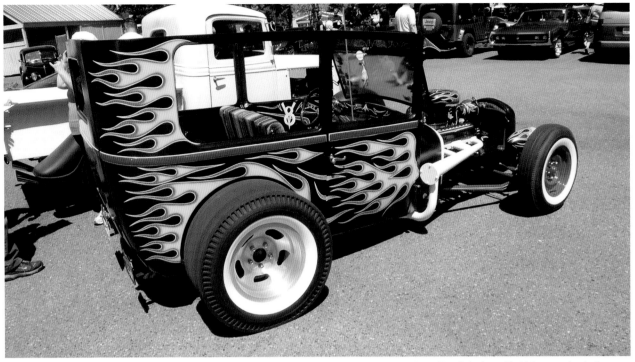

Tom Knebel put a ton of flames on his superfun '25 Model T. The flames were painted with a spray gun, but this style could easily be done with striping enamel and a foam roller, as demonstrated in Chapter 9.

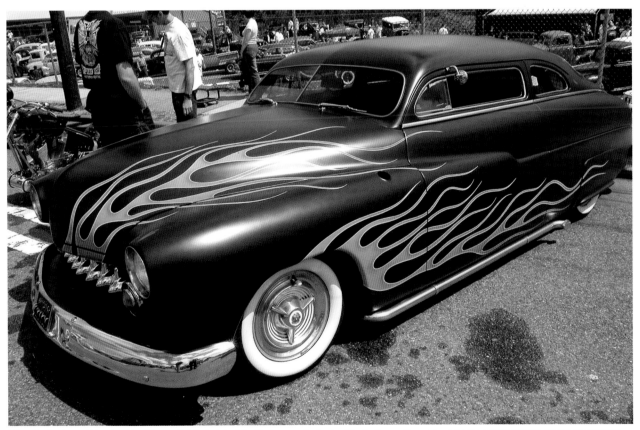

This radically chopped Merc has lots of flames, but the look is distinctive because the fronts of the fenders and the center of the hood were kept satin black. Notice how the flames drop along with the main body styling line on the door and rear quarter panel.

Chapter 11
Ghost Flames

Flames are generally bold, brash, and in your face, but not everyone likes flamboyant custom paint. Some people like their flames the way they like their car modifications—subtle. They prefer the "take a second look" approach instead of "LOOK AT ME!"

Ghost flames highlight parts of a car and add interest instead of dominating the vehicle. Ghost flames get their name from their "now you see them, now you don't," ethereal look. Ghost flames often virtually disappear in subdued light, only to shine brightly in sunlight. The degree of "ghost" varies, but all ghost flames use less paint than traditional flames. Candy and pearl type paints are common with ghost flames.

Ghost flames can be achieved using multistage painting, with the flames themselves masked instead of the usual practice of masking the surrounding area. In this case, the vehicle is covered with one coat of the base color. Then the flames are designed and the area inside the border is taped. Then one or two additional coats of the base color are applied.

After the desired color is achieved, the tape is removed. The flames are the same basic color but several shades lighter. The degree of ghosting will vary, depending on whether the flames are taped over after one coat or two coats. The faintest flames are achieved when flames are taped after one color coat.

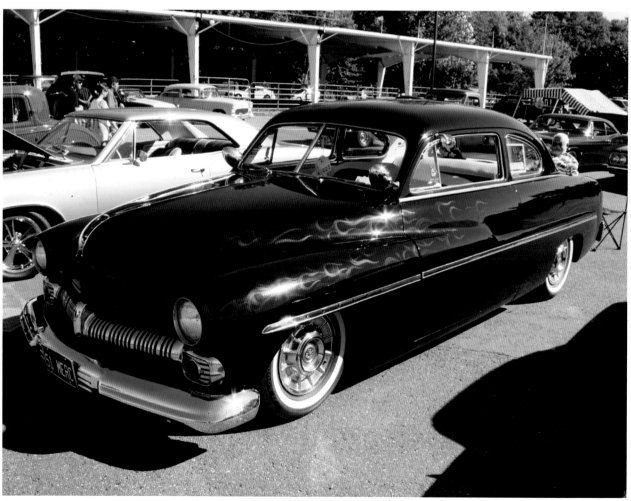

One of the most interesting things about ghost flames is the way they appear and disappear depending on lighting conditions and viewing angles. From afar, this '51 Merc looks black, but when the sun hits the hood, doors, and fenders, ghost flames appear.

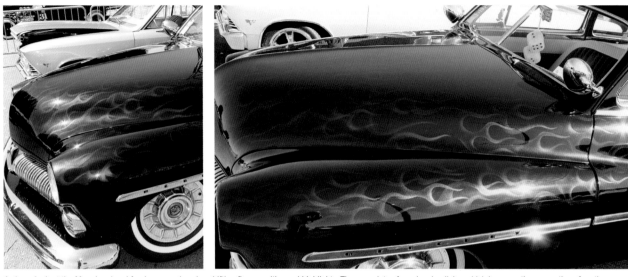

A closer look at the Merc hood and fenders reveals color-shifting flames with pearl highlights. There are lots of overlapping licks, which increase the perception of motion.

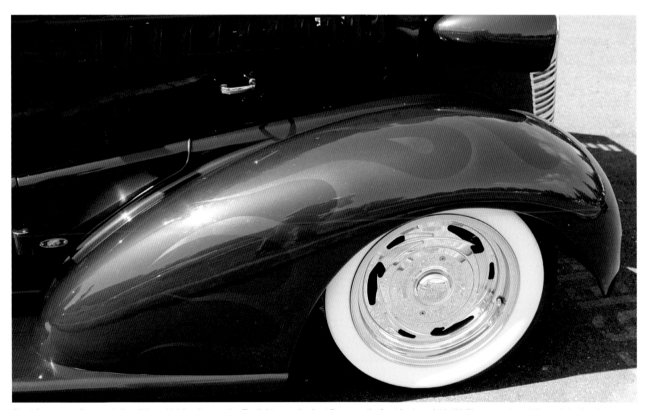

Ghost flames are often a variation of the vehicle's primary color. The lighter purple ghost flames on the front fenders of this '38 Chevy complement the main body color.

Pearl paints are a mainstay of ghost flames. The iridescent nature of pearl paints makes them perfect for this technique. The tiny reflective particles are great for catching light. House of Kolor offers a tremendous variety of possibilities for ghost flames, including many kinds of pearl paints. These include dry and paste pearls, which can be added to clear or other colors; pearls that change color when viewed from different angles; pearls with more brightness and sparkle than traditional pearls; and many others.

A key technique for successful ghost flames with pearls is to make sure the pearl pigments stay suspended during the entire paint job. If the pearl isn't evenly distributed, the paint will look blotchy or striped. Pearl paint should be thoroughly stirred and should be restirred if it sits for more than a few minutes.

Ghost flames are seldom pinstriped, so extra care must be taken during the taping and masking stages. Crisp borders are a must because you don't have the luxury of pinstriping to hide any uneven edges or small paint bleeds.

You don't need crisp edges if you want to give the illusion of amplified motion, however. In that case, a few blurry edges can pass for added motion. Also, depending on how ghostly the flames are, some less-than-great edges probably won't be noticed by anyone without a magnifying glass.

The style of ghost flames will determine your process. If the flames are pretty traditional in size and shape, standard taping and masking procedures can be used. The main difference is in the type of paint and how much of it is used. If the ghost flames are the busy,

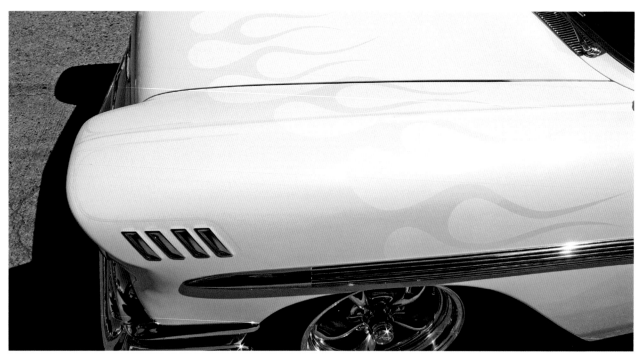

Ghost flames vary in intensity and visibility. Pearl ghost flames on a white car are among the subtlest. Curved areas like the fender tops are the most apt to catch reflective sun rays.

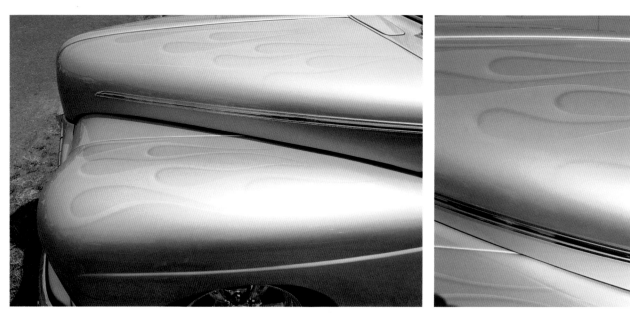

Ghost flames that are either the same color as or slightly different than the main color work particularly well on silver or charcoal cars. Gray or heavily thinned black paint is applied with an airbrush to give shadow-type definition to the flame licks and inner curves.

multilayered, overlapping style, some type of mask or template is usually employed.

The mask can be made from adhesive transfer tape to save masking time, or it can be a cut-out template. Companies such as Artool make solvent-proof masking templates. The templates are moved around as each light dusting of pearl or candy paint is shot. Templates are much faster when lots of licks are involved.

Poster board masks have a limited life span. If they get too much paint on them, the edges get fuzzy. Artool solvent-proof stencils are a superior choice, and they can be reused.

The use of templates for ghost flames is similar to the techniques used for realistic flames. The difference is that crisper, more defined shapes are desired for ghost flames.

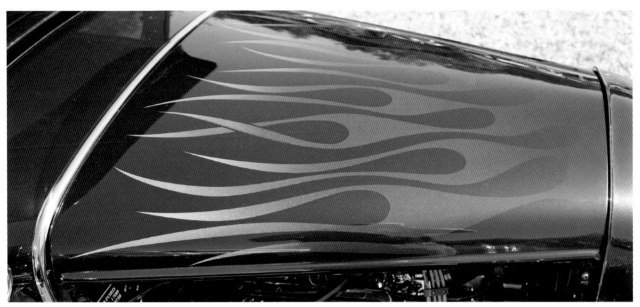

Color blending/shading impacts the appearance of ghost flames. The flames on the nose and hood of this '30 Model A start out body color and get progressively lighter toward the tips.

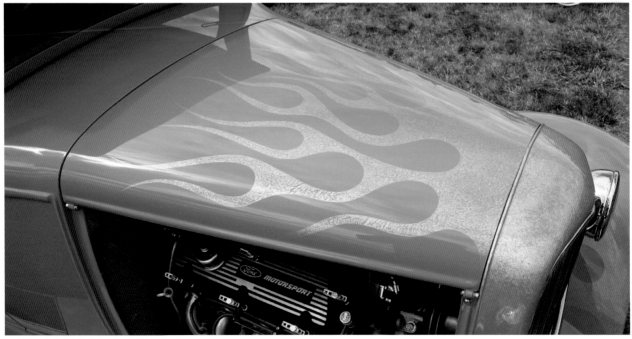

Marbleizing paint was used to give the ghost flame on this Model A hood a unique textured appearance.

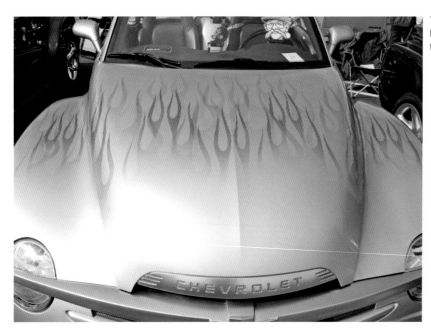

The ghost flames on this Chevy SSR start quite a distance back from the grille. There is a lighter set of licks under the more prominent ones.

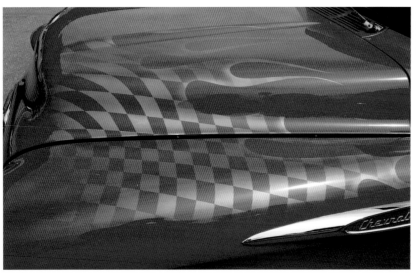

Gold pearl is a good ghost flame color for red, orange, and yellow vehicles. A great deal of masking went into the distorted checkerboard pattern that flows into flames on this '57 Chevy pickup.

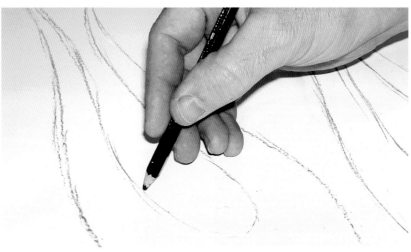

Roy Dunn of Dunn Auto Graphics needed to paint ghost flames on a very wide hood, so he decided to use a static-cling-type vinyl sign painting mask. This opaque material can be drawn on with a Stabilo pencil.

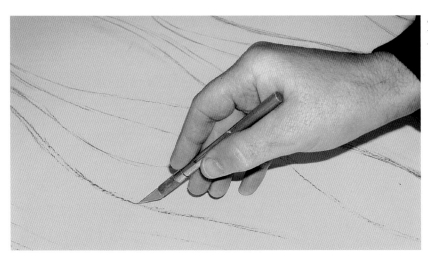

An X-ACTO knife was used to cut out the mask on a big, flat workbench. Since the mask wasn't cut on the car, there wasn't any concern about cutting too deep.

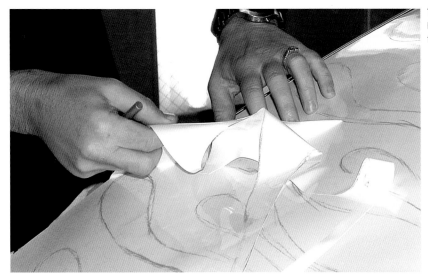

The masking template was separated from its protective backing material. The lightweight material had a tendency to wrinkle, so it took two people to maneuver it.

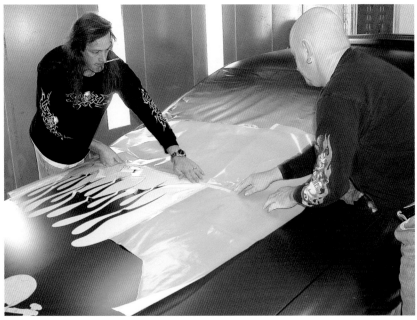

The hood was so wide that the stencil wouldn't cover the full width. It had to be positioned, masked, painted, and moved to the left side of the hood. Tim Fergurgur, who applied the orange base coat, helped Roy position the stencil.

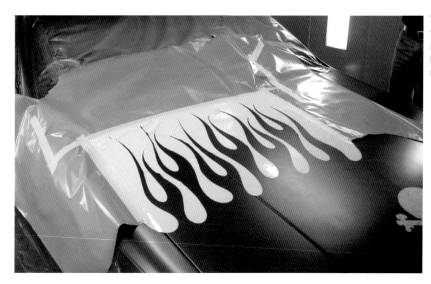

The high contrast between the white vinyl mask and the orange base coat clearly shows the flame design. Relatively big licks were used because this is such a large hood. Painting started near the windshield and moved forward.

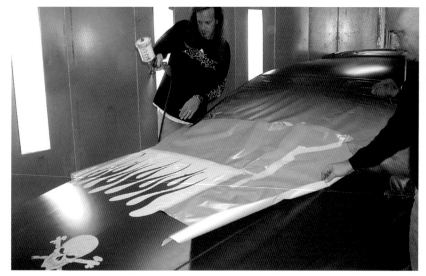

House of Kolor Dry Gold Pearl was used with a slow reducer. It was applied in very light mist coats. Every time the mask was moved, the hood was wiped with a tack rag. Most of the paint was concentrated at the tips of the flames, with less paint near the inside curves. Roy shot paint from the rear to help minimize mask movement.

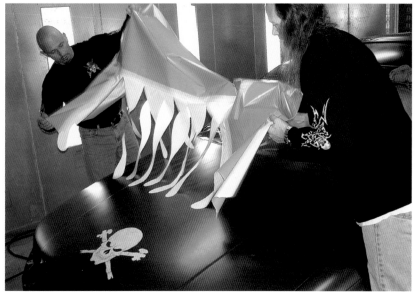

After the first application of pearl flashed, Tim and Roy carefully lifted the mask up and away from the painted section.

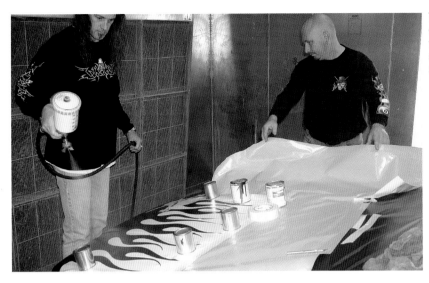

The mask was repositioned several times to get the desired number of ghost flame licks. Clean paint cans were used to help keep the mask in place. A full-size HVLP spray gun was used. Notice that the gun is at least 2 feet away from the hood and the paint is being lightly misted.

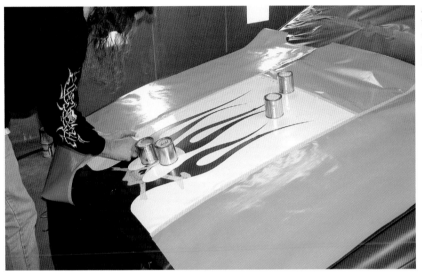

A smaller mask was made for the licks in the center of the hood. Those licks flow from a skull and crossbones that will be airbrushed in the center of the hood once the flames are done. Positioning the mask is very important for the best-looking flames.

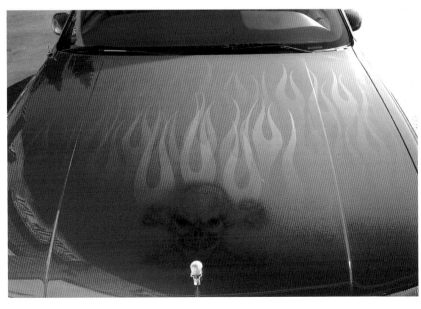

Here is the finished hood with gold ghost flames surrounding the skull and crossbones, which were airbrushed with orange toner to blend in with the body color.

When it comes to mistakes and goofs, ghost flames are pretty forgiving. Because they're so transparent, their appeal is the overall effect rather than the details of each individual lick. If multilayered ghost flames involve different colors, it's possible to position subsequent colors to hide bleed-throughs and other errors.

Depending on the area to be covered, ghost flames can be done with a full-size spray gun, a smaller detail gun, or an airbrush. Minimal quantities of paint are applied, so a small, lightweight gun like the Iwata LPH-50 or RG-2 works very well for this technique. Airbrushes work best on small areas like air cleaners, valve covers, dashboards, and motorcycle tanks and fenders.

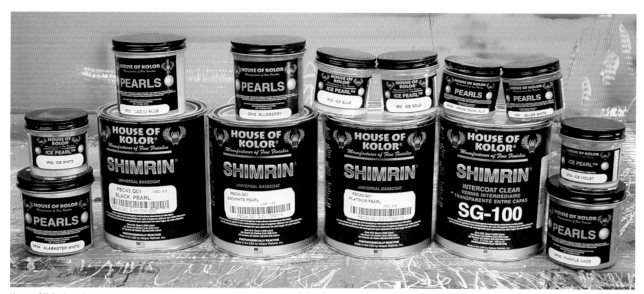

House of Kolor has all the bases covered when it comes to pearl paints and pearl powders. By using a combination of base pearls and clear with powdered or paste pearl, you can create a wild array of ghost flame effects. House of Kolor also makes Kameleon pearls that change colors depending on how they are viewed.

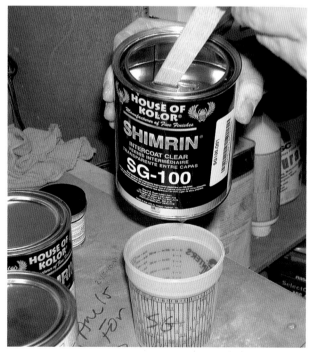

House of Kolor Intercoat Clear (SG-100) can be used as a medium for delivering powdered or paste pearls. SG-100 must be applied over Shimrin universal bases only. The color of the base determines how much pearl to use.

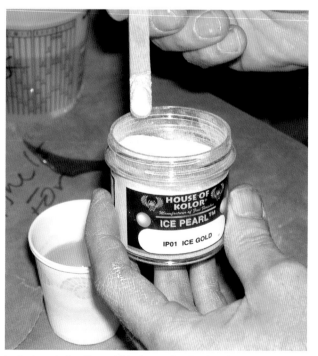

Ice Pearl powder from House of Kolor is a great product for painting brilliant ghost flames. The tiny glass flake pigments are brighter in sunlight than traditional pearls. A clean Popsicle stick was used to add Ice Pearl Gold to a small cup of SG-100 for use in an airbrush. A little Ice Pearl goes a long way, so use it sparingly.

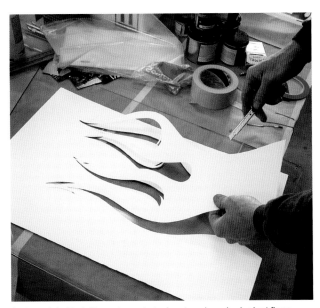

Custom painter Travis Moore demonstrates how to make a simple ghost flame pattern with common poster board. The design was sketched and carefully cut with his stainless snap-blade utility knife. Poster board patterns have a limited life span because paint quickly makes the edges fuzzy.

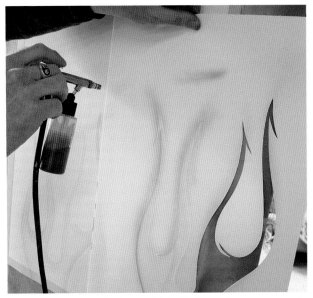

This example piece was painted on a metal sign blank, so surface curvature wasn't a consideration. The stencil was positioned, and light coats of Hot Pink were applied with an Iwata Eclipse airbrush. When using a stencil, the amount of paint needs to be right the first time because you can't accurately reposition the stencil.

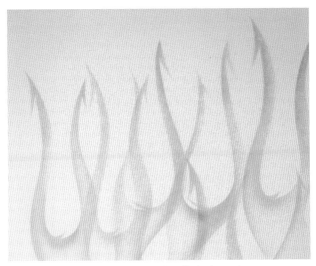

The hot pink flames are quite light against the white background.

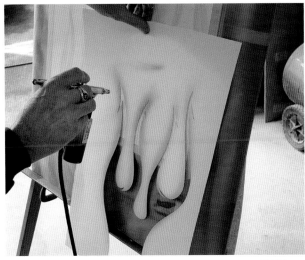

After enough Hot Pink was applied, Travis switched to a second bottle, with Violet Pearl paint. By having separate bottles with different colors, you can add colors at will. These inexpensive plastic, solvent-proof bottles come in various capacities and easily slip onto the Iwata Eclipse airbrush.

It's a good idea to practice on sign blanks or old body panels before attacking a real vehicle. Test panels provide a good idea of how much paint is needed to achieve the desired effect. Always check sample flames in bright sunlight, because that's where ghost flames really come alive.

Travis Moore, a well-known custom painter from Olympia, Washington, helped us shoot some ghost flames on metal sign blanks. Travis made stencils out of poster board. He advises that when cutting out the design, you should make one smooth, continuous cut on each flame lick. If you stop midpoint, you're likely to get a hiccup in the template, which can show up in the final product.

Travis used House of Kolor Shimrin Universal Basecoat in an Iwata Eclipse airbrush. If he had been shooting a real car, he would have used an Iwata LPH-100 or LPH-300 spray gun. On the sample panel he used Hot Pink (PBC-39) and Violet Pearl (PBC-40), since the pink and violet shades complement each other.

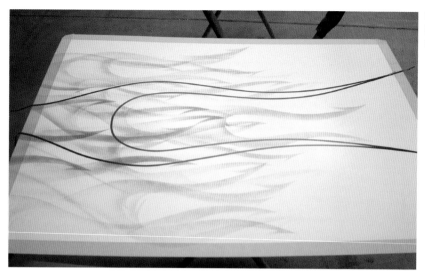

Here are the example pink and purple ghost flames. The blue vinyl tape outline is for a more prominent flame that will be painted over the ghosted background.

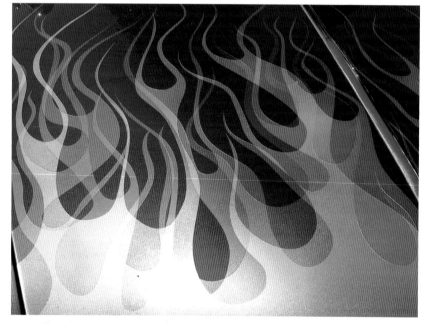

When applying multicolored ghost flames, the order in which the colors are shot makes a big difference to the finished look. This candy red car appears to have a reduced red, followed by gold, violet, and pink (or further reduced violet).

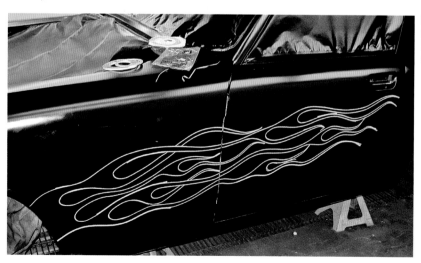

Bob Cody Jr. of Cody Inc. in Spanaway, Washington, demonstrated another way of painting ghost flames on his stretched-nose '76 Chevy LUV race truck. A traditional design was done in ¼-inch masking tape.

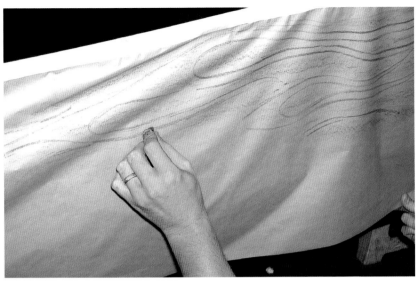

A pattern was made for duplicating the design on the other side of the truck. Masking paper was secured over the taped flames, and a common crayon was used to trace the flames.

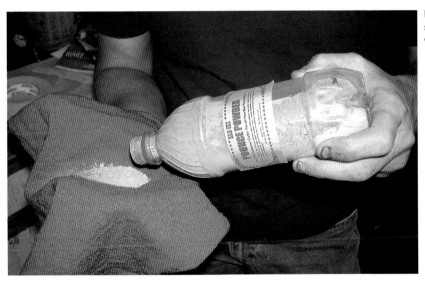

Pounce powder or carpenter's chalk is placed in a clean shop rag for use in marking the pattern after a pounce wheel was used to perforate the paper.

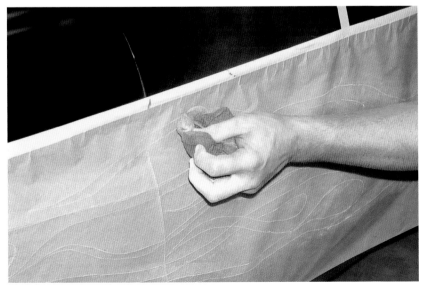

The perforated template paper is placed on the truck using pre-established reference points. Pat the paper thoroughly with the powder-filled rag.

Travis also added House of Kolor Gold Ice Pearl to HOK Intercoat Clear to cover some Shimrin Tangelo flames. In this case, the flames weren't ghosted, but adding the pearl gave them more interest. The SG-100 Intercoat Clear is often used as a medium for applying pearls.

Pearl paints should always be well covered with protective clear. The idea is to bury the pearl under the clear so that color-sanding and buffing won't affect the pearl. The key thing to remember about ghost flames is to go easy with the paint. Adding more paint is simple, but taking away paint isn't. Ghost flames are a great way to be bold yet slightly conservative at the same time.

Color-shifting or chromatic paints are great for ghost flames. Bob Cody designed long flowing flames for the front fenders and doors of his radical, stretched-nose Pro Street Chevy LUV pickup. The flames are almost hidden in low light but really pop out when the light hits them. The colors shift according to your viewpoint. The shifting colors increase the sense of motion.

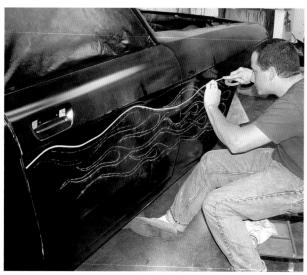

Bob followed the chalk outline with ¼-inch masking tape.

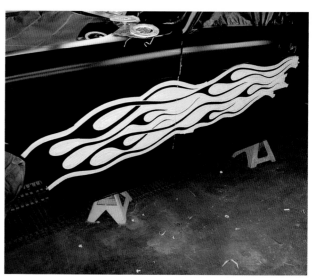

Green ¾-inch automotive masking tape was used to tape off the flames. All areas of the truck not being painted were thoroughly masked.

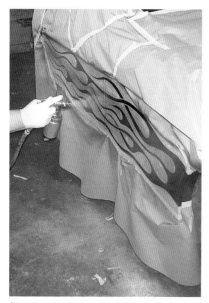

Chameleon (flip-flop) candy paint was applied in four light coats according to the manufacturer's directions. The touchup gun pressure was set at 40 psi.

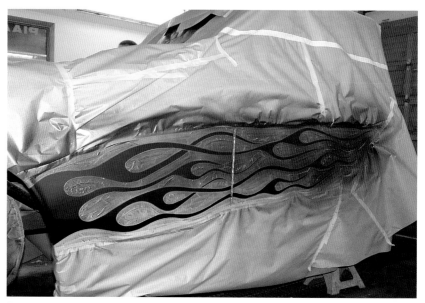

Four coats of clear were applied over the flames. The flames and clear were color-sanded after 48 hours of curing. The flames don't look very distinct in the spray booth, but they'll look fine in the sunlight.

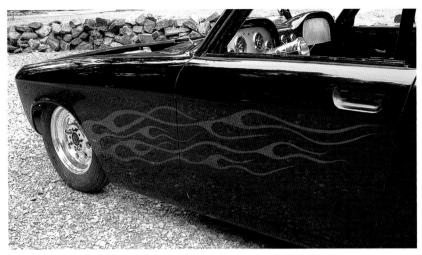

Because ghost flames are rarely pinstriped, Bob Cody uses a common plastic body-filler squeegee to lightly go over the flame edges. This process helps knock down any ridges without chipping the paint.

From this angle, the ghost flames on Bob Cody's truck appear mostly orange and red.

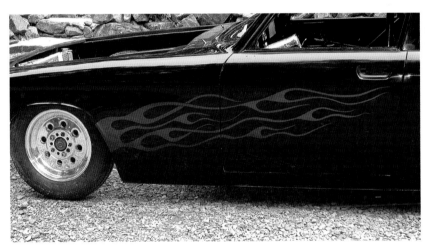

From a slightly different angle, the flames show up as shades of blue and purple. That's the neat thing about chameleon paint.

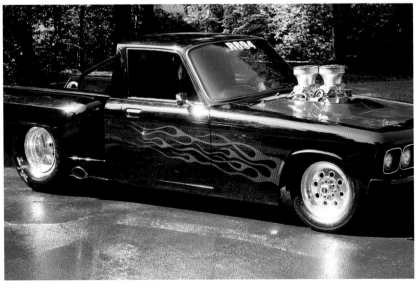

Here is the finished truck with its monster big-block engine sticking up through the hood. The flame design compliments the long nose (stretched 24 inches) and raked stance of the radical LUV.

Chapter 12
Pinstripe Flames

Pinstriping is an integral part of many flame styles. The primary role of pinstriping is to outline the flames. Pinstriping adds contrast and helps define the flames. Striping can also cover up problem areas along flame borders and can be used to correct and tighten design errors or flaws.

In some cases, the pinstriping *is* the flame. Stand-alone pinstripe flames are one of the easiest, least expensive ways to flame a vehicle. They're a great way to add highlights to engine compartments, dashboards, frame rails, rear-end housings, valve covers, air cleaners, and tailgates.

The good news about pinstripe flames is that the most minimal equipment and materials are required. A can of 1 Shot lettering enamel and a pinstriping brush (also known as a sword or a dagger) are the two main items. The bad news concerns a critical third element—good hand and eye coordination. Unlike laying out flames with masking tape,

you can't pick up the painted line and reposition it. Your hand pressure on the brush as it deposits paint on the surface determines the width and uniformity of the line. Masking tape is a fixed width.

There are ways around the natural talent/coordination stumbling block. The easiest solution is to pay a professional striper. They're reasonably priced considering the years of practice it takes to master professional-quality striping. The pros know a lot about color, which is very important. Color choice can make a substantial difference in the finished look of a flame job.

You can learn pinstriping. There are helpful books and videos on the subject, but the underlying necessity is practice. Given the extremely low cost of a can of paint and a brush, it's certainly worth trying. Many people discover that they have a natural talent for it.

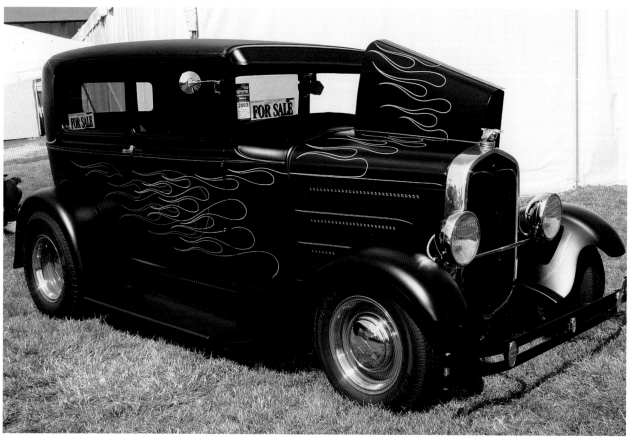

Pinstripe flames are a great way to add interest to a car without overpowering it. The yellow and orange pinstripe flames on this '31 Model A sedan contrast the black body and complement the orange wheels.

Sign Painters' 1 Shot lettering enamel is a very slow-drying paint. That means mistakes can be wiped off easily. If you watch professional stripers, you'll notice that they frequently wipe off an area and start over. The downside of the slow-drying paint is that you need to be careful not to touch it with your hands or clothing.

An old clean T-shirt makes an excellent rag, because it's soft and easy to wrap around your index finger. Since the T-shirt isn't very thick, it allows good control of where you wipe without affecting the areas you want left alone.

STRIPING TRICKS AND TECHNIQUES

There are some tricks that make pinstriping easier for novices. One trick is to lay out the design with 3M blue fine-line tape. You can use any width you wish, since the tape is simply a guide. The ⅛- or ¼-inch tapes are good choices. When you're satisfied with the design, use the tape to guide the brush.

You can also lay out the design with chalk or a Stabilo pencil. A benefit of a Stabilo pencil is that it's water-soluble. Stabilo pencils tend to get soft when warm, so store them in the refrigerator. After sketching the design, lightly rub the area

A close-up of the Model A flames shows how the two different colored sets of flames were overlapped to provide a greater sense of movement.

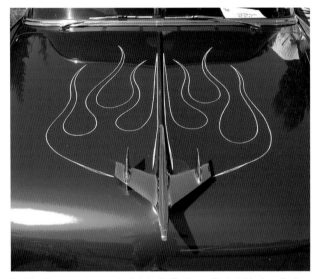

Pinstripe flames can be very simple but still effective, as illustrated by these basic white flames on the hood of a '55 Chevy.

Sign Painters' 1 Shot lettering enamel is the industry standard for striping paint. The company makes many standard colors, plus neons and pearls. Painters combine colors for thousands of additional shades.

Striping brushes come in a variety of sizes for painting different width lines. Striping brushes are also known as swords or daggers (a reference to their shape). These Mack brushes vary from (top to bottom) a No. 4 bold line (approximately ½-inch wide) to a No. 00 very fine line (approximately ⅛-inch wide).

with a dry cloth. The idea is to remove heavy concentrations of Stabilo pencil. You need only a faint image to follow with the striping paint.

Another technique is to cut out flame templates from white poster board. Use the template as a guide for the brush. Templates can be especially helpful when you're painting tricky inside curves. Various premade flame stencils are also available.

Roy Dunn demonstrated a few basic techniques for pinstripe flames. One trick Roy uses is to make the long lines first. He starts from the tip of the lick and pulls the line toward the inner curve area. He stops just after the line starts to curve inward. He paints the long lines with a pinstriping sword. A pinstriping dagger (as the name implies) is better for shorter lines. The sword holds more paint than the dagger.

After Roy does a few long lines, he comes back and connects the lines via the inside curve using a lettering quill. The short bristle quill is much easier to maneuver than the longer bristle brushes. The quill needs to produce the same size line as the sword. In the example photos, Roy used a No. 0 pinstriping sword and a No. 1 lettering quill.

A trick for making pinstripe flames is to pull the two long lines from the tips to the start of the inside curve before painting the curve. In this example, Roy Dunn is using 1 Shot Process Blue lettering enamel loaded on a No. 0 pinstriping sword.

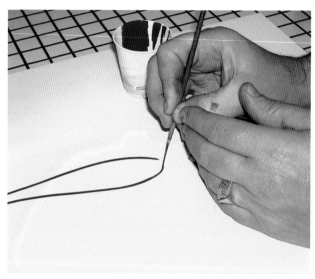

After the two long lines have been pulled, they're connected with a No. 1 lettering quill. The quill holds just enough paint for this short distance, and it's easy to manipulate.

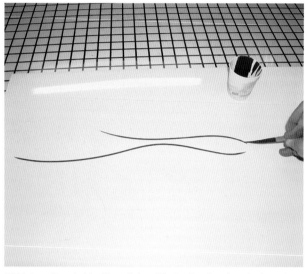

Lettering quills come in many sizes and with tapered and flat-tip bristles. The numbering system for lettering quills differs from that of striping swords.

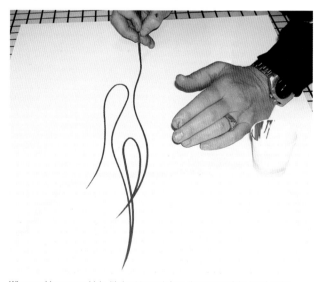

When working on a vehicle, it's best to work from the center of the hood to the outside and from the top of the fenders to the bottom. You want to avoid putting your hands in fresh paint. Notice that one tip overlaps the other for some added interest.

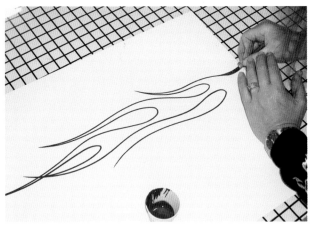

In this photo, Roy is contradicting the suggestion in the previous caption, but he has room to work since this is the outside of a test panel. Here he demonstrates how he often uses his free hand to guide the hand holding the brush.

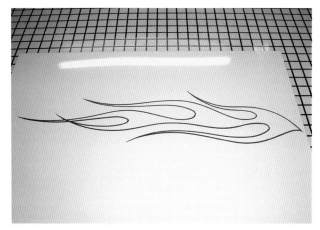

Here is the finished pinstripe flame. A metal sign blank, a few cans of 1 Shot, some reducer, a couple different pinstriping brushes, and lettering quills are all it takes to have hours of fun experimenting with pinstripe flames.

Loading the striping brush with a maximum amount of paint is a learned technique. A properly loaded brush will allow the longest possible uninterrupted line. A glossy magazine makes an excellent, disposable palette. Small drinking cups are perfect for mixing paint.

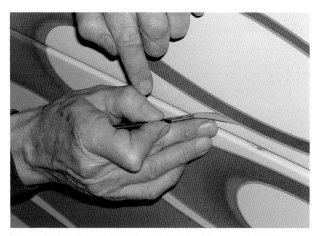

Learning to use both hands to steady the striping brush is an important skill. Hand position and bracing vary, depending on what is being striped and where it's located.

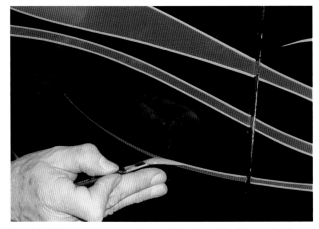

Pinstriping is the most common typing of outlining for traditional flames. Besides giving added contrast and pop to these flames, the striping makes the superthin tips a little more visible. Notice how Donn Trethewey holds the brush at the rounded part of the handle.

Sign Painters' 1 Shot striping enamel stays wet quite a while, so it's easy to wipe off mistakes or change colors. A soft clean rag, such as an old T-shirt wrapped around your index finger, works well for removing wet paint.

Roy could do the entire design with a pinstriping brush, but he suggests the lettering quill as an easier alternative for beginners. The design of pinstriping brushes makes it possible to rotate the brush between your thumb and index finger. Rotating the brush is handy when doing curves.

The inside curves need to be connected soon after the long lines have been pulled so that the paint doesn't start to dry. When the paint is still very wet, the areas will blend much better. The idea is to make the flame lick look as if it were one nonstop pull from tip to tip.

PAINTS AND BRUSHES

Roy reduces his paint about 10 to 20 percent. He wants it to flow as smoothly as possible without being too thin. You should experiment until you find what works for you. Roy mixes the paint and reducer in small, unwaxed paper drinking cups. He uses pages of a glossy magazine as a palette for loading the striping sword. The idea is to get the paint up into the bristles so there's enough paint to pull a continuous line.

Loading the brush bristles takes practice. You want a full load of paint, but you don't want to overload the brush and

Here is another example of supporting the brush-holding hand with the free hand. Travis Moore was adding very fine highlight slashes to a flame lick and wanted to keep his hands off the test panel.

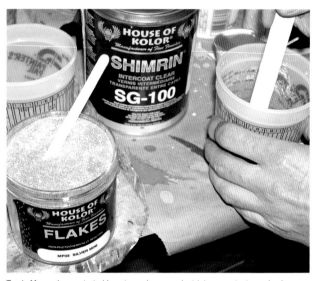

Travis Moore demonstrated how to apply spray pinstriping on a test panel using House of Kolor Silver Mini Flake (MF-02) as the base and outline color. The dry flakes are added to HOK Intercoat Clear (SG-100). The mix is sprayed on the flame licks as normal.

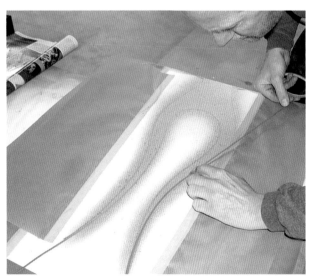

The silver flake made it difficult to see the underlying tape, so Travis retraced it with fresh ⅛-inch 3M blue fine-line tape.

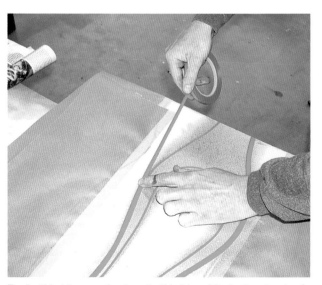

Fine-line ¼-inch tape was placed over the ⅛-inch tape, following the outer edge of the ⅛-inch tape. That placed the ¼-inch tape ⅛ inch inside the border of the silver flake licks.

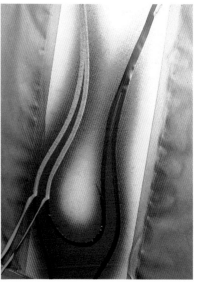

A batch of House of Kolor Shimrin Hot Pink Pearl was mixed up and shot over the silver miniflake base. A single shade was used for this example, but the licks could have been done in multiple colors for a superwild effect.

When the tape is first removed, the stripe looks quite wide. Actually, the outer part of the silver is over the original flame border tape.

When the original blue outline tape is removed (notice that Travis pulls it back over itself), the resulting thin silver flake spray striping is revealed. It's a neat effect and not difficult to do.

Small details can be created with pinstriping paint and brushes. Donn Trethewey likes to add flaming woodpeckers to the lower cowl or frame rails on many of his flame jobs. The basic woodpecker outline is made with a paper pattern, pounce wheel, and carpenter's chalk the say way patterns are made for full-size flames.

get sags. Some painters like to put paint in a small paper cup and use their fingers to work the paint into the bristles. If you use this method, wear protective gloves. Pulling the brush through the paint on the palette gives you a feel for the paint. This "feel" helps experienced stripers know when paint is the right consistency. Like so many things in custom painting, getting the perfect consistency requires practice.

There are two types of pinstriping paint: the old favorite, Sign Painters' 1 Shot lettering enamel, and a newcomer, House of Kolor urethane striping and lettering enamel. The HOK paint can be used underneath clear coats, while 1 Shot is designed to go on top of the clear coat. It is possible to add catalyst or hardener to 1 Shot and use it under the clear, but most stripers prefer to apply 1 Shot as the final touch.

Almost any surface can be used to practice pinstriping. Anything metal is good, as is a piece of common window glass. Glass is easy to wipe clean and use over and over.

SPRAY PINSTRIPING

True fine-line pinstriping takes lots of talent and practice. You could use 3M blue fine-line tape to back-tape the flames and then stripe the outline. This technique involves a great deal of taping, but it prevents a wiggly line from crossing into the flames. Keep in mind that true pinstripes aren't laser perfect. That's part of their appeal—they don't look machine made or taped. You just don't want them to be too sloppy.

One method of outlining flames without hand pinstriping is known as spray striping. It's also known as back-taping. Instead of hand striping, the outline color is sprayed first. The area where the "striping" is desired is then taped over. After the flames have been sprayed, the thin border tape

is removed, leaving spray stripes. This method involves extra taping, but it will get the job done if you don't have access to a professional striper and don't have the skills to hand stripe.

This technique works well for flake striping. Since you can't apply flake paint with a brush, the base flake color serves as the outline. Travis Moore demonstrates this technique in the photos in this chapter. The same basic idea applies to any type of paint.

The flames are designed as usual, although you might want to make them ⅛-inch bigger to account for the sprayed striping. The base color is applied. With the flake stripes, it was House of Kolor Silver Mini Flakes (MF-02), which Travis mixed with HOK Shimrin Intercoat Clear (SG-100). This is the base flake color and the pinstripe color.

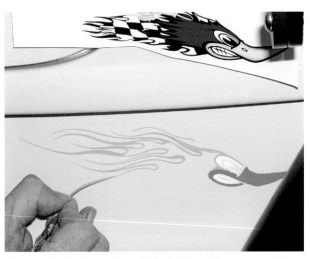

After the head outline is done, Donn adds freehand flames, but a pattern could be used here too. A similarly styled woodpecker decal is used for reference.

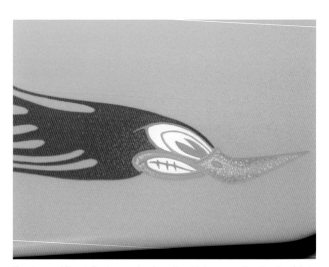

Here is one of Donn's flaming woodpeckers. He added very small contrasting dots to the flames and beak for greater detail.

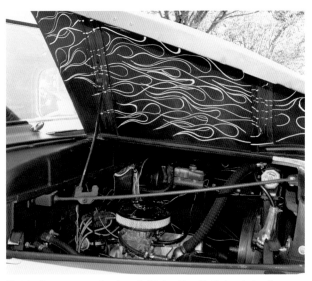

Pinstripe flames were used underneath this hood for added interest when the engine is displayed at shows.

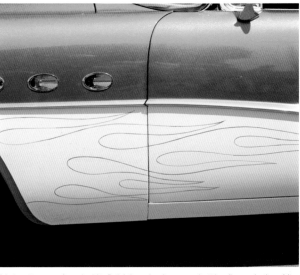

This two-tone green and white Buick has simple green pinstripe flames in the white part of the front fenders and doors. This design is easy to do and easy to undo.

Multiple short pinstripe lines in several colors were layered (after each underlying color was dry) to form an abstract flamelike border for this two-tone red-over-black paint scheme.

When same-color flame licks overlap each other, a darker or contrasting pinstripe has to be used to differentiate the two licks.

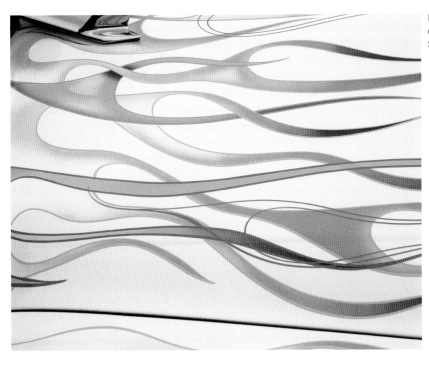

Extra pinstripe flames were used along with the regular licks on this '56 Chevy hood to add a greater sense of motion. Several different colors were used for the pinstriping.

After the flake dried enough to back-tape, the ⅛-inch perimeter of silver was masked off. There are a couple ways to do this. You can simply use ⅛-inch blue fine-line tape to follow the inside border of the existing tape outline. Or, since the silver flake overspray tends to hide the original tape, Travis takes the extra step of tracing the original tape with fresh ⅛-inch fine-line tape. Then he comes back with ¼-inch blue fine-line tape and follows the outer edge of the ⅛-inch tape. This effectively covers a ⅛-inch perimeter of the to-be-painted flames. The ¼-inch tape has better adhesion, and this method lessens the chance of the main color appearing on the wrong side of the silver flake outline.

Then he mixes the candy color for the flames. For this example, House of Kolor Shimrin Hot Pink Pearl (PBC-39) was chosen. Enough paint was applied to achieve a magenta-like hue. When the blue fine-line tape was removed, the result was hot pink licks with nicely contrasting silver flake borders.

Some painters choose not to pinstripe their flames. That's a good choice for flames that aren't quite as bold as traditional flames but are more pronounced than ghost flames. Precision taping is critical if you decide to skip pinstriping.

Traditional, hand-painted pinstriping is the preferred way to highlight flames, but there are creative alternatives.

Chapter 13
Tribal Flames

America is a society that loves to label things. We're obsessed with branding and classifying products, people, animals, and events. Somehow labeling helps us feel better about things. The item might essentially be the same old thing, but with a newer, more attractive label.

Station wagons were once cool. Then they became passé. Then someone renamed them sport utility vehicles and they were cool again. Then they weren't as cool, so variants were developed such as compact SUVs, mini-utes, hybrid SUVs, and crossovers, but they were all basically variations on the old station wagons.

That's sort of the situation with tribal flames. Tribal flames are stylized flames. They're flames that don't follow all the old conventions of flow and form, but from a distance they still look like flames. Tribal flames have notches and holes where traditional flames simply flow from front to back. Some of the licks are reversed. The designs are supposed to be more primitive, as if some remote civilization designed them for ceremonial purposes.

Mixing, matching, blending, adapting, and changing traditional styling trends to produce new variants is a key theme of hot rods and custom cars. Tribal flames are a visual

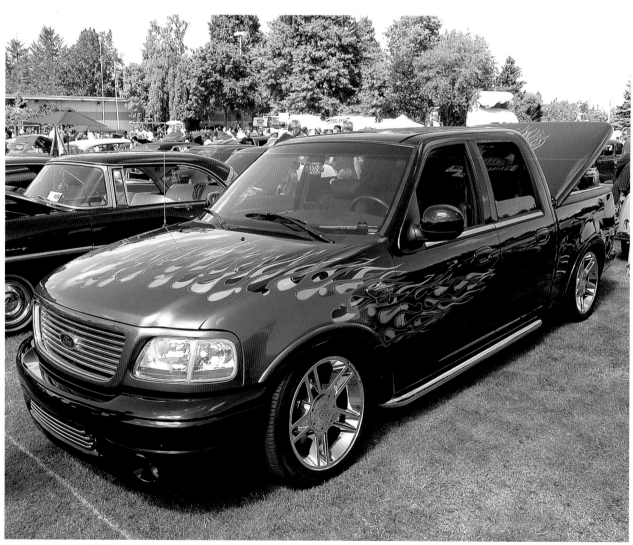

From a distance, this Harley-edition Ford F-150 looks like it has a multicolored flame job with predominantly purple flames.

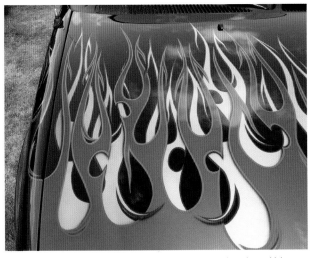

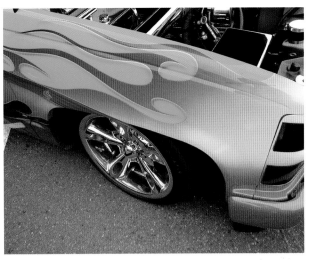

A close-up view reveals that the flames have reverse licks and notches, which qualify them as tribal flames. The silver flames were painted before the purple ones. A lot of taping and masking was required.

Traditional flame colors (yellow, orange, red, and magenta) were used on this Chevy pickup, but licks incorporate nontraditional tribal elements. Extensive use of airbrush shadowing makes the flames appear to float above the fender.

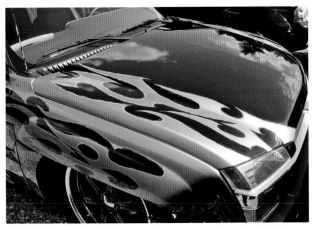

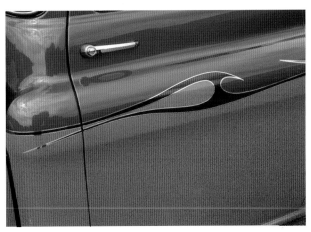

The single-color tribal flames on this truck were done on a large scale, which is fitting for a big truck. The flames were outlined in slash-style pinstriping.

This very wild purple-over-orange '57 Chevy pickup uses a simple tribal flame design to separate the two colors.

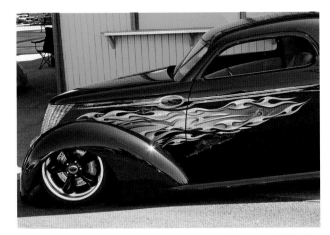

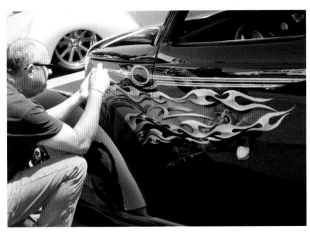

Tribal flames were incorporated into the frenetic design on this phantom '37 Ford pickup. Airbrush highlights were used to simulate chrome.

Modern digital cameras are so small, so affordable, and so good at capturing detailed images that everyone should carry one to car shows. You can take detail shots of interesting paint tricks and use them later for reference and inspiration.

example of this underlying customizing tenet. Tribal flames can be a blend of styles. A traditional flame layout can be made tribal by throwing in a few extra turns and forward-facing points. Some people equate tribal flames with the kind of elaborate designs seen in tattoos. Classifying something as tribal is pretty subjective, but as with all flames, it's the look that counts, not the name.

Once the unique design has been established, layout and masking techniques are the same as with any flames. Custom painter Travis Moore of Olympia, Washington, shared a tribal layout technique that works well for him. He lays out a pretty traditional flame design with 3M blue fine-line tape. Then he comes back and overlays the sharp points, zigs, and zags. This way he maintains a smooth flow to the flames and injects the tribal elements later.

When Travis is satisfied with the additions, he uses his snap-blade utility knife to carefully cut and remove the unneeded sections of tape. With the knife, he can achieve sharper lines

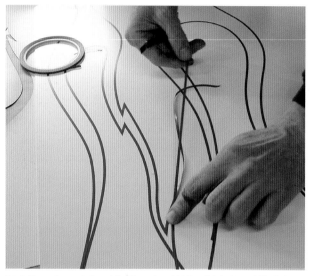

Travis Moore demonstrates a tribal flame layout trick on this test panel. He starts with a pretty traditional design. Then he comes back and tapes over areas to produce the sharp points and other tribal elements. After all the taping is done, he cuts out the unwanted sections with a fresh blade in a stainless snap knife.

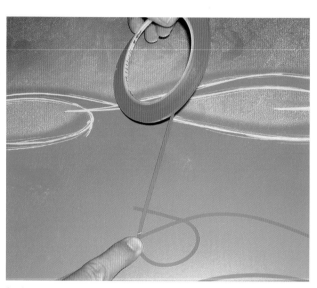

Another tribal flame taping trick involves making forward-pointing tips by inserting small circles inside a traditional flame layout.

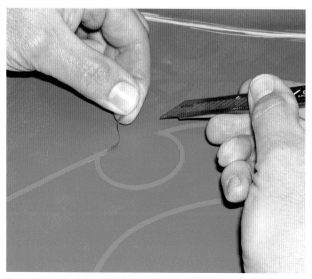

A snap-blade utility knife is used to carefully cut and remove the unwanted section of 3M blue vinyl tape. This process is much easier than trying to form these shapes during the initial layout. Transfer tape can be used to mask these areas.

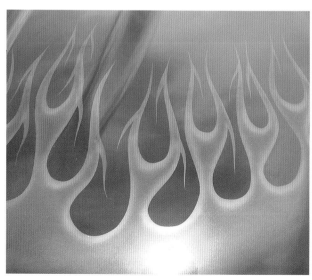

These mostly traditional flames were given a tribal flair with the addition of small reverse-direction barbs.

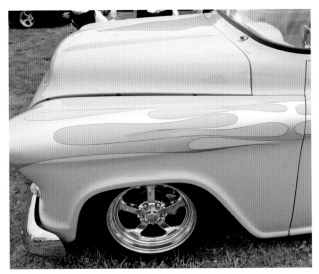

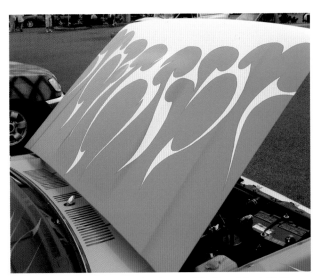

Subtle, tasteful, silver tribal flames were used only along the fender tops and beltline of this pale green '57 Chevy pickup. Copper pinstriping was used.

Simple white tribal flames were used on the nose of this blue minitruck. Slightly darker blue pinstriping helps separate the licks from the rest of the truck.

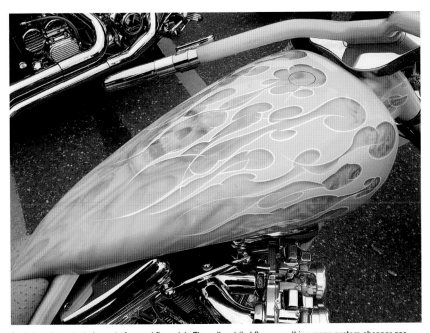

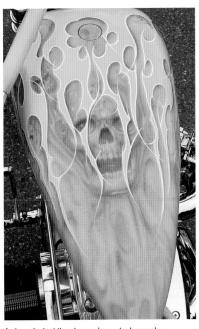

Scale is an important element of a good flame job. The yellow tribal flames on this orange custom chopper gas tank are ideally sized. The colors are complementary.

A closer look at the chopper's gas tank reveals several airbrushed skulls underneath the flames. Faint airbrushed flames also flow toward the back of the tank.

more quickly and easily than if he tried to accomplish it all on the first pass with the tape. This technique might seem like extra work, but Travis claims it actually saves time.

A variation of the cut-and-remove layout technique involves tribal flames that are curvier but still have forward-facing points. The traditional flame licks are designed with fine-line tape. Then a curve is taped inside the lick. That curve connects in two places to the original tape outline. That original section of tape is then cut away, and you have a smooth tribal lick. The front and rear of the "hole" still have a smooth flow, but there is a gap. From a distance your eyes will sense the flow, even though the licks are interrupted by the tribal elements.

Masking off tribal elements can be difficult with traditional masking tape. The solution is to cover these areas with transfer tape and carefully follow the blue fine-line tape with a sharp utility knife. Regular masking tape or masking paper can be added to the areas beyond the flame design.

Chapter 14
Scallops

Scallops are closely related to flames. Scallops can be considered straight flames. In their most traditional sense, they flow from front to back, get thinner as they progress, and end in pointed tips.

The basic design ideas and painting techniques are similar to those applying to flames, although scallops are more regimented. Scallops are derived from race cars and high-performance airplanes. Their visual goal is to imply and enhance motion, two common themes of racing planes and cars.

In their earliest, most traditional form, scallops were quite linear. That is, they went from front to back, with a pronounced taper toward their pointed tips. Since then, the term "scallop" has been used to describe various lines or stripes with generally pointed tips and rounded corners.

Customizers in the 1950s did much to popularize scallops. Besides front-to-back scallops, they also made scallops with more curves and twists. Scallops were used as borders for other custom paint tricks and to follow or highlight a vehicle's styling cues.

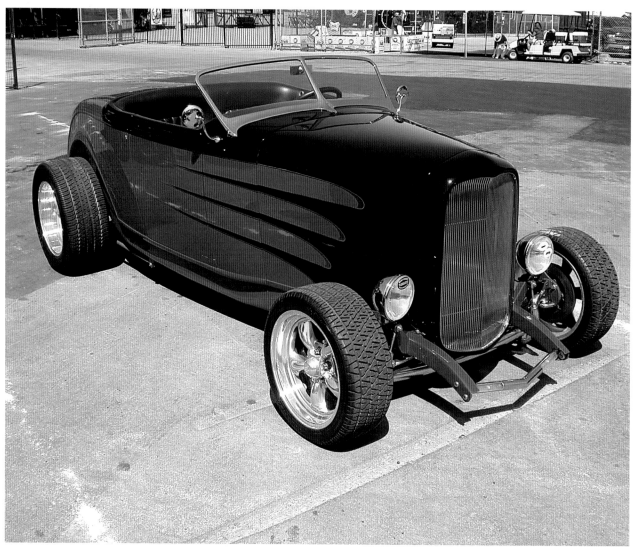

Scallops are similar to flames in that they impart a sense of motion. Good scallops flow well. This '32 Ford highboy looks fast even when parked. The scallops work great with the two-tone paint scheme.

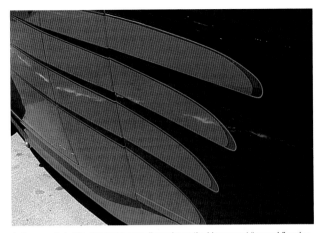

A close-up shot of the '32 highboy scallops shows the blue accent "swoosh" under the main scallops. A lighter blue pinstripe was used to accentuate the scallops.

The flame connection is very evident on this Track T because the scallops are painted in traditional flame colors that fade from white to yellow, orange, and red with blue tips.

A very simplistic but iconic scallop treatment is the bold white nose scallop over red that goes through the windshield and tapers onto the rear deck lid. This signature paint scheme was popularized by the So-Cal Speed Shop on its late 1940s/early 1950s salt flats racers and shop trucks. A thick black border separates the two colors.

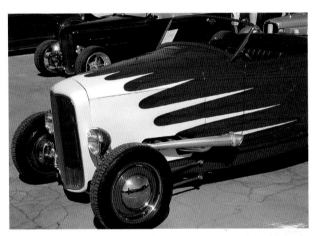

This variation on the white-over-red scallop treatment has a second set of dark red scallops underneath and between the more prominent white scallops.

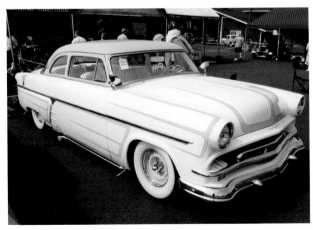

Scallops are popular on traditional custom cars like this '54 Ford. Notice the forward slant of the scallops and how the angles match. Gold pinstriping sets off the scallops.

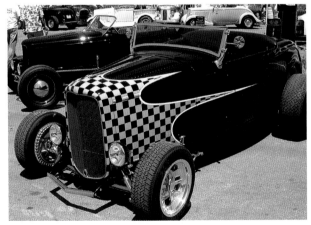

Many early hot rod scallops were influenced by race cars and closed-course racing airplanes. The checkerboard pattern on this '32 Ford highboy roadster amplifies the racing connection.

Scallops are almost exclusively symmetrical. Some 1950s and 1960s customizers experimented with "maze" scallops, which twisted and turned, but those are best considered hybrids rather than true scallops. The symmetrical nature of scallops demands careful measurements and precise layouts. The easiest way to assure symmetry is to lay out one side first. Then make a pattern or use body/trim items as reference points.

Fine-line vinyl tape from 3M is the preferred medium for designing scallops. Taping is quicker than drawing a design with a Stabilo pencil, and it's easier to obtain long, straight lines with tape. The trick is to position the tape

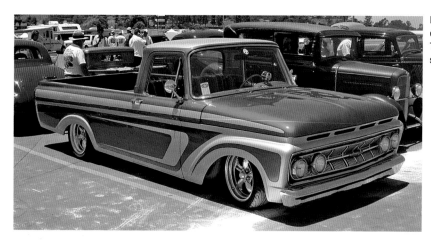

Panel painting, which is beautifully exemplified on this custom Ford unibody pickup, is a variation on scallops. The scallops play off the truck's natural styling lines. The silver contrasts nicely with the candy green.

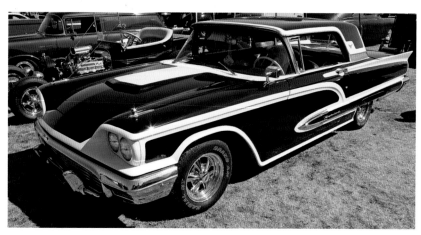

The paint scheme on this "square bird" is a tribute to legendary custom painter Larry Watson. This outlining style of scallops relies on the car's body lines. Watson is credited with inventing panel painting.

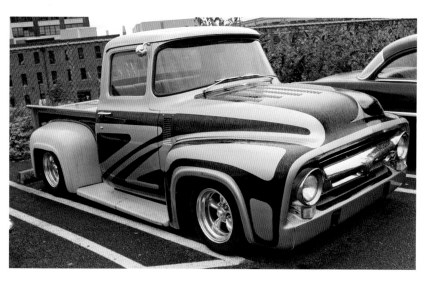

This '56 Ford F-100 custom has a hybrid of scallops and panel painting. Gold and brown are conservative colors, but the design is anything but sedate.

at the front of the scallop and stretch it out to the end. When it looks straight, stick the end of the tape to the body. Make a few reference measurements and sight down the tape to be sure it's straight. When you're satisfied with the straightness, use your fingertip to secure the full length of the tape.

One popular style of scallops uses upper lines that are parallel to the pavement, floor, or ground. The lower line provides the taper. When designing this style scallop, it helps to position all the upper lines first. Then check to ensure that they're straight and parallel. Then the lower line can be started at the rear point and gradually tapered to the front of the scallop.

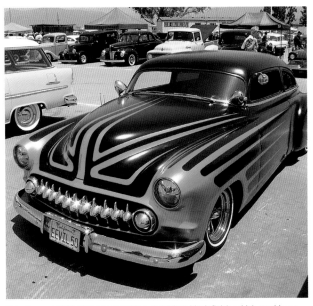

This chopped 1950 Chevy custom has a semigloss black finish, which provides a supercontrast for the wild candy green scallops. The design accentuates the shape of the hood. The staggered start of the fender scallops implies forward motion.

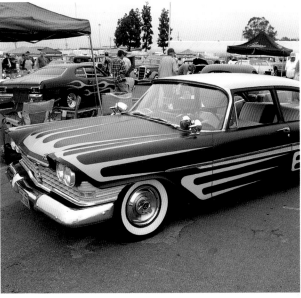

Scallops are an easy way to spice up a budget-mild custom like this '59 Plymouth Savoy sedan. The robin's egg blue contrasts nicely with the black primer. The color scheme was repeated on the upholstery.

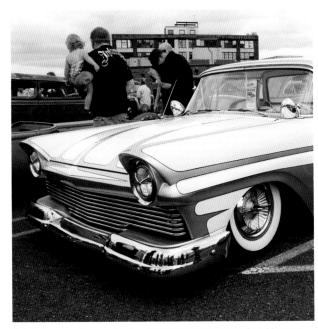

Well-designed scallops can significantly boost the visual impact of a mild custom like this outstanding '57 Ford Ranchero. Note how the scallops accentuate the natural styling lines.

The hood of the Ranchero illustrates a neat trick—a scallop within a scallop on the center of the hood. Black pinstriping works great with the silver scallops and white body.

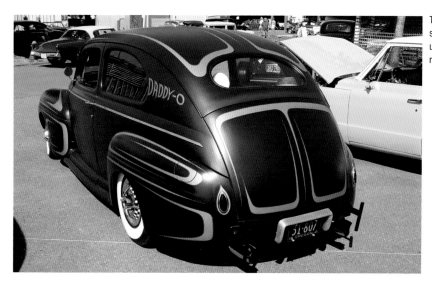

This primered '41 Ford Tudor uses lots of bold gold scallops that go both forward and backward. The scallops use the body shapes for their direction. Red pinstriping really helps the gold pop against the flat black body.

The author built this modified Chevy crew cab dually in 1990. Since the truck was so large, it was decided to place the scallops only on the truck's flanks. The magenta scallops were in the same general color family as the red base. Thin purple secondary scallops were used as highlights.

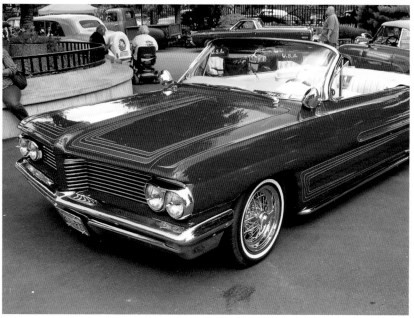

Purple scallops were used to great effect on Bob Jasper's red '62 Pontiac Bonneville convertible. Blue pinstriping was used. Notice how the scallops follow the body lines.

Scallops don't have to overpower a vehicle. Moderately sized red Metalflake scallops were used very effectively around this white Chevy pickup's wheelwells.

The white nose scallops on Mike Hoffman's red oxide primered '33 Ford Tudor go very well with the fenderless race-influenced look. Notice how the scallops flow around the hood louvers.

The scallops on this '48 Chevy custom convertible suggest a late-1950s East Coast influence.

SCALLOPS

The curved parts of scallops are very similar to flames. The curves need to be smooth and flowing, without any interruptions or unevenness.

Some scallops use an underlying shadow for accent. These accents should be taped after the main scallops. Their forward arcs need to match the larger scallops. Some painters use a darker shade of the primary scallop color, while others use black. Silver can be used, with some airbrushed "chrome" highlights, to give the scallops a 3-D look.

Extra care is needed when designing scallops relative to body lines. Curved areas such as fenders can be difficult. The position of a scallop and how it rolls over a curved

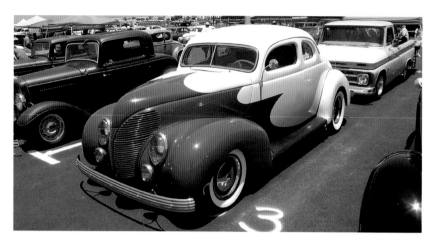

The large purple swoops on this '38 Ford coupe give it a very traditional look that fits perfectly with all the other period touches, such as the DeSoto bumper, '50 Ford hubcaps, and rubber running board covers.

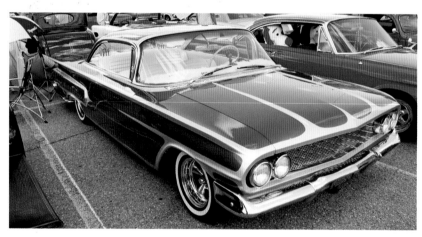

When a car like this custom '60 Chevy is painted a candy color, the silver base coat can do double duty as the scallop color. Pink pinstriping was used.

Here is another example of how a limited number of scallops can work as an effective accent. The three white scallops flow off the white firewall on this Model A coupe.

area impacts the finished look of the design. One trick is to start a layout at the difficult areas. That way, those areas are handled and the design doesn't awkwardly end up there.

A design concern that's common to flame layouts is accounting for the width of the masking tape. When ⅛-inch or ¼-inch tape is used to design the scallops, your eye sees the outer edge of the tape as the extent of the scallops. In reality, the inner edge will be the extent of the scallops. Using two pieces of ¼-inch tape means the actual scallops could be a full ½-inch thinner than you envisioned. Factor in tape width in all custom paint designs.

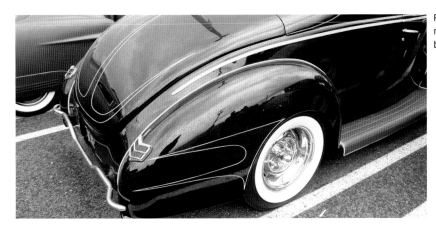

Relatively thick white pinstriping really helps the candy red scallops on this '40 Ford coupe stand out against the black body.

This '60 Pontiac is a rolling showcase of custom paint tricks, including cob-webbing, panel painting, fades, and extensive use of Metalflake. Scallop-type designs are used on the rear fenders and hood to separate light and dark color panels.

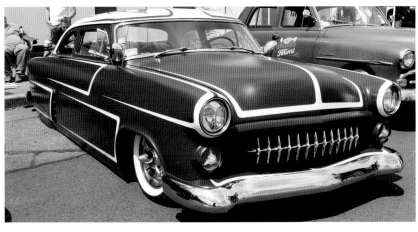

Long thin white scallops add a sense of length to this already superlow, chopped-top custom '52 Ford. The white roof has flames and red scallops.

Chapter 15
Special Effects

Custom paint flames are like ice cream. You've got the always-popular vanilla, chocolate, and strawberry (yellow, orange, and red), but beyond that are every flavor and color combination imaginable. Special effects are the extra toppings and mix-ins of flames.

Color variations are a basic way to produce unique and distinctive flames. This subject was discussed in Chapter 2. Within color variations are a myriad of textures and designs within designs. A good example is the use of subtle, realistic flames within the boundaries of traditional rigid-border flames.

Airbrushes and touchup guns are ideal for creating special effects. Shadows, shading, and textures can all be created with an airbrush. Some of the best special effects are the subtlest. We call them head snappers or double takes because you don't notice them at first. But when you do, they're very impressive.

A good way to learn about special effects is to study cars, trucks, and motorcycles at shows. The more you learn about how custom paints work, the easier it will be for you to figure out how a trick was executed. You can also ask owners, as most are happy to talk about their rides.

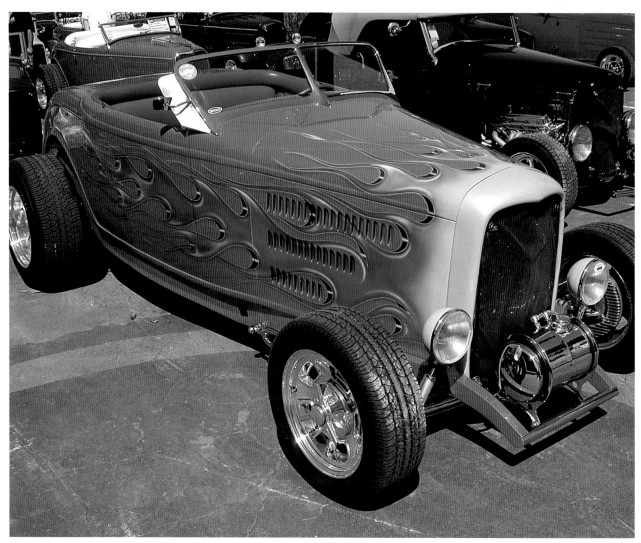

This '32 Ford highboy roadster illustrates several special effects, including shadowing, 3-D, overlaps, highlights, and blending.

Many "big name" painters used to claim/imply/suggest that their spectacular paint jobs were partially due to "secret" techniques or paint formulas. However, other painters are too talented for any "secret technique" to remain proprietary very long. The point is that natural artistic talent, hand to eye coordination, and experience is more important than any technique or secret paint formula.

SHADOWS AND BODY COLOR FLAMES

Shadows give depth and definition to flames. Shadows are most commonly used where flame licks cross. Drop shadows make the upper lick appear to float above the lower one. Some painters place shadows along the entire length of the lick. That gives the whole flame the appearance of floating above the base color.

The most common method of creating shadows is to spray diluted black paint underneath the flames. The idea is to create a shadow where light would make one if the flames were 3-D. A product that works well for black shadows is House of Kolor Basecoat Black (BC- 25). To make the black more transparent, it should be over-reduced. Real shadows aren't always perfectly black, so transparent black works very well.

Shadows using a variation of the flame's color also work well. With House of Kolor Kandy or Shimrin Pearl paints, you can use the same color in HOK Kandy Koncentrate. The Kandy Koncentrate is mixed with HOK Intercoat Clear (SG-100). The result is a highly transparent version of the main color.

A good reason to use variations of the flame color for shadows is that real shadows aren't black. You're seeing the underlying color, but without as much light as on a flame that supposedly receives full light.

People say that something casts a shadow, but the truth is that some of the light is blocked. The color you see in the blocked area is the difference between viewing it in direct sunlight and at dusk. If you grasp this concept, it should make shadowing more understandable.

Since real shadows usually depend on a single light source, that concept should be applied to flame shadows. Determine where the hypothetical light source is and treat all the licks the same. If the "light" is at the top of the vehicle, the shadows should be on the lower side of the flame licks. Consistent shadows are the most realistic.

The light source concept is the trick behind body color flames, which are made without changing the vehicle's base color. An airbrush is used to draw the outline of flames. The tops of the flames are done in white, pearl, or another light color. The undersides of the flames are done in a darkened shade of the main body color. The result is flames that appear to rise above the base paint but are the same color. The success or failure of this technique depends on getting the light source and corresponding shadows right.

Some flame jobs go beyond what is normally visible. This '33 Ford coupe's painter went to a great deal of extra work by running the wild flame licks through the door jambs.

This very subtle drop shadow is used only where one lick overlaps another. The shadow almost blends into the fogged orange paint around the inner curve of the flame lick.

A very creative use of shadows is seen on this red car. The black shadows start tight to the bottom of a lick, veer off, and get farther away from the lick as they approach the tip of the flame. This effect gives an exaggerated sense that the flames are floating above the surface.

Shadows aren't mandatory for flame licks that cross over. These bright flames have lots of crossovers but no shadows. The flames appear flatter to the surface, but they still look great. Notice how the Process Blue pinstriping helps the flames pop off the black base.

In this example of drop shadows on a black vehicle, the shadows were placed only where the licks crossed over the orange and yellow areas. You can't have a shadow on black paint.

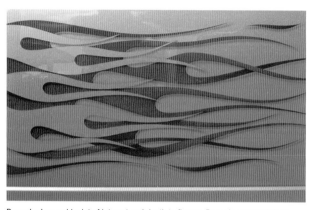

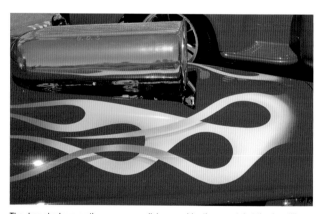

Drop shadows add a lot of interest and depth to flames. Properly executed drop shadows give a 3-D look. This excellent example shows how versions of the main colors were used for the shadows instead of black. Where the magenta licks overlap the orange, a darkened shade of orange was used for the shadows. Where the orange licks overlap the magenta, a purple hue was used for the shadows.

The drop shadows on these crossover licks are wider than most, but they're still very effective. The shadows are all done as if the light source were above the flames. Maintaining a consistent light source is key to realistic shadows.

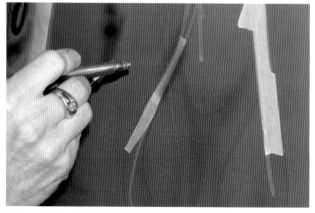

When making black shadows, it's a good idea to dilute the black paint so that it's semitransparent. House of Kolor Basecoat Black (BC-25) works well mixed with Intercoat Clear. Notice how thin the paint looks on the mixing stick.

Travis Moore used the diluted HOK black to put shadows on some crossover flame licks. Because the flames are very thin where they cross, he taped the flames to protect them while he airbrushed the shadows. Airbrushes are great for shadows because you can gradually build up the amount of paint and intensity of the shadow.

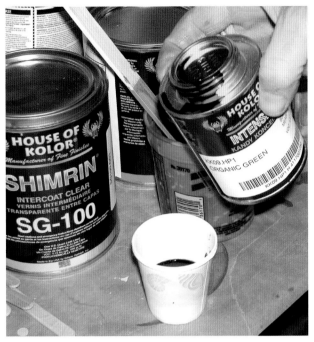

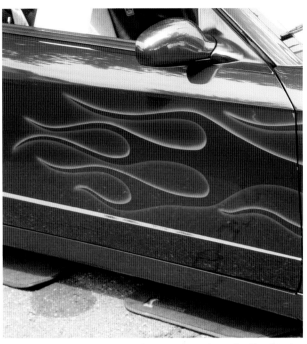

House of Kolor Kandy Koncentrate intensifiers come in the same hues as popular HOK Kandy and Pearl colors. You can make excellent color-coordinated shadows by mixing the appropriate Kandy Koncentrate with Intercoat Clear. Instead of removing the pressed-in protective seal, Travis Moore pokes a small hole with an awl. Because he uses only a small amount of Kandy Koncentrate at a time, he just dribbles some into the mixing cup.

The blue flames on this Mustang are the same color as the car. An airbrush and clever use of shadows makes the flames stand out. Diluted shades of blue were used, with the darker shading on the bottoms of the licks and the lighter shades on top.

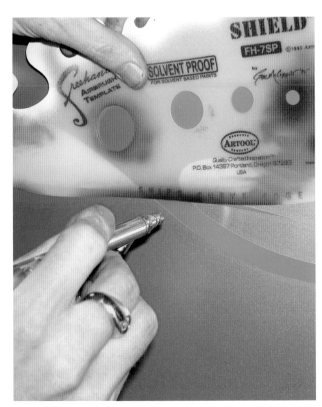

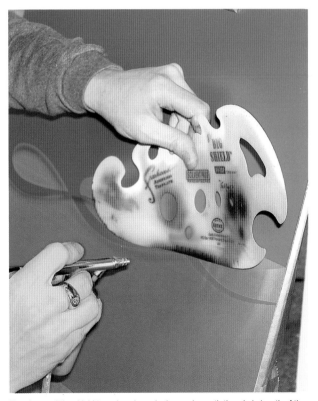

Travis first used the darker green paint and his handy Artool stencil/shield to make drop shadows where the flame licks cross each other.

Then he used the shield to make a long shadow underneath the whole length of the flame lick. A shield can save a lot of time when doing shadows.

3-D FLAMES

When the inner curves are accentuated, flames can appear 3-D. The basic idea is to paint an extra arc in the curved areas of the flames. The arc looks like a crescent shape, with the convex and concave edges terminating in points. The thickness of the crescent and length of the points affect the 3-D look.

The arcs or crescents are frequently done in shades of black, gray, and silver. They're supposed to be a shadow or made to look as if the flame is part of a chrome emblem. Airbrushed light streaks or reflection spots are used to reinforce the chrome or metal look.

Three-dimensional arcs are most often pinstriped on both sides of the arc. The striping further defines the depth. Sometimes only the line between the flame color and the arc is pinstriped. Some painters do arcs without any striping. It's a matter of choosing the technique that looks best to you.

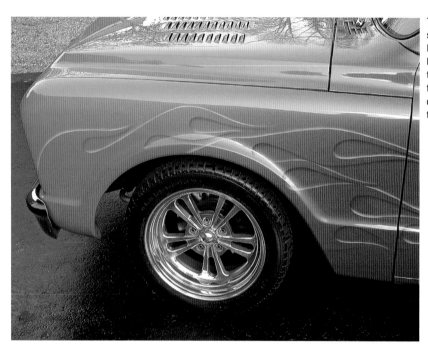

The flames on Mike Hoffman's '68 Chevy pickup are the same House of Kolor Sunset Pearl that Chris Odom of Extreme Metal and Paint applied to the rest of the truck. Mike Lavallee airbrushed light and dark highlights to give the illusion of flames. A white outline was airbrushed on the top side of the licks; a dark orange outline (or shadow) on the bottom side. Notice that the colors change just past the midpoint of each curve.

Curved 3-D inner shadows were used on these tribal flames to provide an enhanced sense of depth. The bright green pinstriping really pops the magenta flames against the yellow body.

These flames separate a two-tone paint scheme. The flames are slightly darker than the orange top color. Gray arcs on the inside of the curves give a 3-D look to the flames. These arcs weren't pinstriped, but many painters do stripe them for added definition.

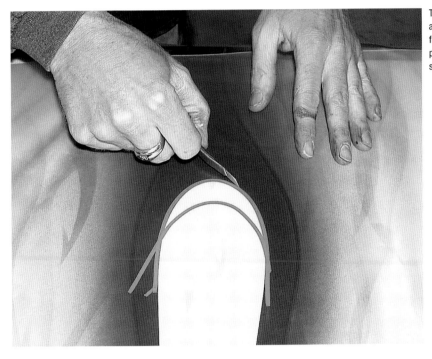

Travis Moore demonstrates how to make 3-D arcs on a test panel. He uses blue fine-line tape after the main flame has been painted. He uses silver, gray, or charcoal paint in an airbrush to shade the arc. He sometimes adds small white or silver highlights to simulate a reflection.

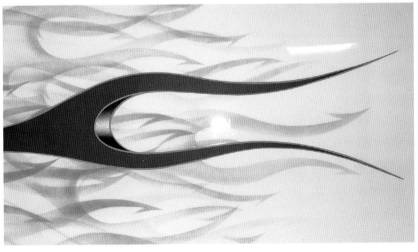

Here is the finished test panel. Travis used white paint with a little pearl added to airbrush the "reflection" in the center of the arc. He pinstriped the arc with lavender striping paint the way he did the rest of the flame. The pinstriping helps accentuate the taper at the top and bottom of the arc.

MARBLING TEXTURES

Marbling or marbleizing is a technique that encompasses a variety of effects. The effects mimic the veins in marble, but marbleizing products can be manipulated to achieve many different looks.

HOK's Marblizer comes in neutral (clear) and colored versions: silver-white, gold-blue, red-red, blue-pink, lilac-lilac, and green-blue. Any of the four dozen or so HOK dry pearl powders can be added to neutral Marblizer to create special effects.

The way HOK Marblizer looks also depends on the base it's sprayed over. Black is commonly used, but any of the many Shimrin bases can be used. Black pearl base is a good color for extra sparkle. Marblizer must be applied over a base color. The base color needs to dry for 15 to 30 minutes before Marblizer is applied.

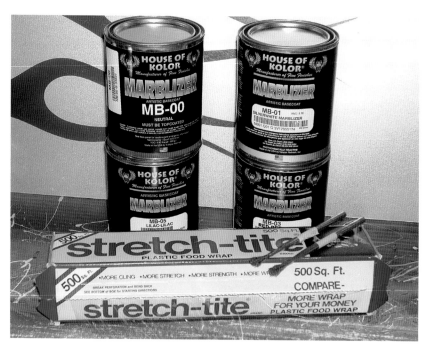

House of Kolor Marblizer is called an artistic base. It's sprayed over another color and manipulated while wet. Plastic food wrap is the most common item used to give a wrinkled, veined look to the underlying paint. Aluminum foil can also be used. Inexpensive metal utility brushes can be used to draw designs in wet Marblizer.

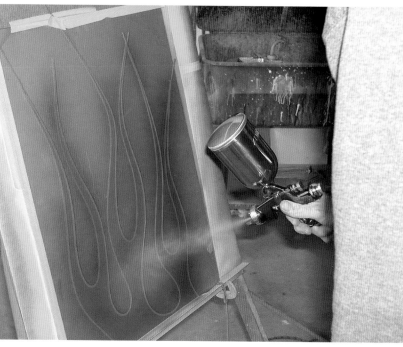

Travis Moore demonstrates how to use House of Kolor Marblizer basecoat to apply a unique textured look to some test panel flames. The design was done with blue fine-line tape covered with transfer tape, cut out with a snap-blade utility knife, and base-coated with HOK Shimrin Orion Silver (FBC-02). HOK Shimrin Majik Blue Pearl (PBC-37) was applied with an Iwata LPH-100 spray gun.

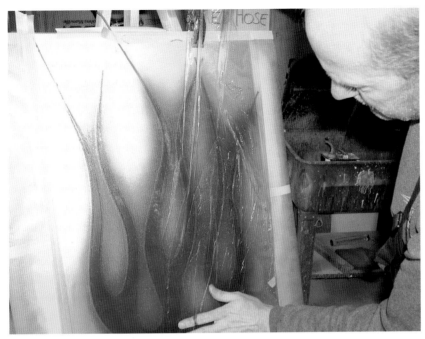

The Majik Blue Pearl dried for 30 minutes before being covered with one wet coat of House of Kolor Neutral Marblizer (MB-00). Then a wrinkled piece of plastic wrap was placed over the wet Marblizer. The wrap was removed, leaving a subtle veined look that is similar to real marble. Plastic wrap can be manipulated to make different effects.

Marblizer can be difficult to see in photos, but it looks trick in person. A great number of special effects can be done with Marblizer depending on the colors used and the medium used to manipulate it. Dry pearls and flakes can be mixed with neutral Marblizer. HOK Marblizer also comes in colors.

HOK Marblizer is ready to spray; just stir well and strain. Apply Marblizer only to an area you can work with in a few minutes. Plastic wrap is the most frequently used medium for manipulating Marblizer. It needs to be applied about one to two minutes after the Marblizer is sprayed. If the Marblizer dries, it won't work.

The way the plastic wrap is manipulated determines the finished look. The simplest way to use plastic wrap is to let it wrinkle as it's placed on the wet Marblizer. Other techniques include stretching the wrap and patting the stretched section on the Marblizer. The wrap can also be wadded up and touched to the Marblizer.

Other items can be touched to or dragged through the Marblizer. Cheap, coarse-bristled acid brushes work well for "drawing" textures. Bubble wrap, aluminum foil, feathers, and natural sponges have all been used successfully to manipulate Marblizer.

Marblizer must be clear-coated, and you can also apply various candy colors over the Marblizer before clear-coating. The use of candy colors below and above the Marblizer increases the number of possible effects.

FADES AND BLENDING

Fades and blends are a traditional part of flame painting. The idea is to make one color fade or blend gradually into the next. Seamless fades are a mark of talented painters.

One popular style of fading is to have the nose of the vehicle the same color as the main body. The flames gradually start a foot or two back from the nose. The first color starts off very lightly and gradually gains intensity before fading into any additional colors. A very light and controlled trigger finger is needed to do perfect fades.

If too much paint gets on the leading edge of the fade, the look is ruined. Any blotches or loading up on body seams also detract from the desired effect.

Fades are easier to do around the inner curves of flames. The idea is to simulate a stylized high-intensity area within the flames. Contrasting colors are frequently used for these fades. Smoothly tapered fades look much better than ones that stop abruptly.

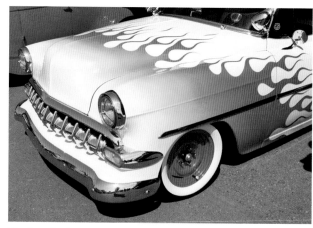

Blending or fogging one color into the next is a difficult but time-honored facet of flame painting. It takes considerable skill with a spray gun to make seamless fades/blends. This '54 Chevy has a very gradual blend, from very pale yellow (almost white) on the bumper splash pan to progressively darker yellow to light orange and finally dark orange.

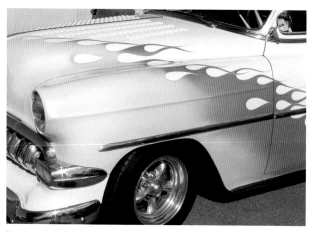

Here is a similarly flamed '54 Chevy. This car has more white pearl on the nose, and the yellow extends past the wheelwell before fading to orange. The two cars illustrate how similar yet varied flames can be.

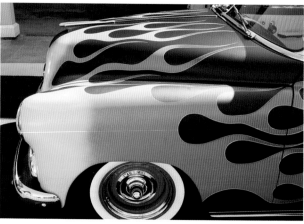

A clear top coat can help blend the overspray generated when fading colors. This primered '51 Chevy has a rather distinct transition between yellow and orange because it doesn't have a glossy top coat.

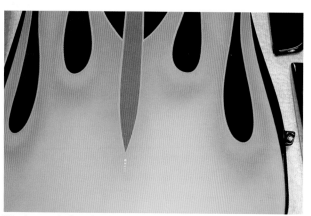

This close-up of a flamed engine cover shows how the orange licks were smoothly blended into the primary school bus yellow. A small amount of pink was blended into the orange near the inside curves.

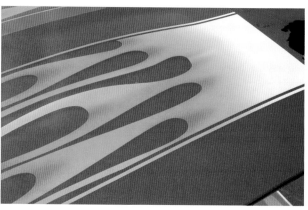

Flames were placed within the hood stripes on this first-generation Camaro. Yellow was skillfully blended into the white, both on the main part of the stripes and on the thinner outer stripes. Orange was fogged out from the inner curves.

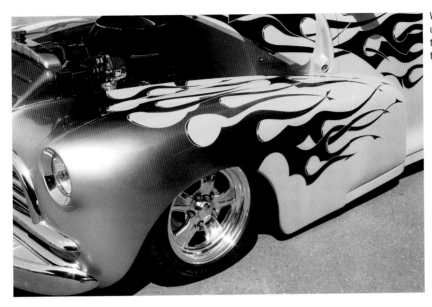

When candy flames are sprayed, base silver or gold can be used as the leading color, as seen on this '46 Chevy with tribal flames. The candy magenta main color was smoothly fogged from silver to light magenta to full strength.

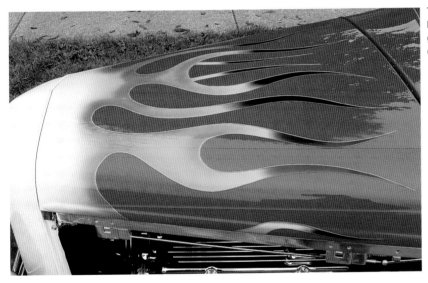

The flames on this '32 Ford roadster feature lots of color blends. The most unusual one is the small amount of green that goes between the main orange licks and the dark blue tips.

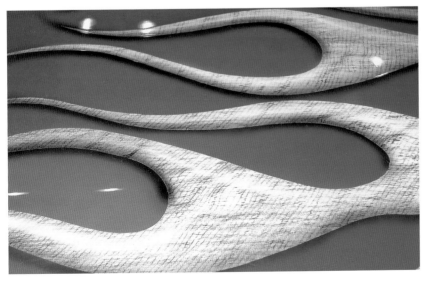

Any texture you can imagine can be used inside flames. These unique flames were made to resemble carbon fiber. Drywall repair or seam tape (the woven kind—not the solid stuff) can be used to simulate carbon fiber. A blue base was applied to these flames. Then they were covered with the drywall tape, and white was sprayed. Removing the tape leaves the underlying blue grid. The edges of the flames were shaded dark blue to give a 3-D look.

GOLD AND SILVER LEAF

Gold and silver leaf can give a unique look to entire flame jobs or to just the tips of flames. Gold leaf is most commonly used as a highlight material, but it can be used for entire flames. Gold leaf works best for small flames.

Gold leaf, available at art supply stores, comes in different colors. The color of the "veins" is the main difference. Gold leaf is very thin and fragile. It comes in little booklets with wafer-thin sheets.

Sizing (a special glue) is brushed where gold leaf is desired. Wherever the sizing goes, the gold leaf will stick. The gold leaf is gently pressed to the sizing and then lightly burnished (rubbed). When it dries, excess material is brushed off.

A clear coat is used to protect the gold leaf. Pinstriping is used, because it helps seal the edges and covers any raggedness.

SKULLS AND OTHER IMAGES

Skulls, Tiki images, animals, words, and virtually anything else you can imagine can be worked into flames. These additional elements are most often seen within realistic flames. The objects can be buried deep in the flames, or they can be more prominent and serve as leads from which flames emerge.

Stencils are the key to making easy skulls and other objects. Companies such as Artool make solvent-proof stencils with a large assortment of designs and sizes. Stencils make repetition easy.

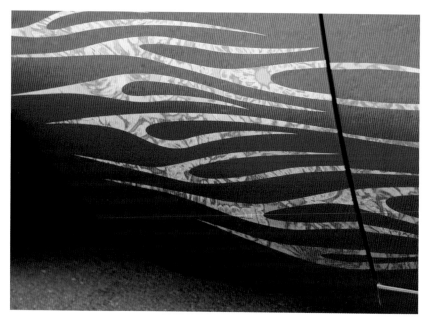

Variegated gold leaf was used to make this series of thin, delicate flames along the lower front fender and door of a custom '49 Plymouth. Gold leaf is sold in fragile sheets at art supply stores. You secure it by pressing it onto a brush-on sizing (glue) within the flame design. A clear top coat protects the gold leaf. These gold leaf flames weren't pinstriped.

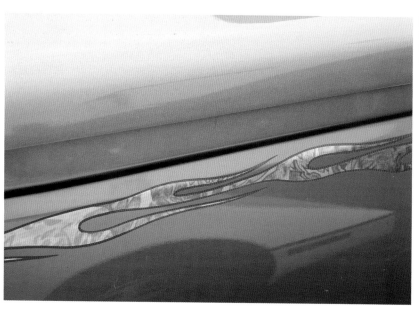

A thin band of gold leaf flames makes a great beltline design or a border between the colors of a two-tone paint scheme. These gold leaf flames were pinstriped in orange for added definition.

Skulls are quite popular as an added design element on realistic flames. The custom stripes on this Z/28 Camaro look almost solid from a distance, but closer inspection reveals first the realistic flames and then skulls within the flames.

Several interesting special effects were used on the flame band that separates the orange and silver two-tone paint on this early Nova. A skull stencil was used to spray black partial skulls in a random orientation within the flame licks. Lime green slash pinstriping delivers an extra punch.

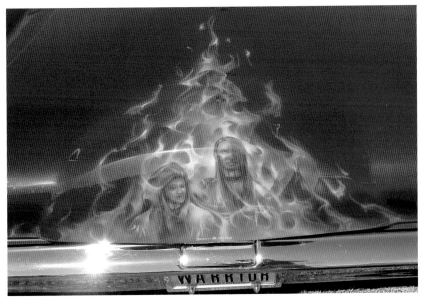

Skulls aren't the only things that can be incorporated within flames. Animals or people can also be used, but they require true airbrush artistry, as seen here in one of Mike Lavallee's creations.

FAUX PATINA

The well-worn, faded-paint look of barn finds and rat rods has become very popular—so much so that many painters purposely distress perfectly good paint.

Real patina comes from years of wear. Multiple layers of paint are worn away and faded from years of hard use and exposure to the elements. Fake patina can be achieved by building up thin layers of paint and artistically rubbing off sections. Study old trucks to see which areas typically have the most wear. Tops of fenders and hoods, roofs, bed rails, areas around door handles, and edges of styling lines typically exhibit the most wear.

The faux patina look would work well for flames on a primered vehicle. The faded flames could be traditional red, yellow, and orange or just different shades of primer. On a primered car, aerosol spray paints can be used, because a smooth, glossy finish is not the goal.

A touchup gun or larger airbrush works well for creating faux patina, since only thin coats of paint are needed. Once the paint dries, it can be worn down with either fine-grit sandpaper or carefully applied rubbing compound. Use light pressure and go slowly so that the layers of paint are exposed at peak "wear" areas.

Faux patina techniques are popular for creating weather-worn fictitious shop names on rat rod trucks or sponsorship names on pseudo race cars.

You can give primered or weathered vehicles equally distressed flames or lettering by making a faux patina. Inexpensive spray paint can be used to simulate layers of worn paint.

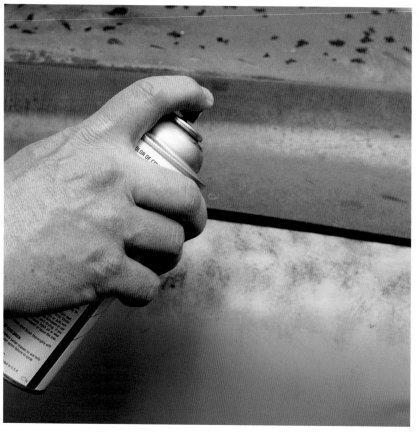

The layers of paint can be misted on or even splattered with a partially clogged nozzle. More paint than needed should be applied so that there is plenty to sand through.

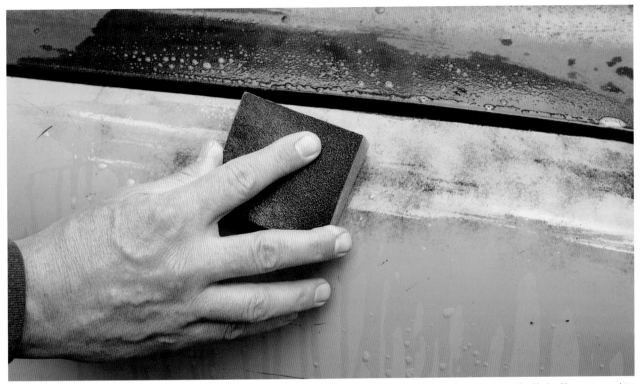

The layers of spray paint should be gently wet-sanded to give a worn, weathered look. Regular sandpaper and a sponge can be used, or a sanding block with a sponge center, as shown.

These flame tips on a primered truck illustrate how sanding can be used to create blends between colors.

Chapter 16
Finishing Touches

A great flame job is more than designing, masking, and painting. The finishing touches of clearing, color-sanding, and buffing are essential ingredients of a perfect flame job.

Unless you've decided to apply 1 Shot roll-on flames, you're going to need a protective clear top coat. The clear does more than protect the underlying paint; it adds depth and shine. Clear is very important to candy and pearl paints; it's what makes them sparkle. Clear is also an obvious part of a base-coat/clear-coat paint job. Without the clear, you might as well be shooting primer.

Pinstriping can be done before or after clearing. Traditional enamel striping paint, such as Sign Painters' 1 Shot, must be applied on top of the clear. House of Kolor's urethane striping and lettering enamel can be applied underneath the clear. The benefit of using the HOK striping paints is that the surface will be totally smooth.

Proper safety precautions should be observed in all phases of flame painting, but spraying clears requires extra care. Many clears use isocyanate-based catalysts for the hardening process. All urethanes are toxic, but isocyanates are the worst; this is some really nasty stuff. They can enter your body through your skin as well as your lungs. Carefully follow all manufacturer's safety instructions.

If you don't have a properly ventilated work area and all the necessary personal safety gear for spraying clear, it would be wise to have a professional body shop handle this task. Your long-term health is worth far more than any paint job.

There are a variety of clear products. Companies like House of Kolor offer several different clears. Consult company literature or your local paint retailer to determine the best product for your application.

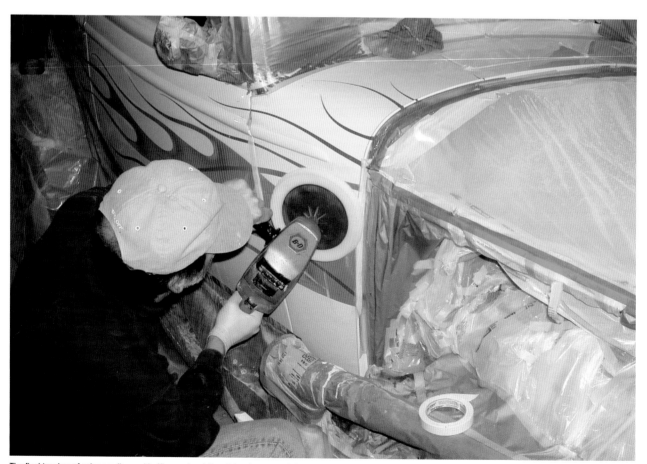

The final touches of color-sanding and buffing are hard, time-intensive, messy jobs. Any areas not being buffed need to remain fully protected.

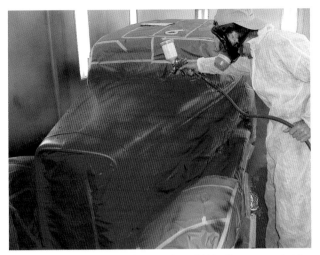

A clear top coat is a key element of most modern paint jobs. Clears are wonderful products, but they can be very toxic. Follow the manufacturer's safety precautions. Donn Trethewey is shown applying clear to the flames on Jim Carr's '35 Chevy.

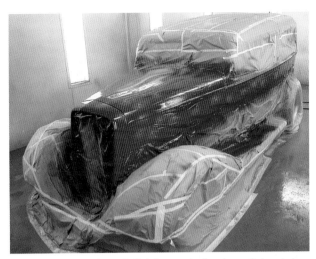

The Chevy looks pretty shiny as it sits in the spray booth and cures. A closer look would reveal a less-than-smooth surface, which is why the clear needs to be wet-sanded and buffed. Notice that the car is still fully masked and taped to the floor.

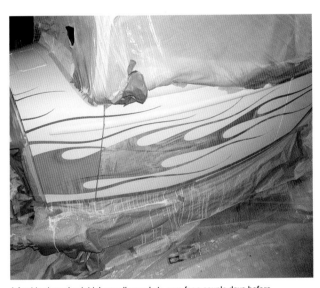

A freshly cleared paint job usually needs to cure for a couple days before color-sanding. Follow the paint manufacturer's curing directions for best results. The plastic masking material helps contain the sanding mess.

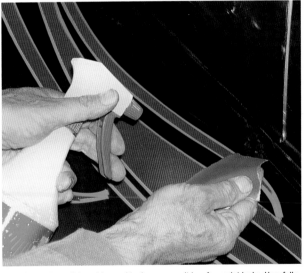

Even the most careful masking and taping can result in a few paint leaks. Hopefully, the overspray is minor and can be sanded off with water (in a spray bottle) and a gentle application of 1,500-grit sandpaper.

Once the clear has been applied and properly cured, the real grunt work begins. No matter how talented the painter is, there is bound to be some orange peel (irregularities on the surface of the paint) in the clear coat. Color-sanding (even though the residue should be a milky white) takes down the high spots and leaves a nice smooth surface. If you see color when you're wet-sanding clear, you've sanded through the clear to the color coats. That's not good.

The basic concept of wet-sanding and buffing is to gradually reduce the grit size until there is virtually no grit. This process uses ever-finer grits to remove the tiny scratches caused by the previous step.

Wet-sanding or color-sanding (different names for the same process) isn't applicable to all brands and types of paint. Consult the manufacturer's directions before wet-sanding. On total repaints, such as the black '35 Chevy that appears throughout this book, the black paint was wet-sanded before the flames were applied.

Jim Carr's chopped '35 Chevy sedan was painted base-coat/clear-coat black by Terry Portch at Kimbridge Enterprises in Clearview, Washington. The clear coat was wet-sanded with 1,500-grit paper. That smoothed the paint but left it looking very dull. If any shiny areas remain, that means more sanding is necessary. The fresh black paint looks like primer in the photos, as it should.

Donn Trethewey designed and painted the red, orange, and magenta flames with base-coat/clear-coat paint. Since the whole car was going to be clear-coated, Donn applied only one coat of clear over the flames. If you're just clearing the flames, follow the manufacturer's instructions. Generally, two to four coats of clear are required. You don't want unnecessary buildup, but you want enough coverage to allow for sanding and polishing.

After the flames were dry and all masking materials were removed, Terry cleared the entire car with four coats. The car sat for a couple days before wet-sanding. The fenders, hood, and running boards were removed for better access. A sanding block was used, even though the 2,000-grit paper

almost doesn't feel like sandpaper. The block or sanding pad prevents finger grooves.

A small amount of common dishwashing detergent in the water bucket will minimize sandpaper clogging. It also helps to soak the sandpaper and sanding block in the water bucket for a few minutes before you start sanding. Be certain that the sandpaper is labeled "wet or dry."

Throughout the wet-sanding process, it's important to check your progress. A clean, soft cloth and a rubber squeegee are needed. As long as the surface is wet, it will appear shiny. By using the squeegee to wipe off most of the water and the cloth to finish the job, you can spot areas that need more sanding.

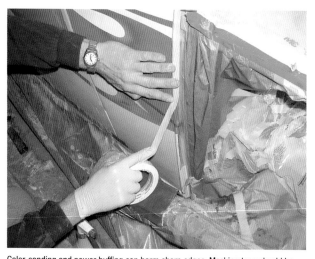

Color-sanding and power buffing can harm sharp edges. Masking tape should be used to protect vulnerable areas. These areas can later be hand buffed.

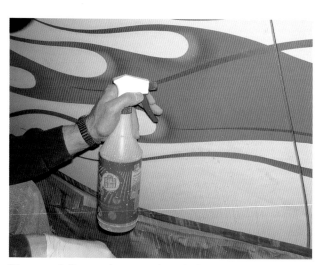

Either a spray bottle or a wet sponge can be used to keep the surface lubricated with water during the color-sanding process.

Ultrafine sandpaper, 1,500- or 2,000-grit wet/dry, is used to wet-sand clear. Check the manufacturer's directions to determine the proper grit. A little dishwashing detergent in the water bucket helps keep the sandpaper from clogging. The paper should still be replaced frequently.

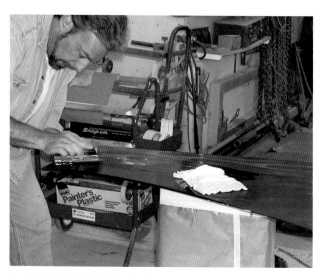

Terry Portch of Kimbridge Enterprises disassembled as much of the car as possible to make the wet-sanding process easier. He removed the hood and front fenders. Raising the parts makes the task easier on your back.

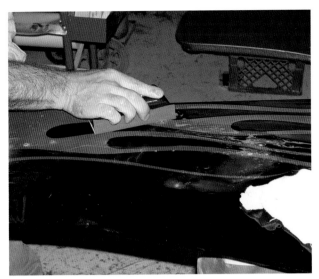

A sanding block should be used to keep the sandpaper flat and to prevent finger gouges. Keep a squeegee and a clean cloth handy to periodically wipe away sanding residue and to check for areas that are still shiny. Notice that the residue has a milky appearance. It shouldn't be colored.

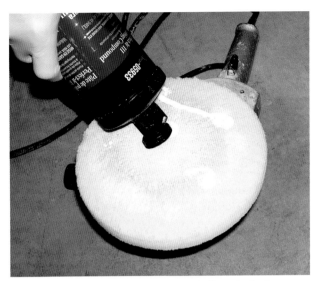

Liquid polishing compound from 3M is applied to the buffing pad rather than squirted directly on the car. The polishing compound is lightly smeared on the surface for the first pass. That helps prevent big globs of compound from flying all over the place.

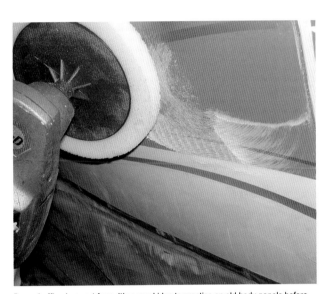

Power buffing is an art form. It's a good idea to practice on old body panels before committing to a freshly flamed car. A power buffer in the wrong hands can do more harm than good.

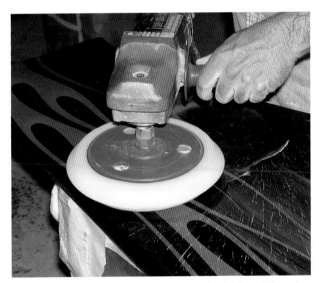

A variable-speed electric buffer is used with a foam pad and various rubbing and polishing compounds during the long buffing process. The buffer must be kept moving at all times to avoid "burning" the fresh paint.

There are black and red rubber squeegees. The black ones are typically used for applying spot putty. Use red rubber during the wet-sanding process, because the black ones can leave noticeable marks.

Once the whole surface is dull, all traces of sanding residue should be flushed away. Buffing and polishing are next in the process. The terms "buffing" and "polishing" are often interchanged. They both refer to using various chemical compounds with a power buffer to increase paint's smoothness and shine. Technically, buffing comes first and uses coarser-grit products. Polishing is the last step. It removes any remaining minute scratches.

Buffing a paint job (sometimes also known as rubbing out the paint) is a specialized skill. A heavy power buffer in the hands of an inexperienced person can do more harm than good. An improperly used buffer can burn through the paint. Burning through a solid color isn't easy to fix, but burning through multicolored flames can be a nightmare. A good buffing job can take a full day of hard work. This is another one of those tasks you might wish to farm out.

Terry Portch likes the 3M Perfect-It III system. It's a stepped system that uses different colored buffing pads to go from heavy to medium cutting compound, to light to soft polish, to a final finish compound. Buffing and polishing is a very messy job, so anything that isn't being buffed should be protected with plastic or masking paper.

The various compounds shouldn't be allowed to dry. Dried compound can damage fresh paint. Wipe off any excess compound with a clean, soft cloth.

Terry uses a variable-speed electric polisher that he typically runs in the 800- to 1,100-rpm range. He works a relatively small area at a time, always keeping the buffer moving. If you stop in one area or apply too much pressure, you stand an excellent chance of burning through the clear or the paint.

Another warning: be extra careful around panel edges or styling lines. Tops of fenders, door edges, and trunk edges should be taped off to protect them from the buffer. Position the buffer's cord so that it doesn't contact the vehicle.

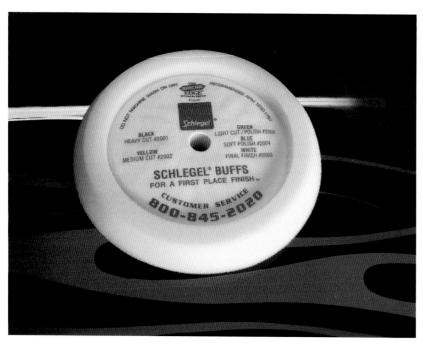

Total buffing and polishing systems consist of graduated compounds and different texture pads. This yellow foam pad is for the medium cut step.

This "before" and "after" split shot shows the wet-sanded dull finish on the left and the glossy buffed finish on the right.

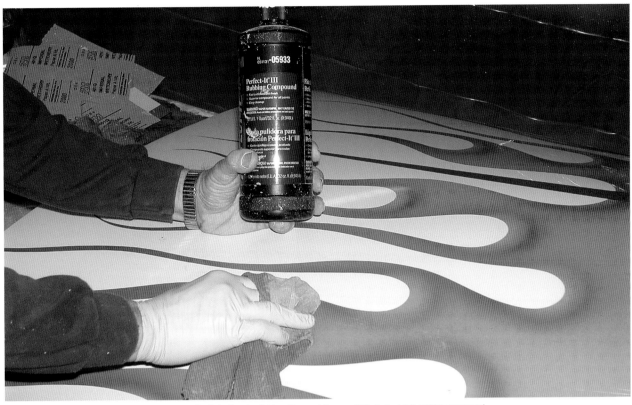

If necessary, you can buy compounds designed specifically for hand polishing. Many painters use 3M's Perfect-It III rubbing compound.

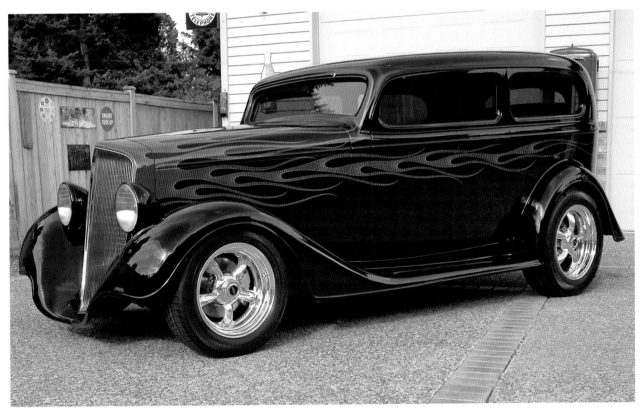

The finished flames on Jim Carr's 1935 Chevy sedan have a jewel-like shine after color-sanding and power buffing.

Chapter 17
Flame Idea Showcase

Hot flame ideas are everywhere, and as with real flames, one little creative spark can ignite a lot of big ideas. Take a look at the following images and see if they fan your imagination.

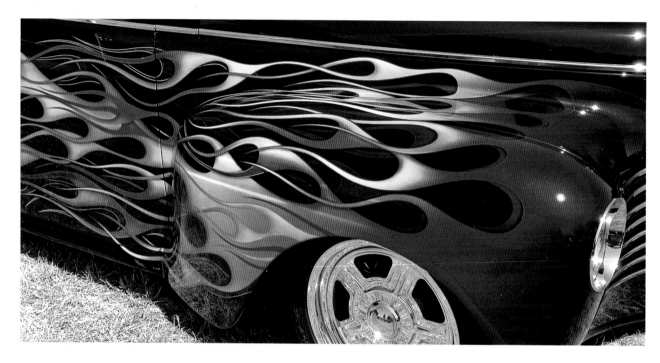

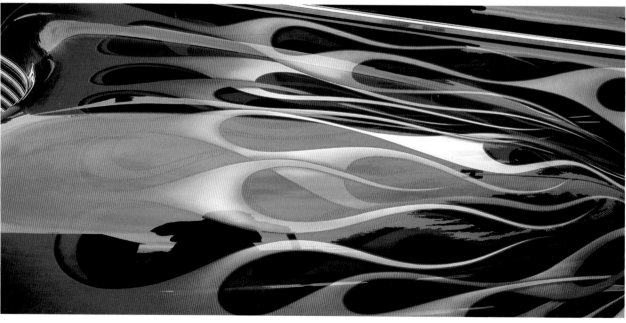

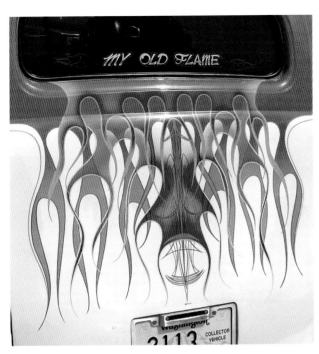

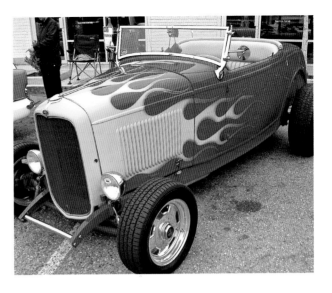

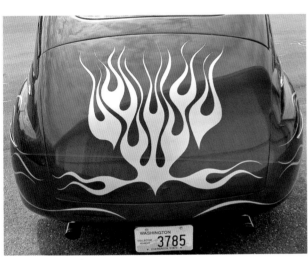

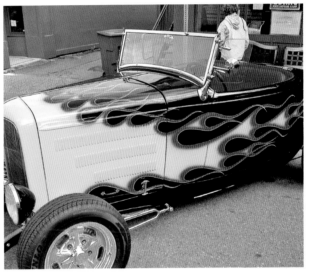

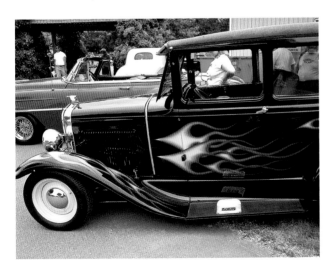

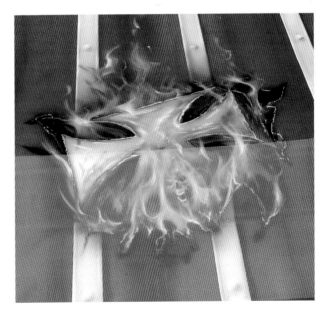

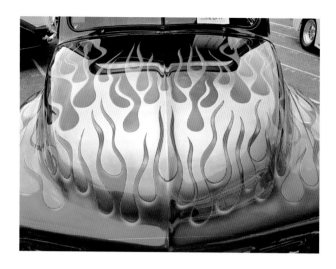

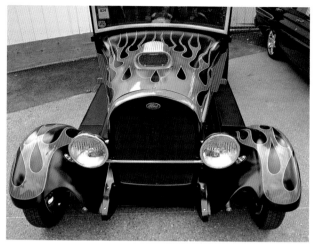

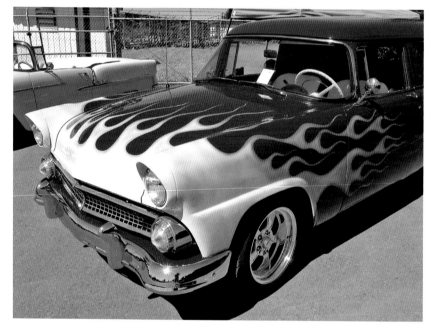

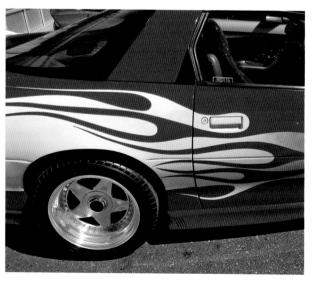

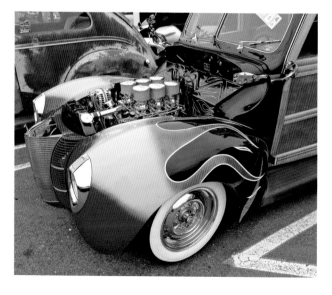

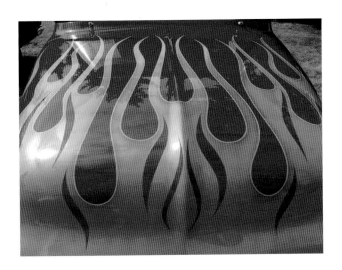

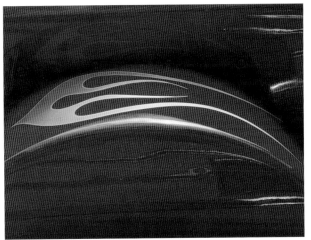

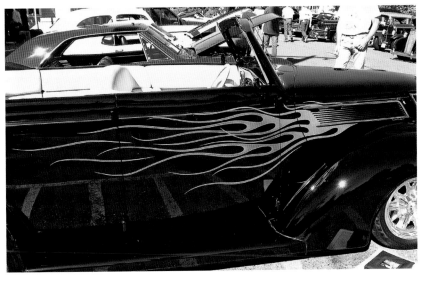

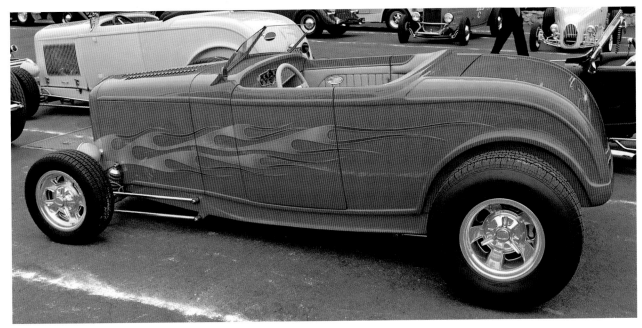

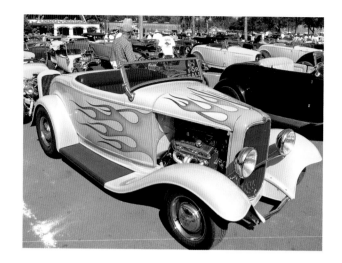

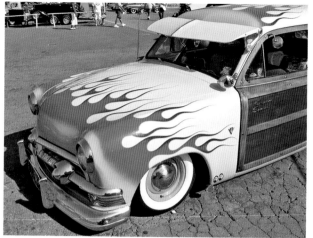

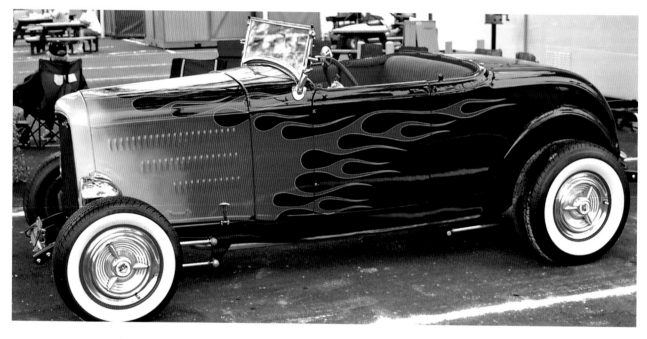

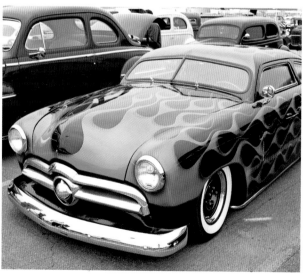

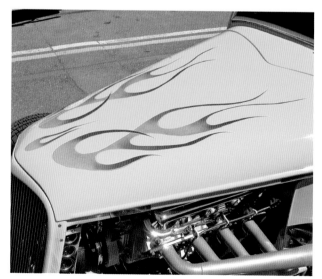

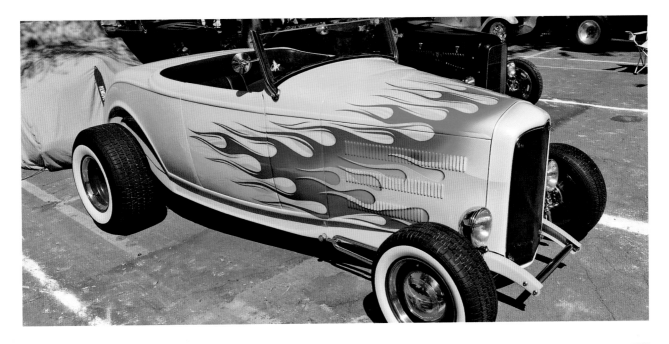

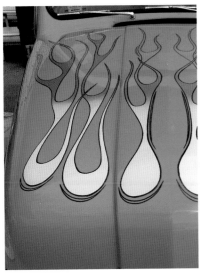

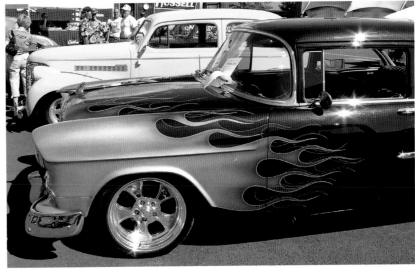

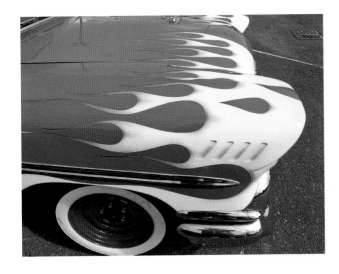

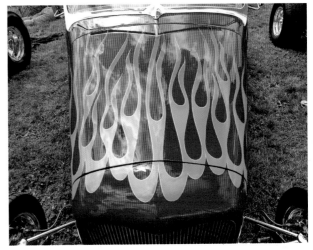

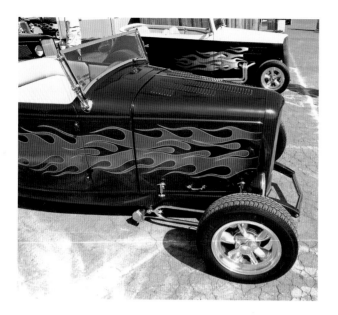

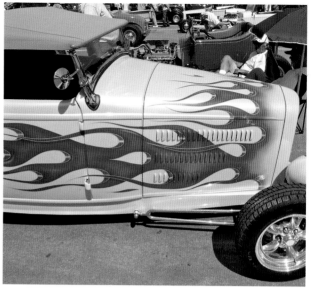

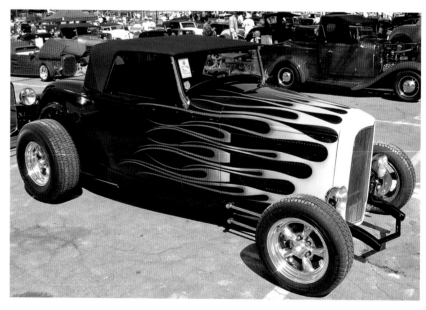

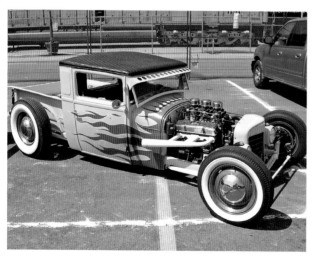

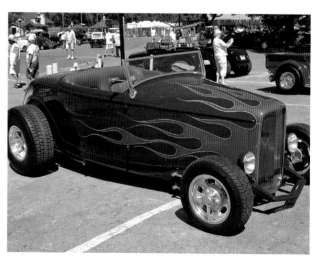

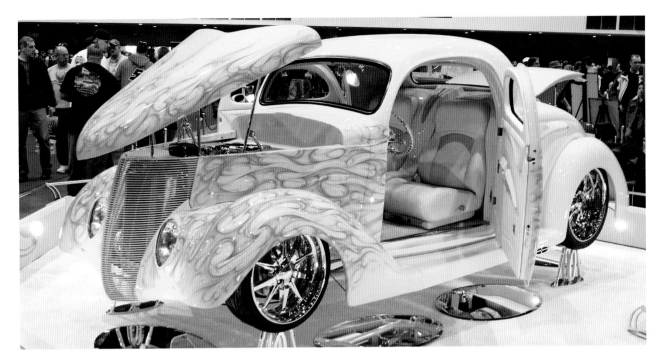

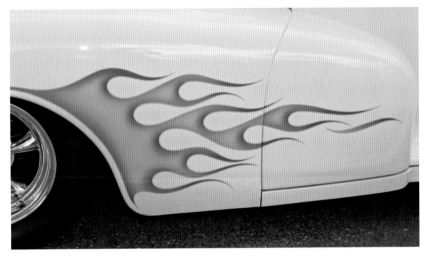

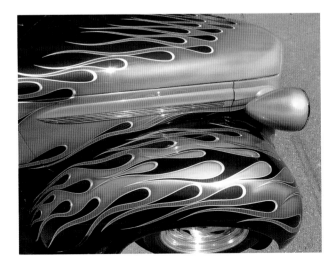

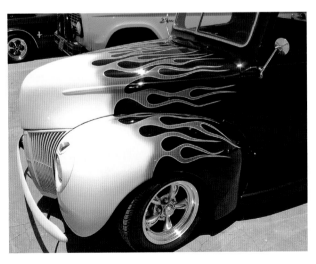

Index

The Best Tools for the Job.

Other Great Books in This Series

How to Paint Your Car
136261AP • 978-0-7603-1583-5

FIX IT! How to Repair Automotive
Dents, Scratches, Tears and Stains
149875AP •978-0-7603-3989-3

How to Master Airbrush
Painting Techniques
140458AP • 978-0-7603-2399-1

How to Repair Your Car
139920AP • 978-0-7603-2273-4

How to Diagnose
and Repair Automotive
Electrical Systems
138716AP • 978-0-7603-2099-0

Chevrolet Small-Block
V-8 ID Guide
122728AP • 978-0-7603-0175-3

How to Restore and
Customize Auto
Upholstery and Interiors
138661AP • 978-0-7603-2043-3

Sheet Metal Fabrication
144207AP • 978-0-7603-2794-4

101 Performance Projects For Your
BMW 3 Series 1982–2000
143386AP • 978-0-7603-2695-4

Honda CRF Performance Handbook
140448AP • 978-0-7603-2409-7

Autocross Performance Handbook
144201AP • 978-0-7603-2788-3

Mazda Miata MX-5
Find It. Fix It. Trick It.
144205AP • 978-0-7603-2792-0

Four-Wheeler's Bible
135120AP • 978-0-7603-1056-4

How to Build a Hot Rod
135773AP • 978-0-7603-1304-6

How to Restore Your Collector Car
2nd Edition 3541-3 145823
128080AP • 978-0-7603-0592-8

101 Projects for Your
Corvette 1984–1996
136314AP • 978-0-7603-1461-6

How to Rebuild Corvette Rolling
Chassis 1963–1982
144467AP • 978-0-7603-3014-2

How to Restore Your Motorcycle
130002AP • 978-0-7603-0681-9

101 Sportbike
Performance Projects
135742AP • 978-0-7603-1331-2

How to Restore and Maintain Your
Vespa Motorscooter
128936AP • 978-0-7603-0623-9

How to Build a Pro Streetbike
140440AP • 978-0-7603-2450-9

101 Harley-Davidson Evolution
Performance Projects
139849AP • 978-0-7603-2085-3

101 Harley-Davidson Twin Cam
Performance Projects
136265AP • 978-0-7603-1639-9

Harley-Davidson Sportster
Performance Handbook,
3rd Edition
140293AP • 978-0-7603-2353-3

Motorcycle Electrical Systems
Troubleshooting and Repair
144121AP • 978-0-7603-2716-6